Compositions Book 12

Music for Strings

by
Ken Langer

Compositions Book 12

Original Music for Strings

by
Ken Langer

Compositions Book 12
Music for Strings
by Ken Langer

Klangermuzik

Klangermuzik
http://klangermuzik.com

First Edition (Softcover)

Copyright © 2013, Ken Langer

ISBN: 978-1-300-90285-0

All rights reserved. No Part of this book may be reproduced or transmitted in any form or by any means, electronic or mechanical, including photocopying, recording or by any information storage and retrieval system, without written permission from the author, except for the inclusion of brief quotations with proper annotation.

Produced in the United States of America

The author may be contacted at ken@kenlanger.com.

Table of Contents

1	A Blaze of Daffodils	violin, cello, piano	9
2	Brentwood Suite	violin, viola, cello	19
3	Cry To Dark Pony	string orchestra	37
4	The Foolish Fiddler	narrator, violin, cello	44
5	Lyrical Poems	string quartet	55
6	When Frost To Dance	viola, piano	117

Introduction

This is a collection of works for various configurations of string instruments.

A Blaze of Daffodils was written for a pair of visiting performers at a music festival in Vermont. *Brentwood Suite* was originally written for a woodwind trio but has been re-written here for strings. *Cry to Dark Pony* was an award winning composition at the annual Kent State University Concerto Competition. It was written after I saw the play by David Mamet entitled Dark Pony. *The Foolish Fiddler* includes a part for a narrator and was conceived as a theater piece for young audiences. *Lyrical Poems* was originally written for piano (see book 1) but has been arranged here for string quartet. It is a collection of 12 short preludes. *When Frost To Dance* was commissioned by a viola player in Vermont who goes only by the name Malone. It is in a sontina form and is meant to be challenging to the performer.

For more information and to hear recordings and transcriptions of music in this and all the other collections please visit http://klangermuzik.com.

A Blaze Of Daffodils

Ken Langer

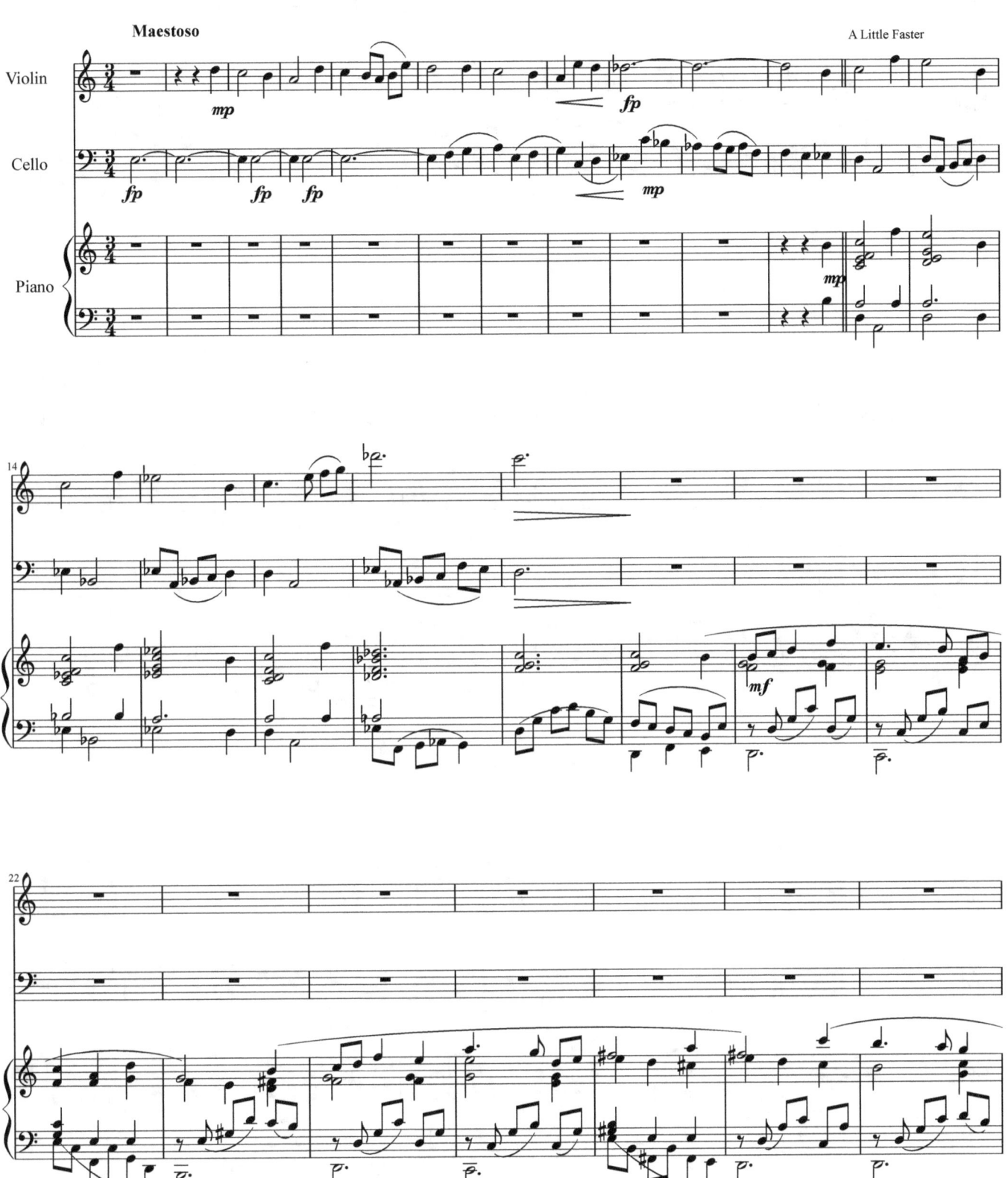

9

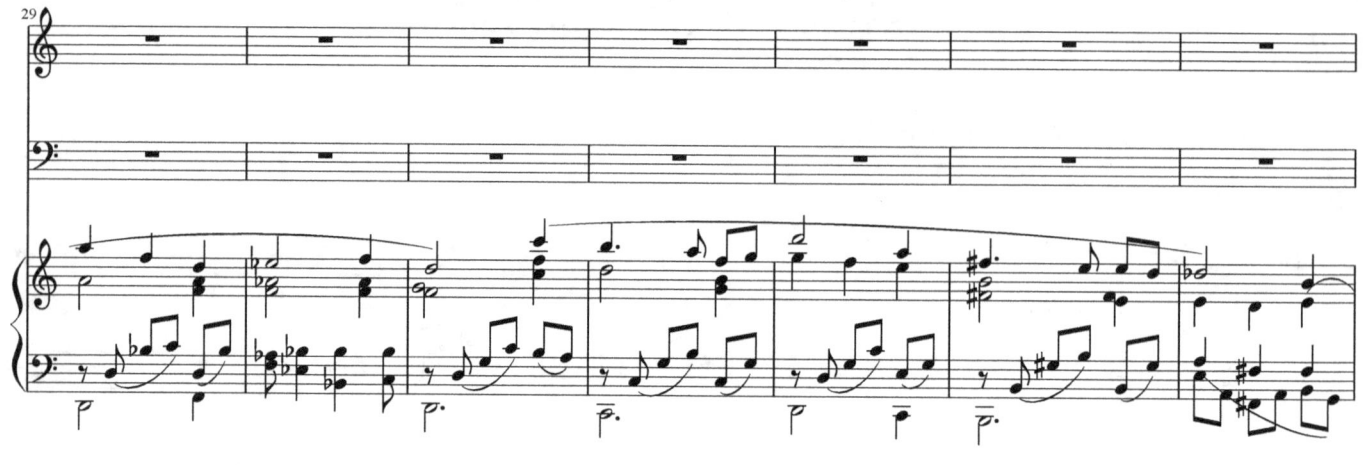
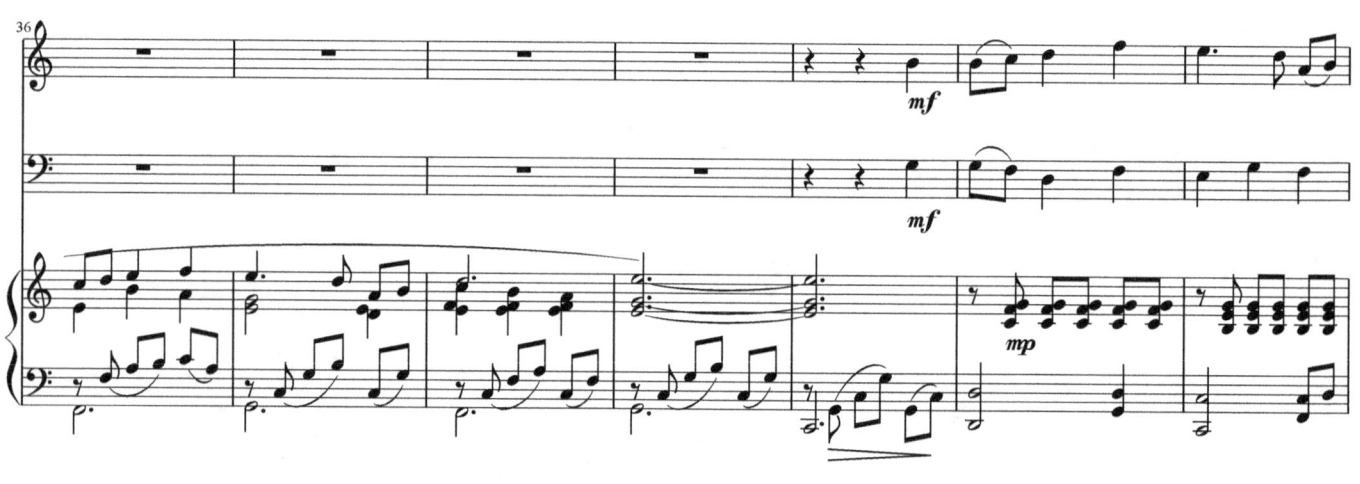

12

Brentwood Suite

I. Prelude

Ken Langer

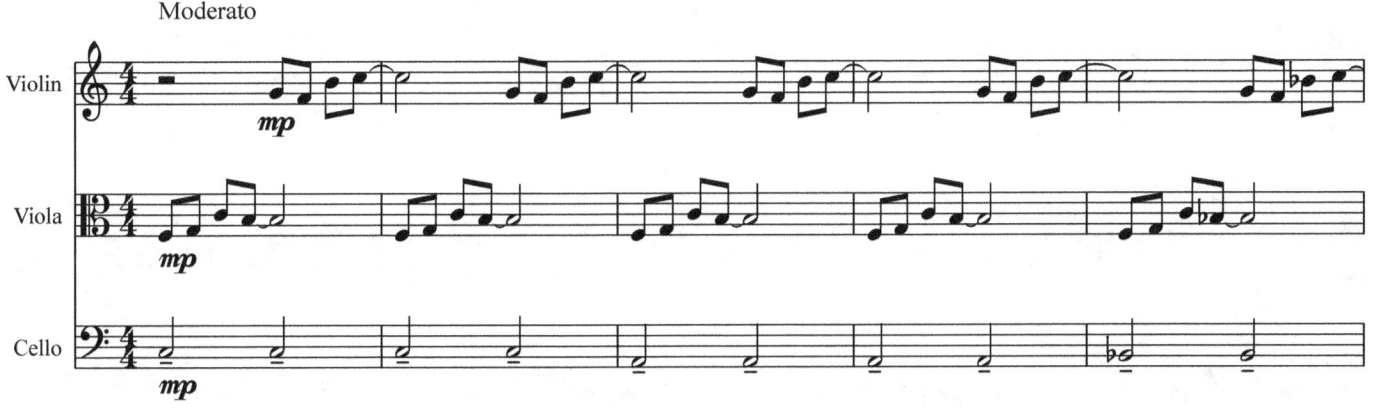
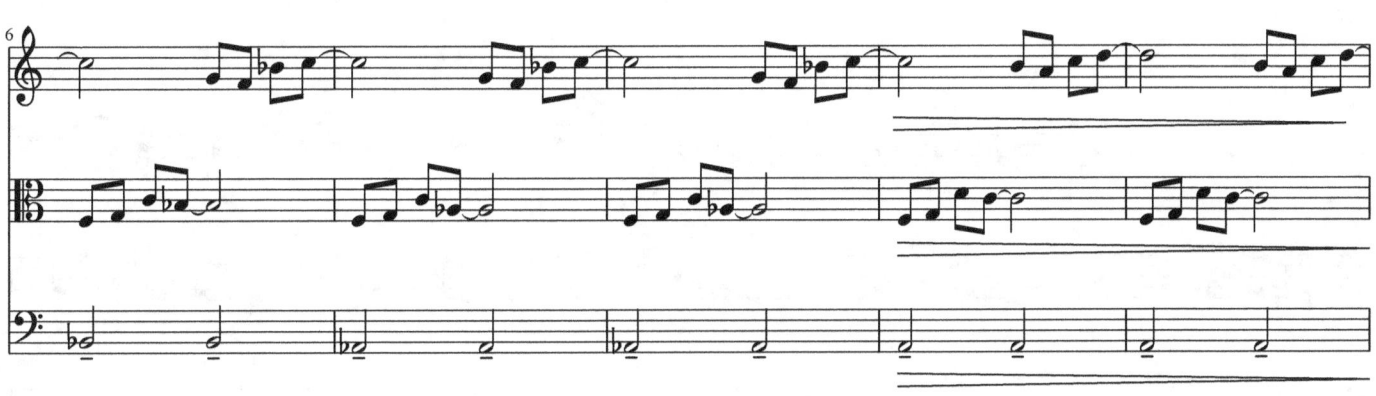
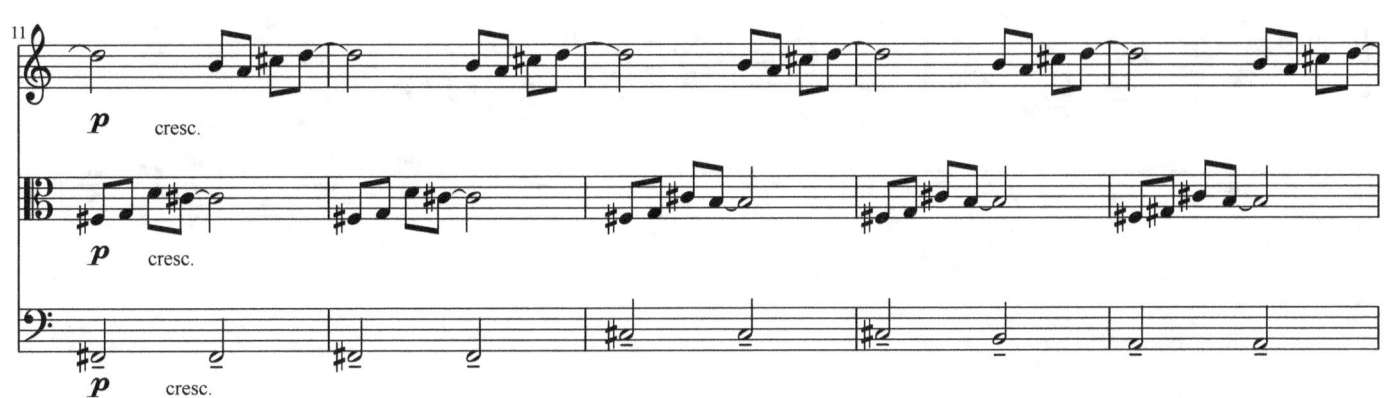

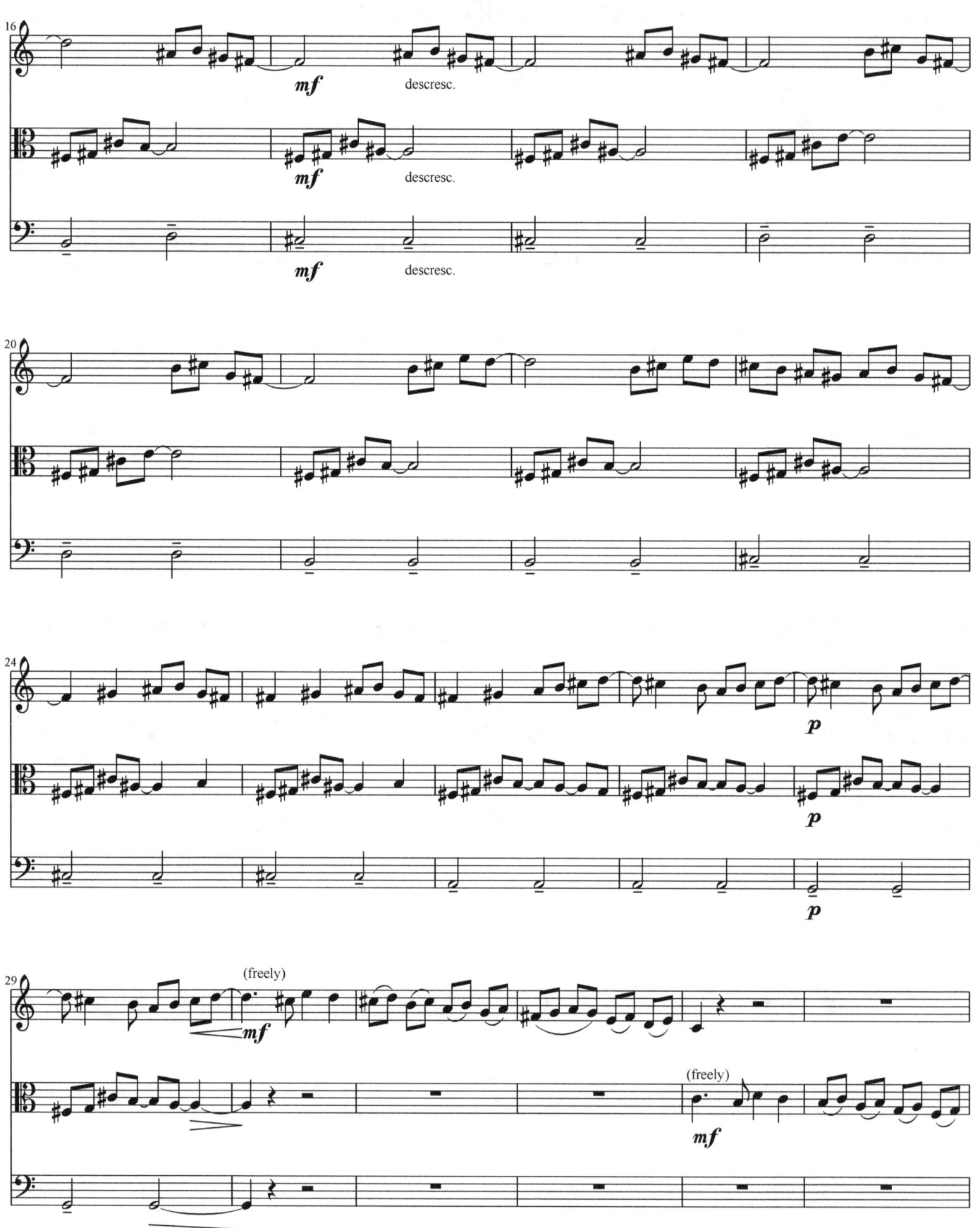

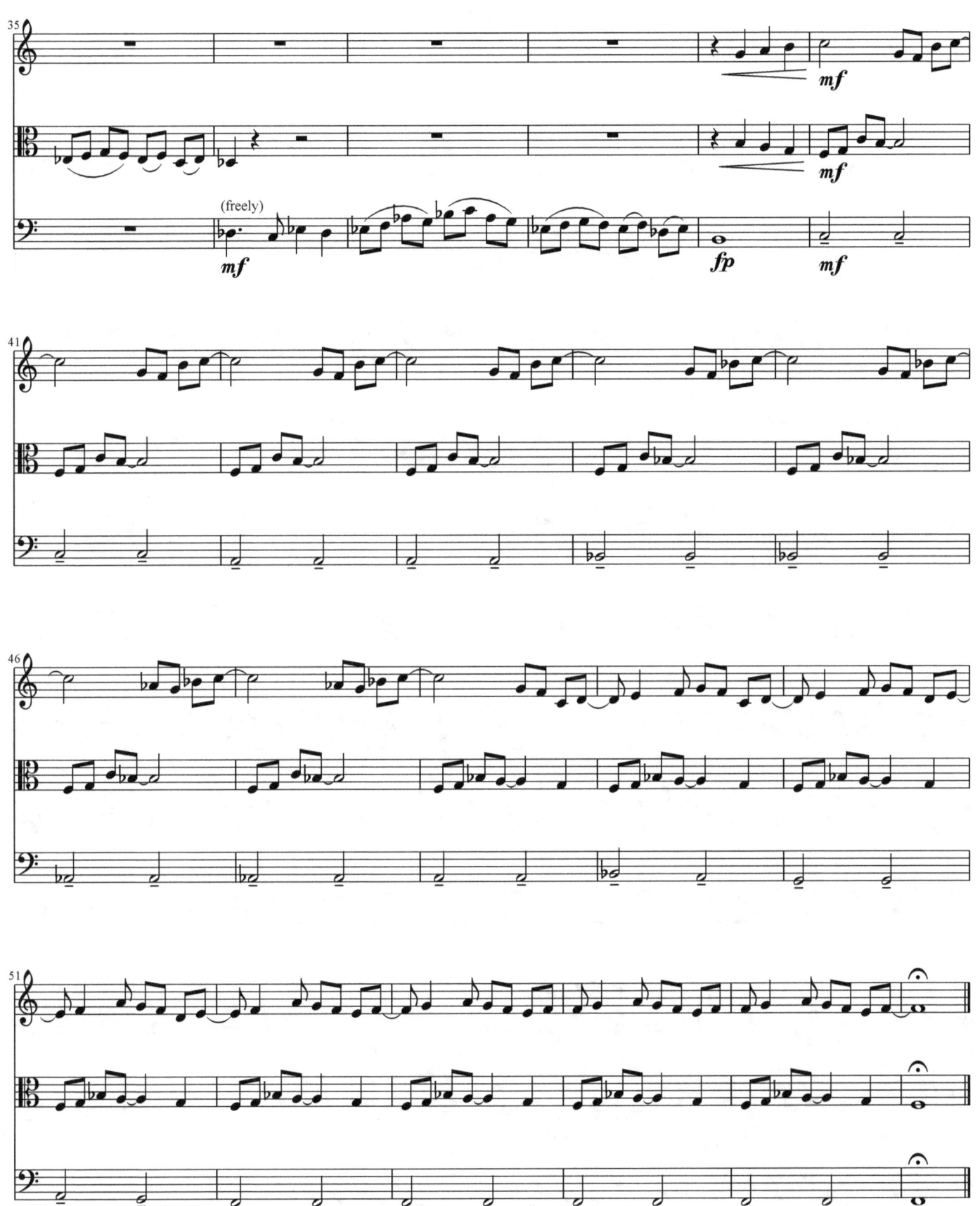

Brentwood Suite

II. Allemande

Ken Langer

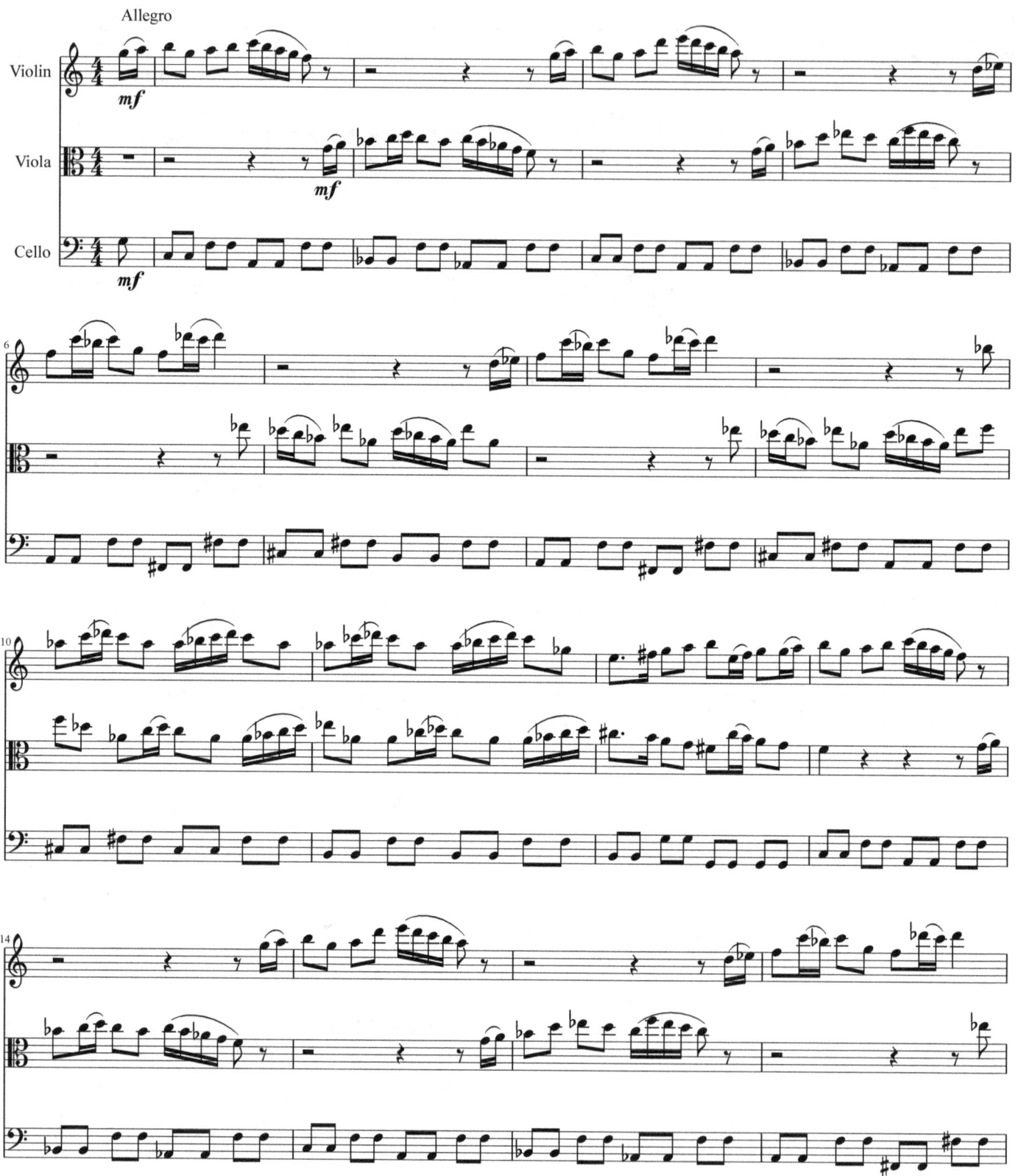

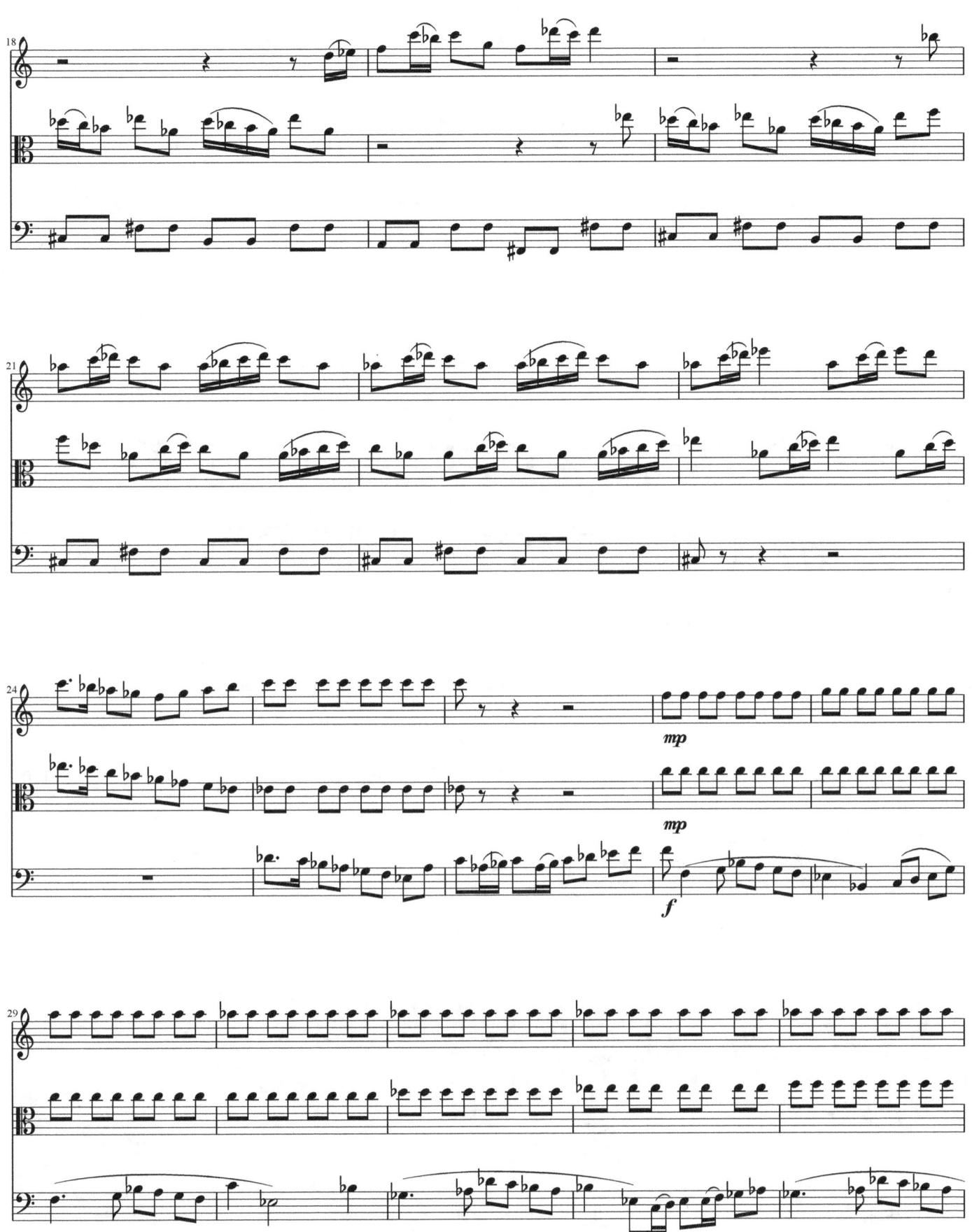

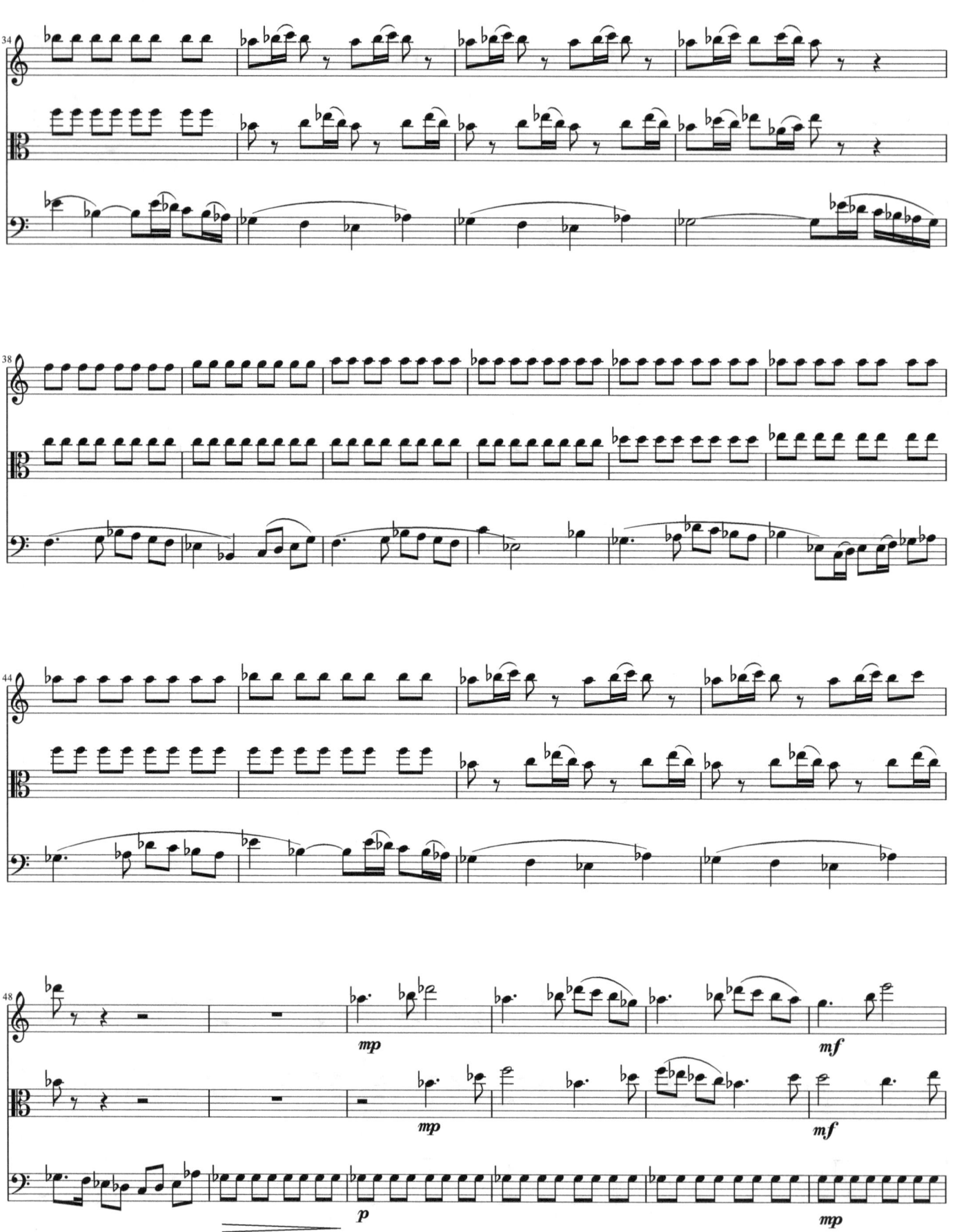

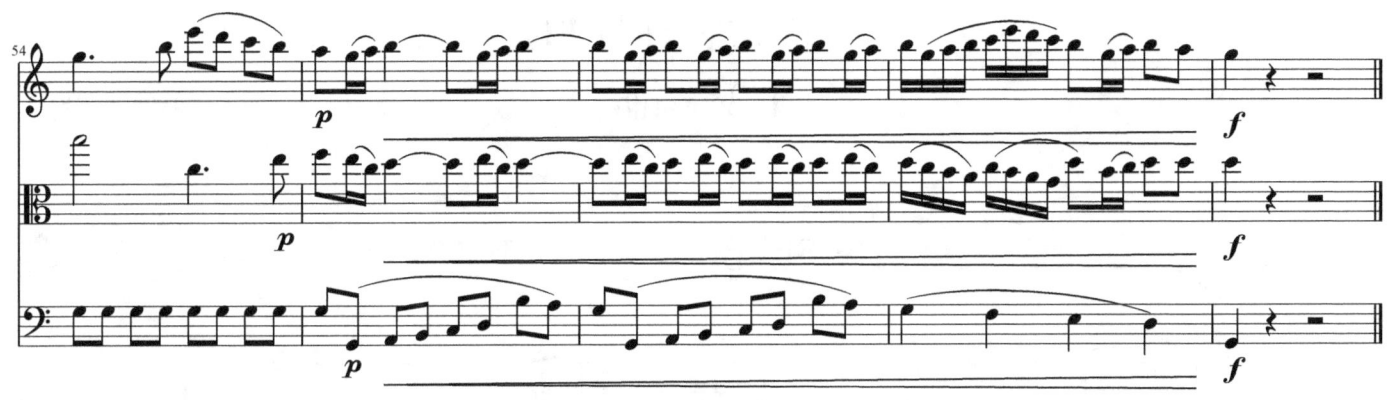

25

Brentwood Suite
III. Courante

Ken Langer

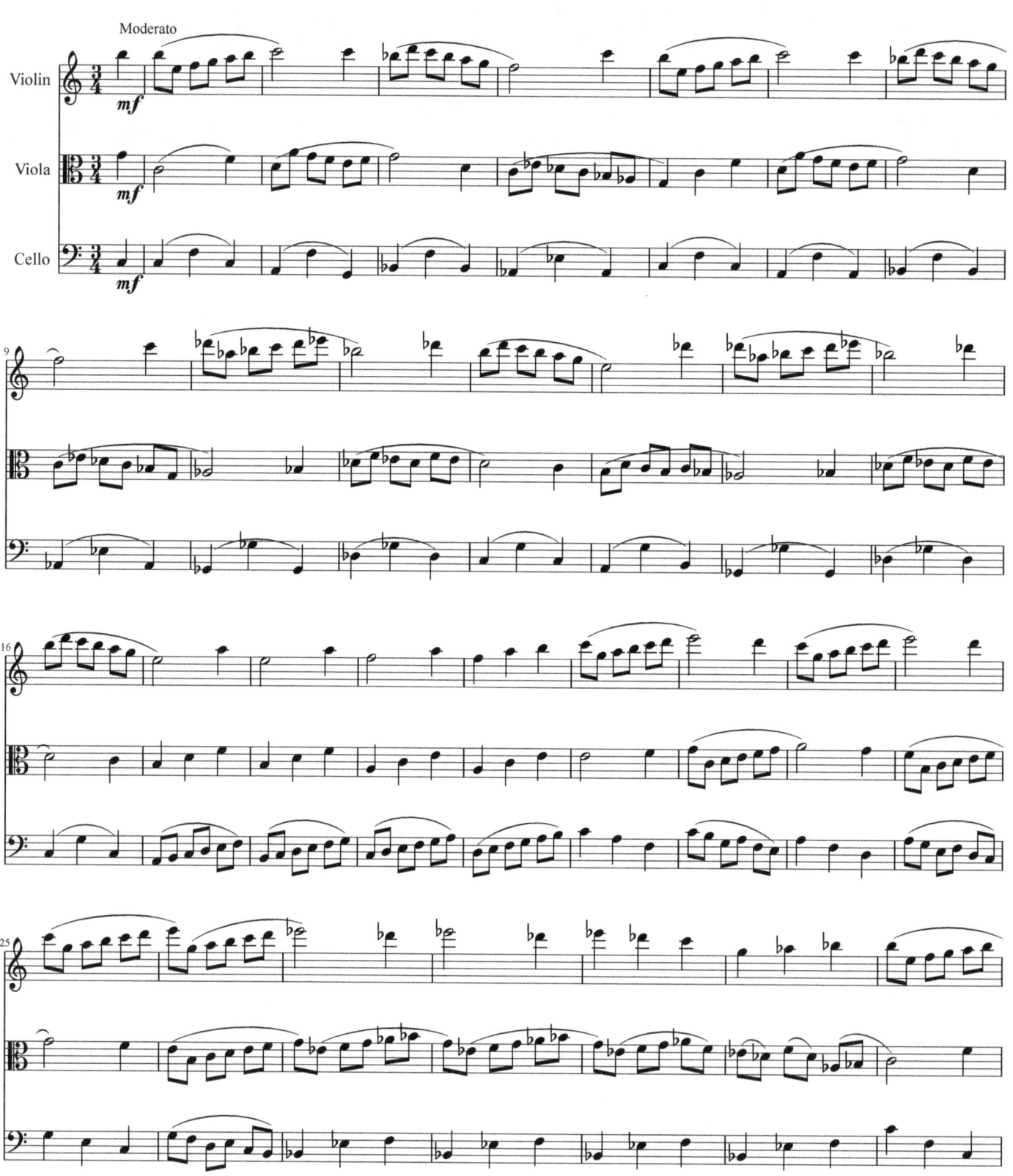

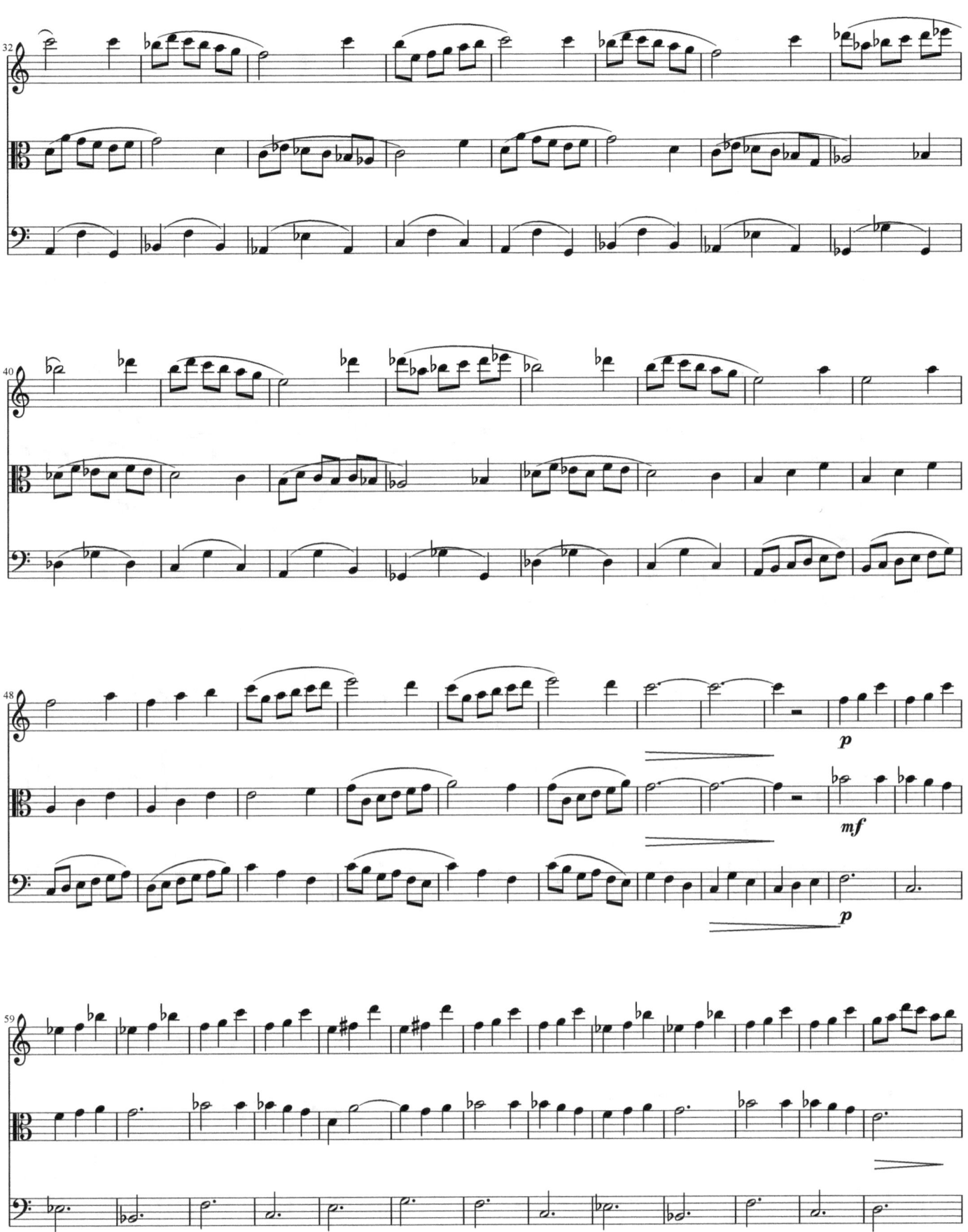

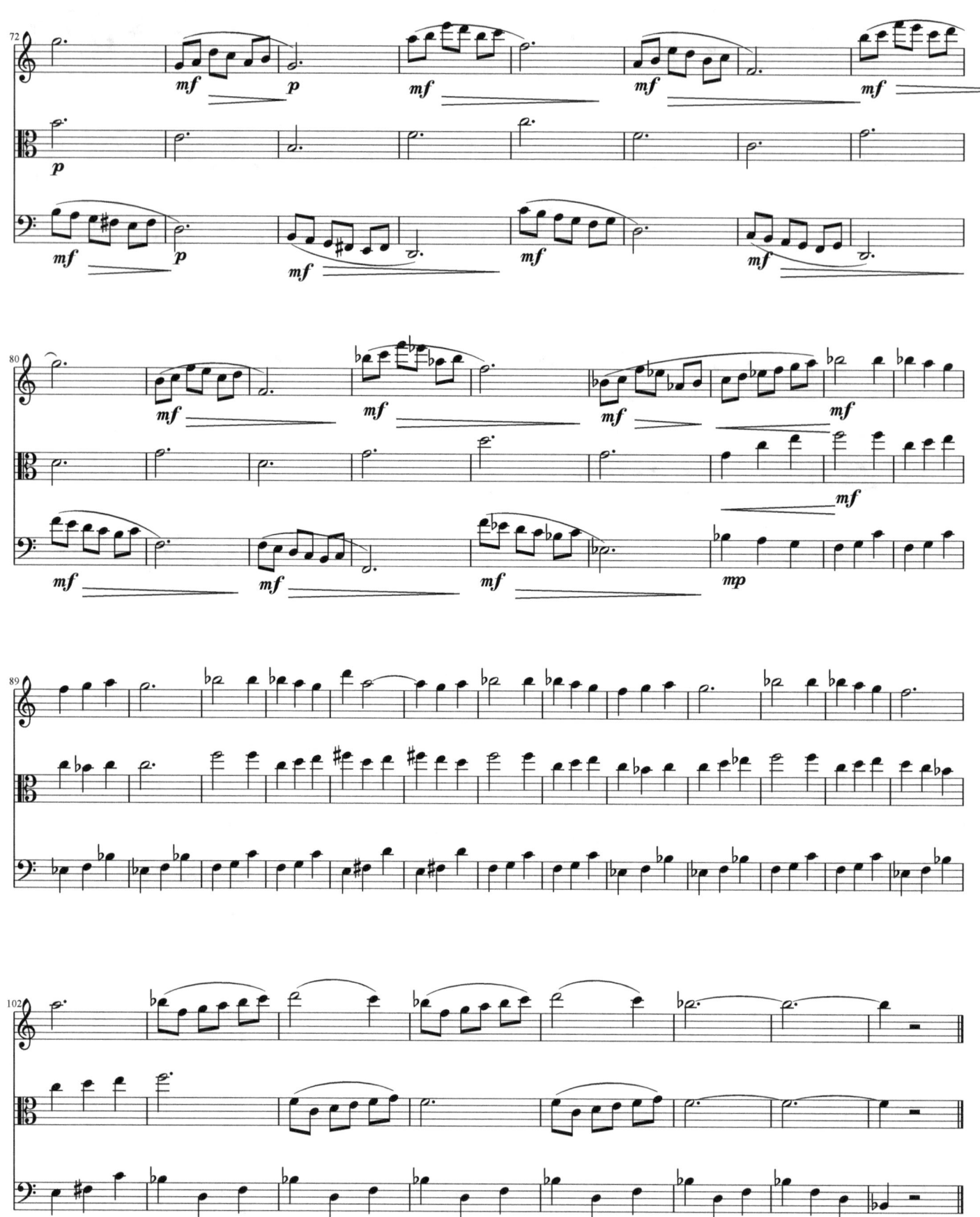

Brentwood Suite
IV. Sarabande
Ken Langer

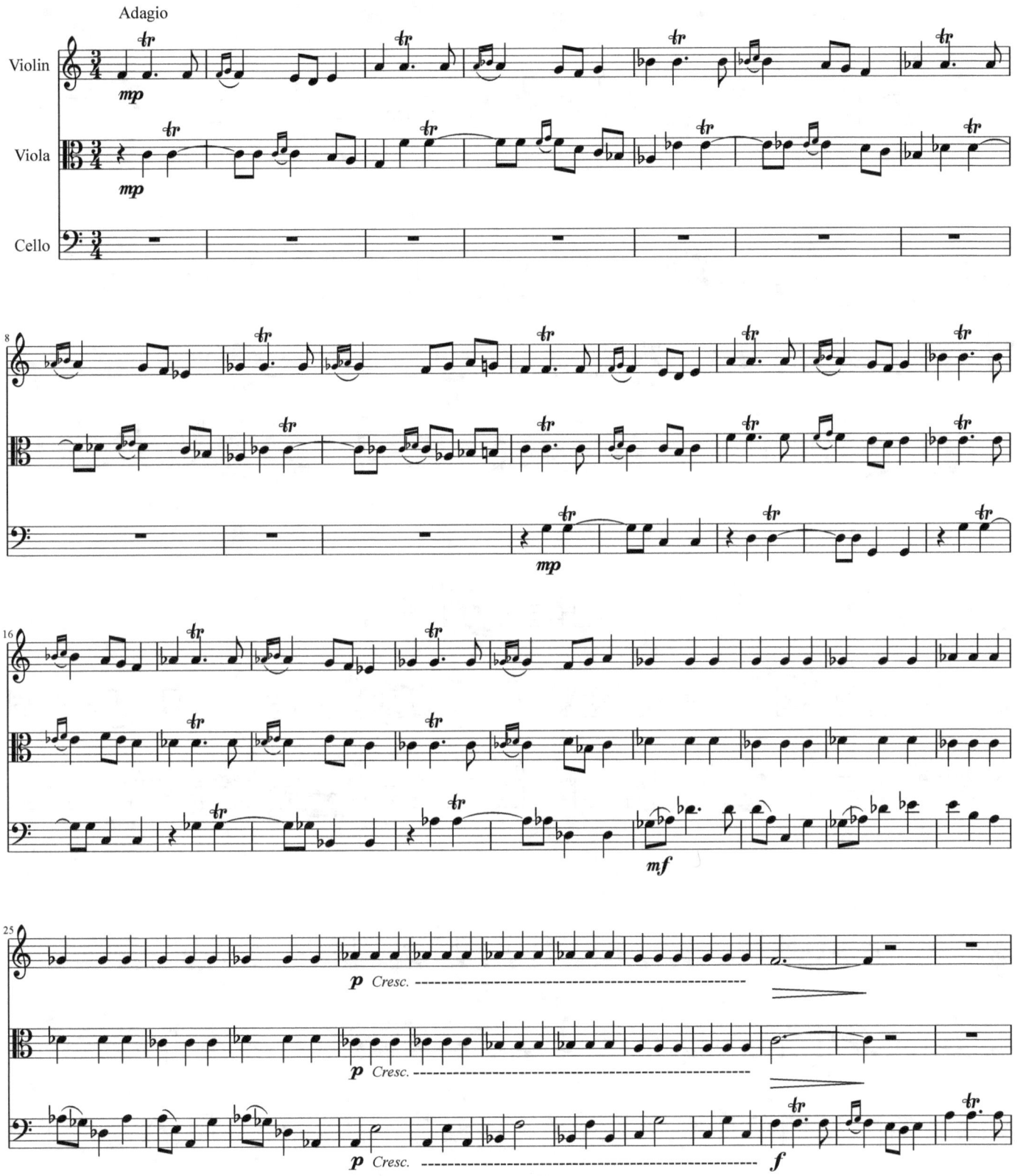

29

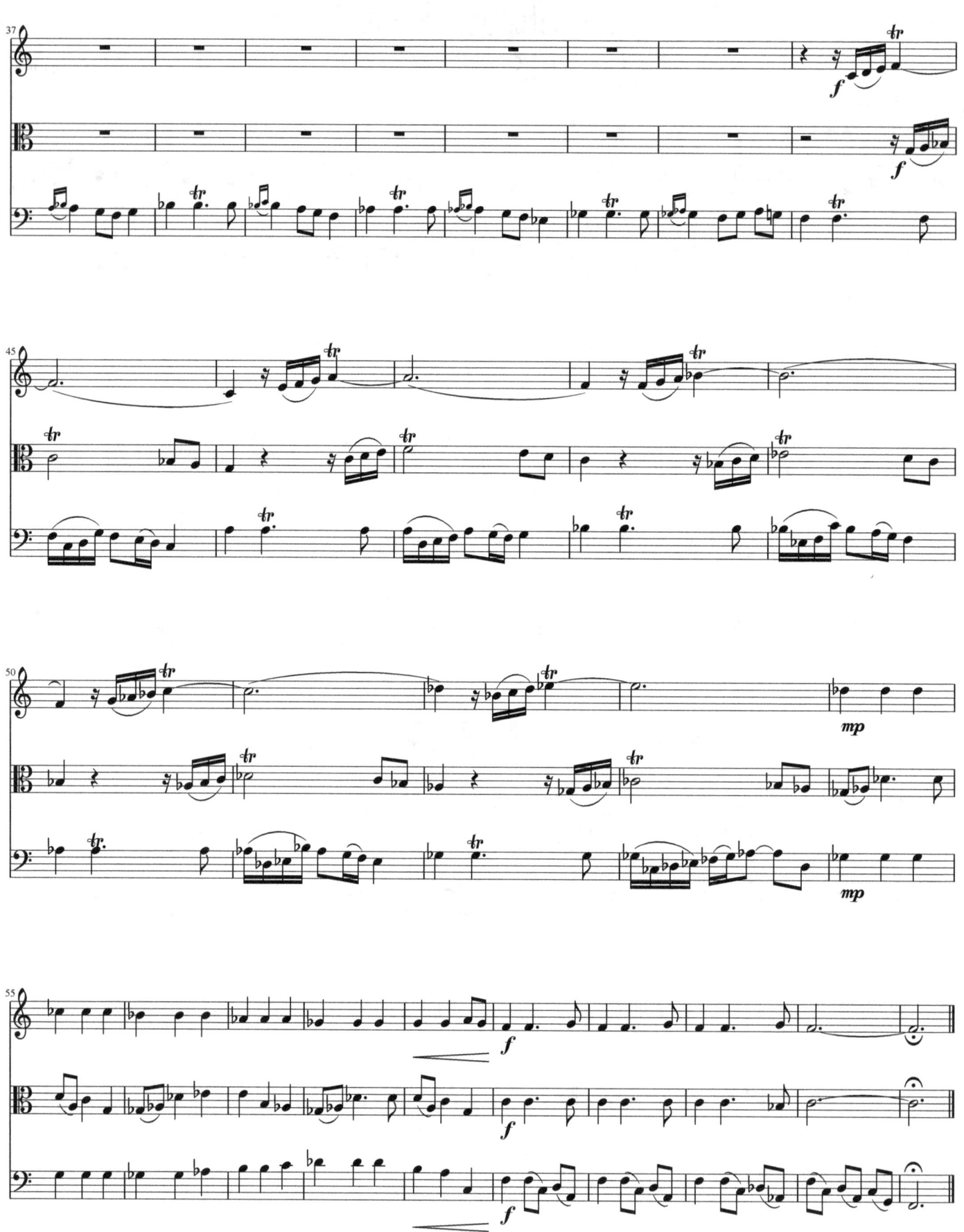

Brentwood Suite
V. Air

Ken Langer

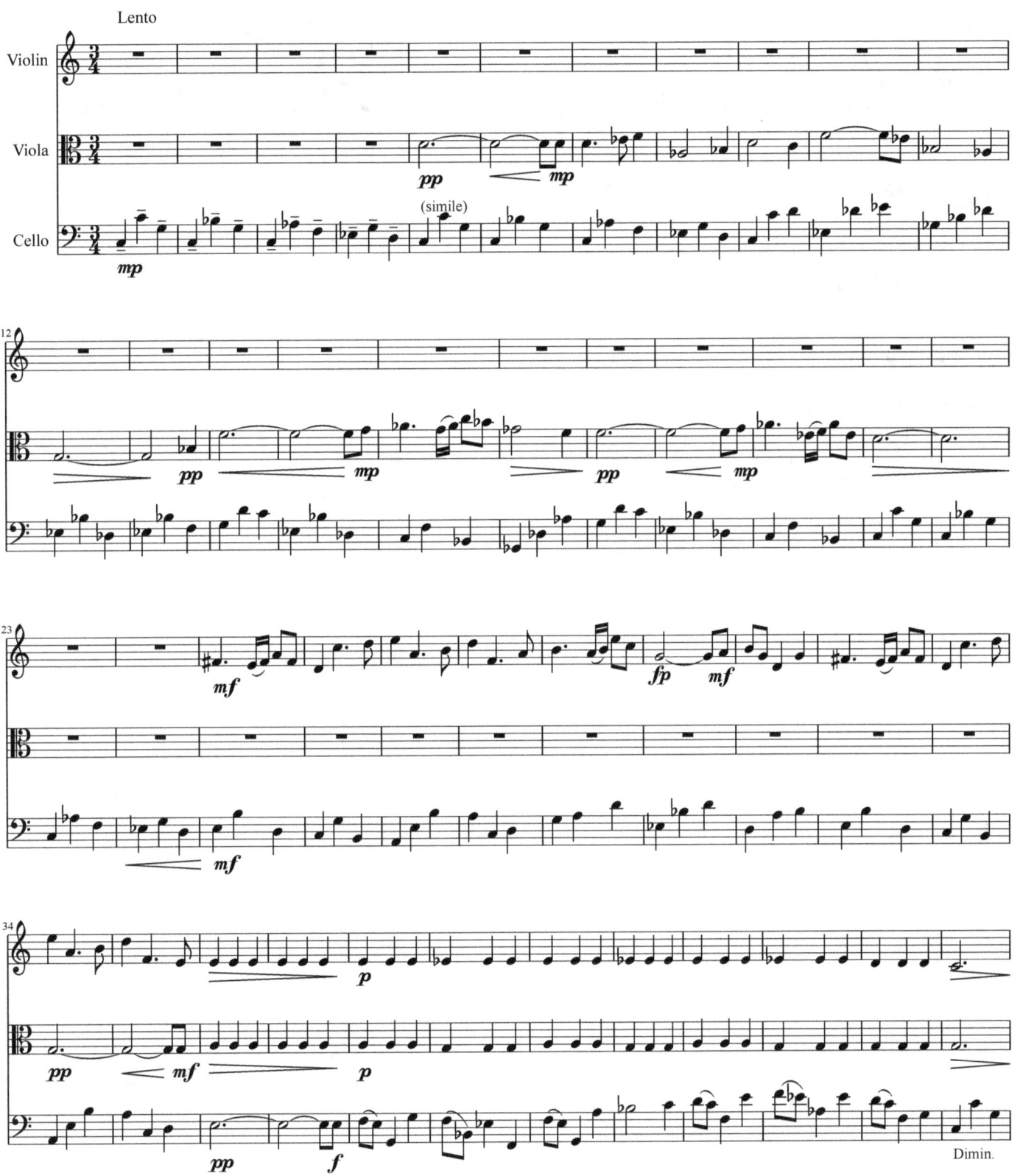

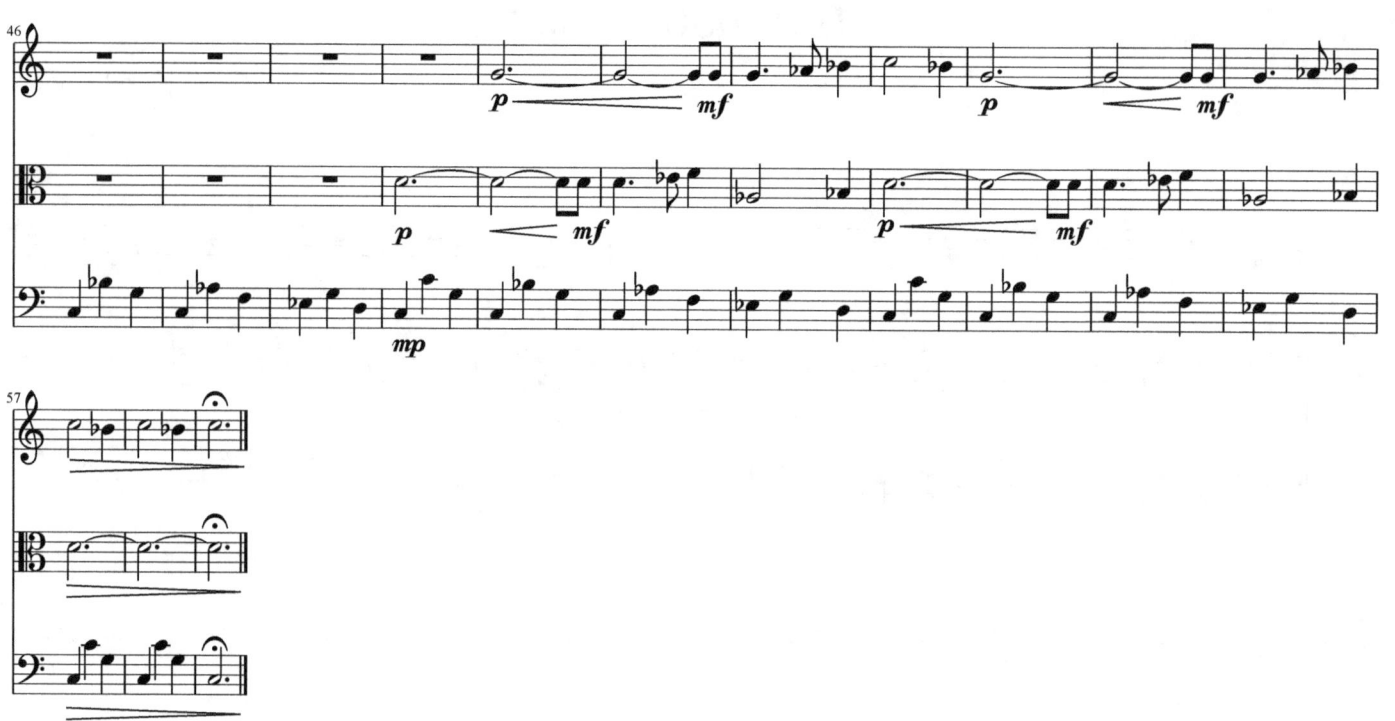

32

Brentwood Suite
VI. Gigue
Ken Langer

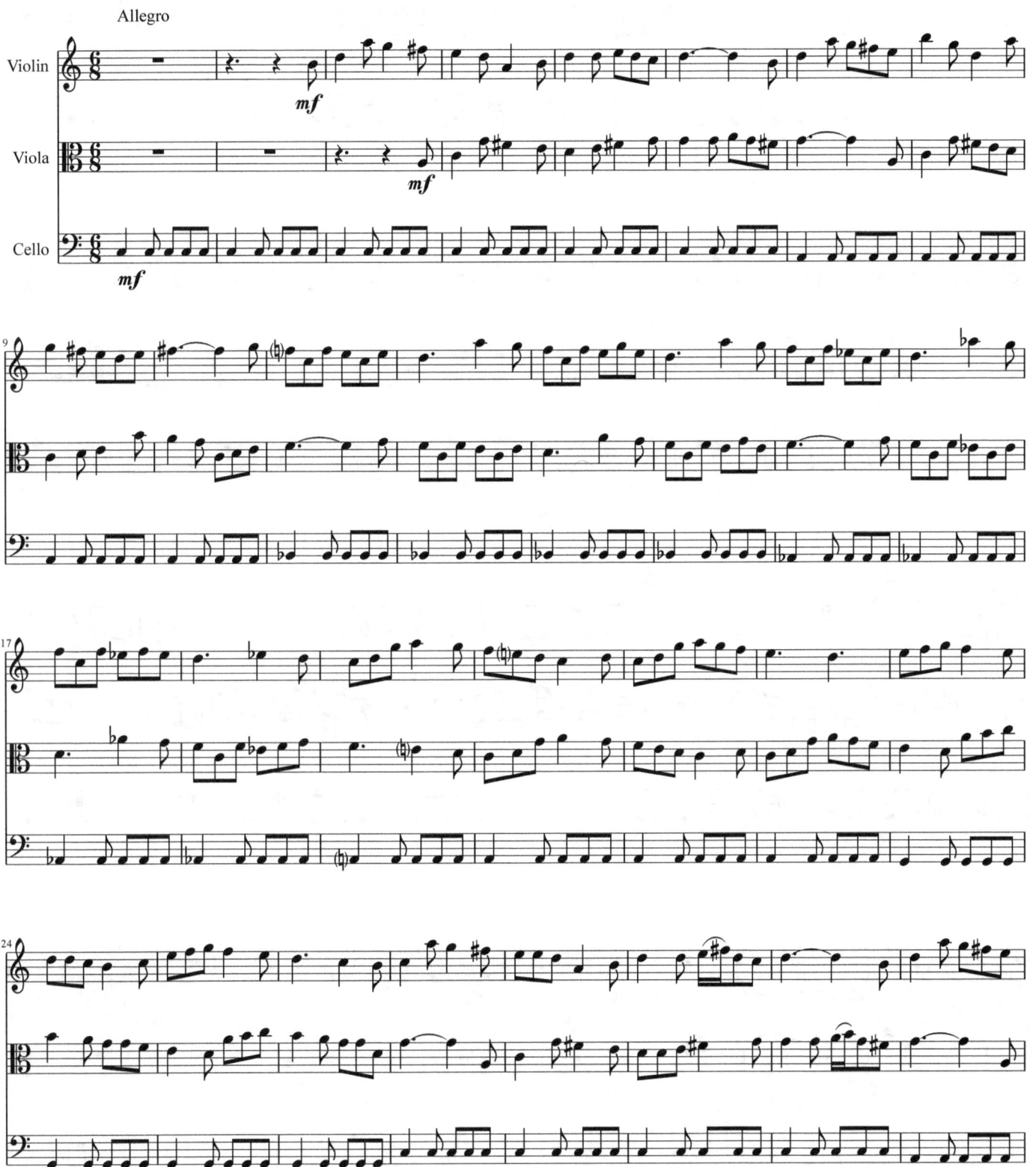

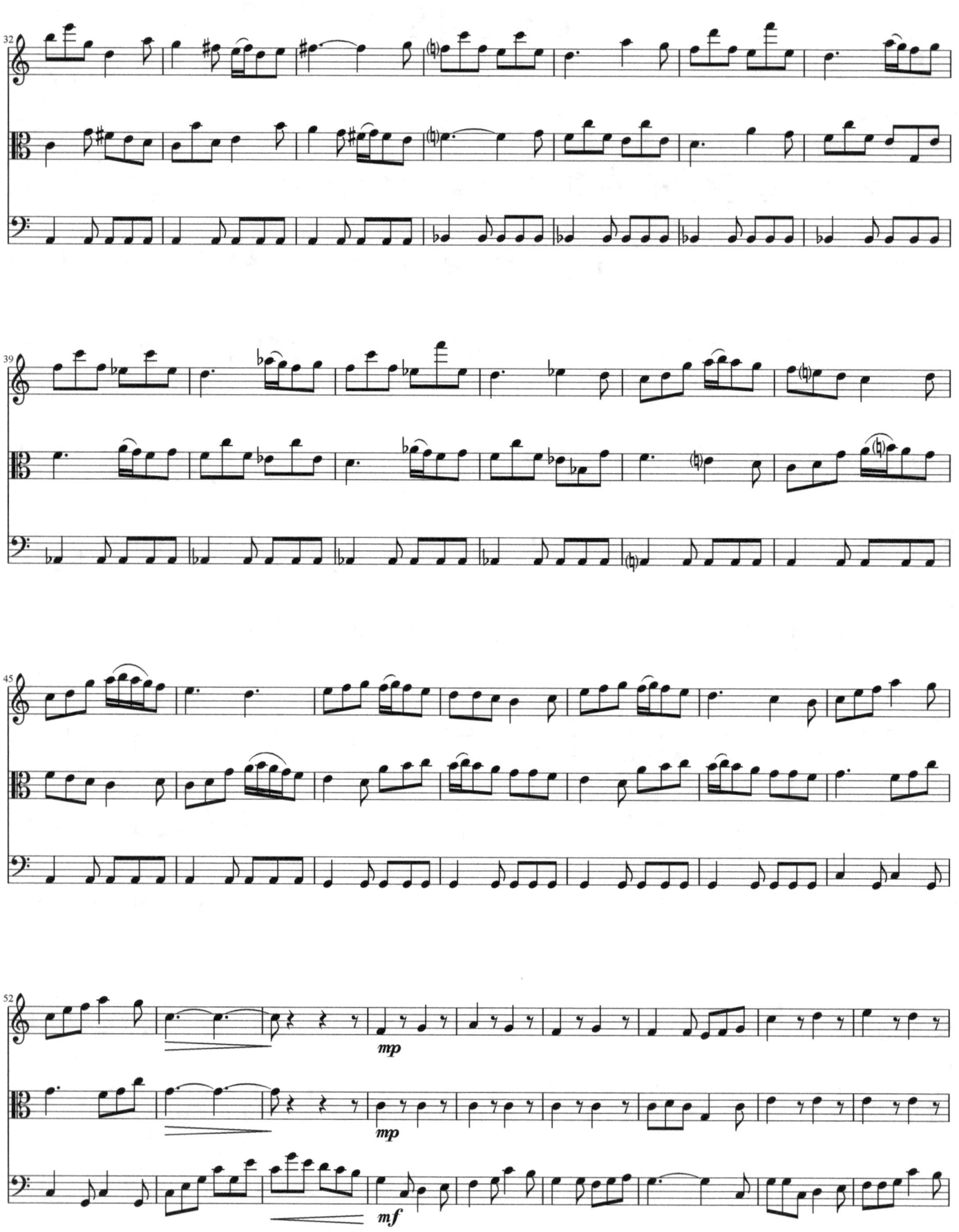

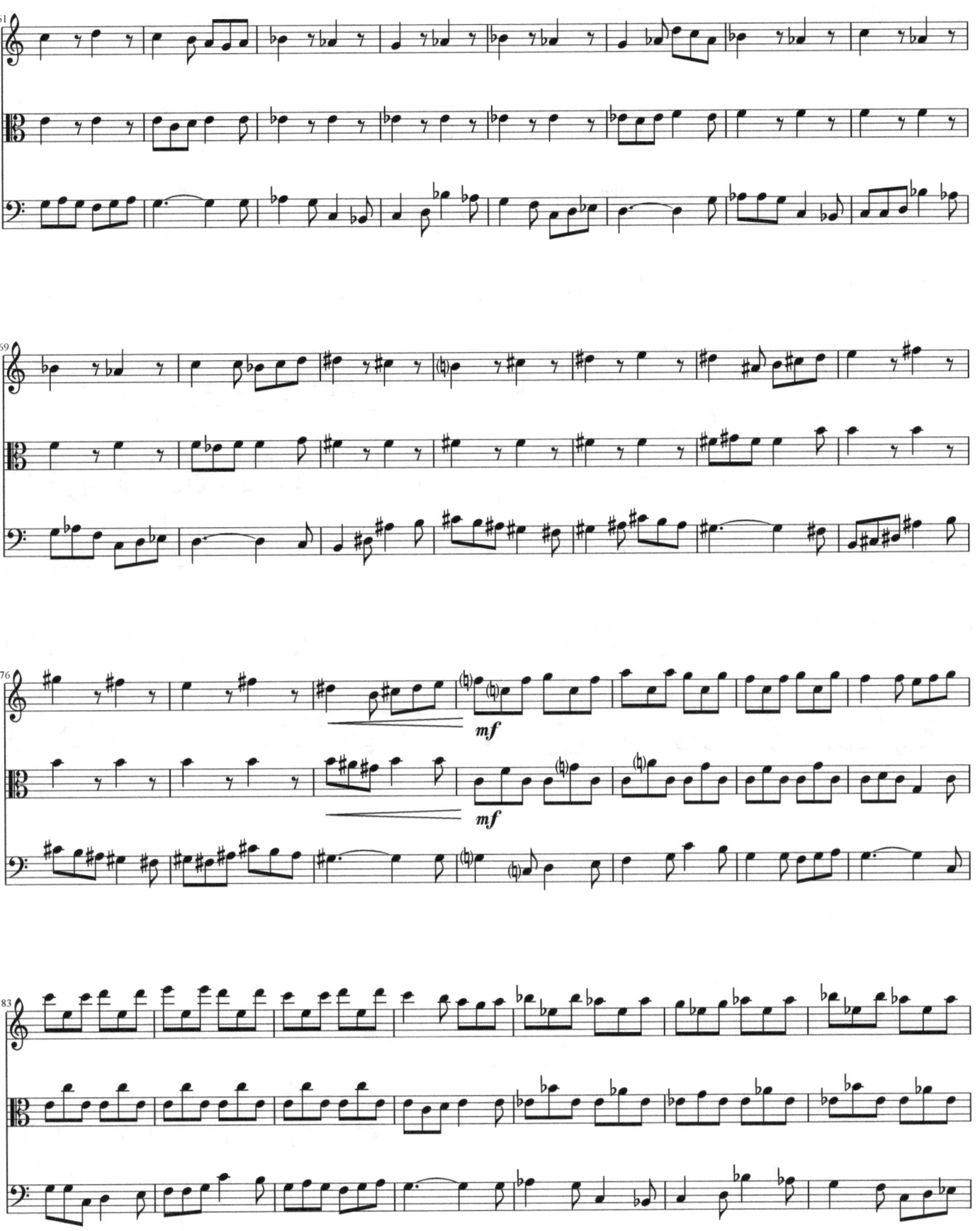

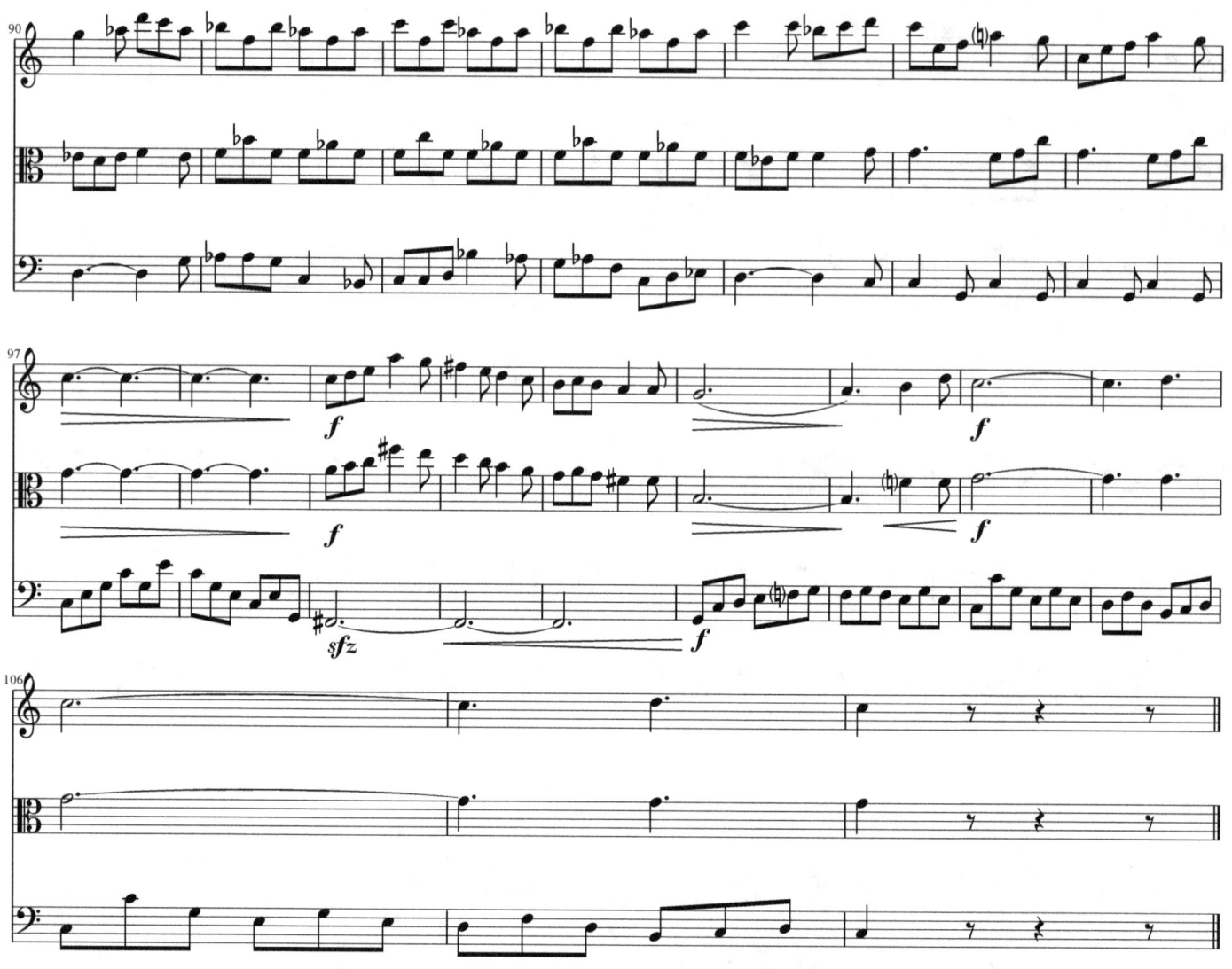

Cry To Dark Pony

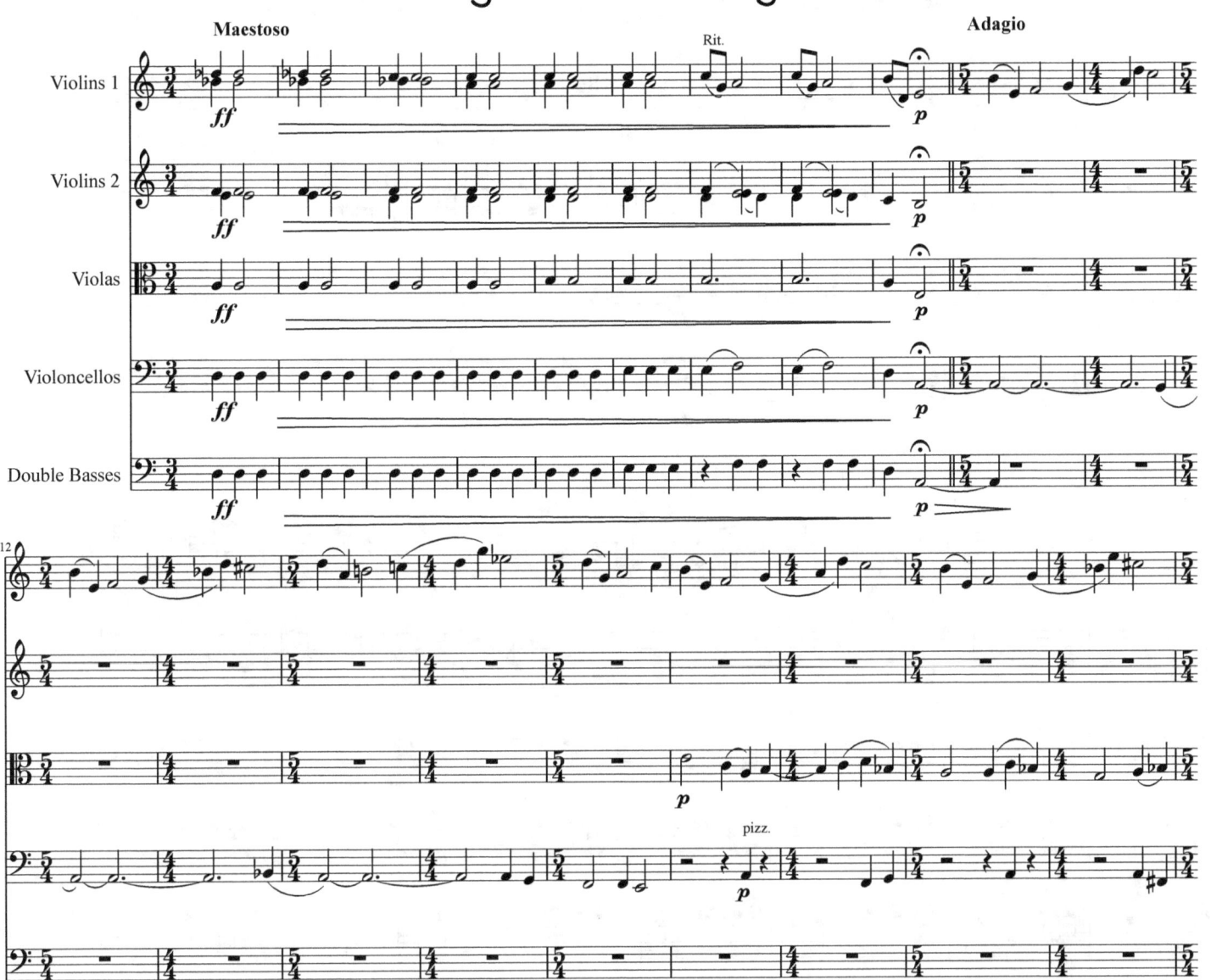

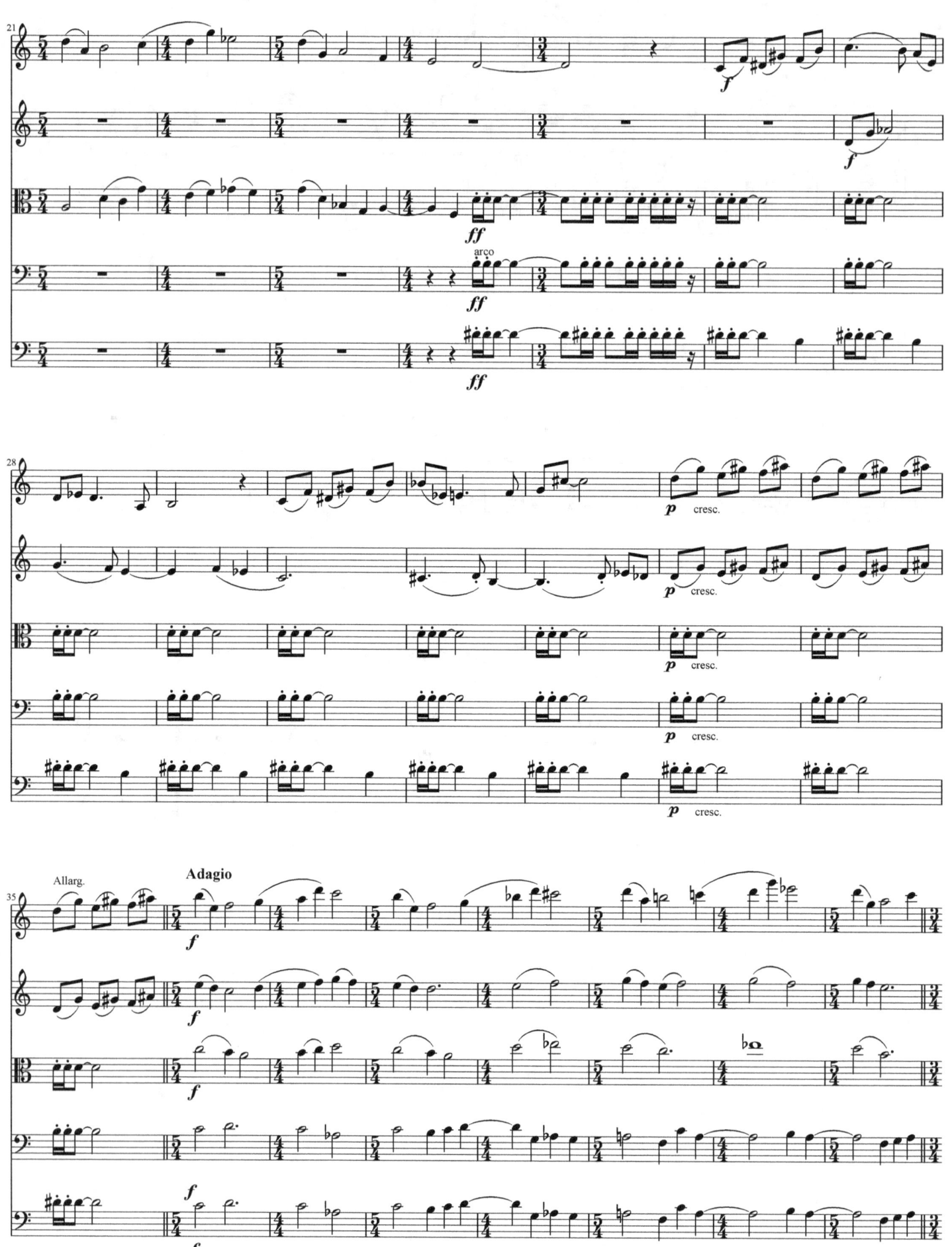

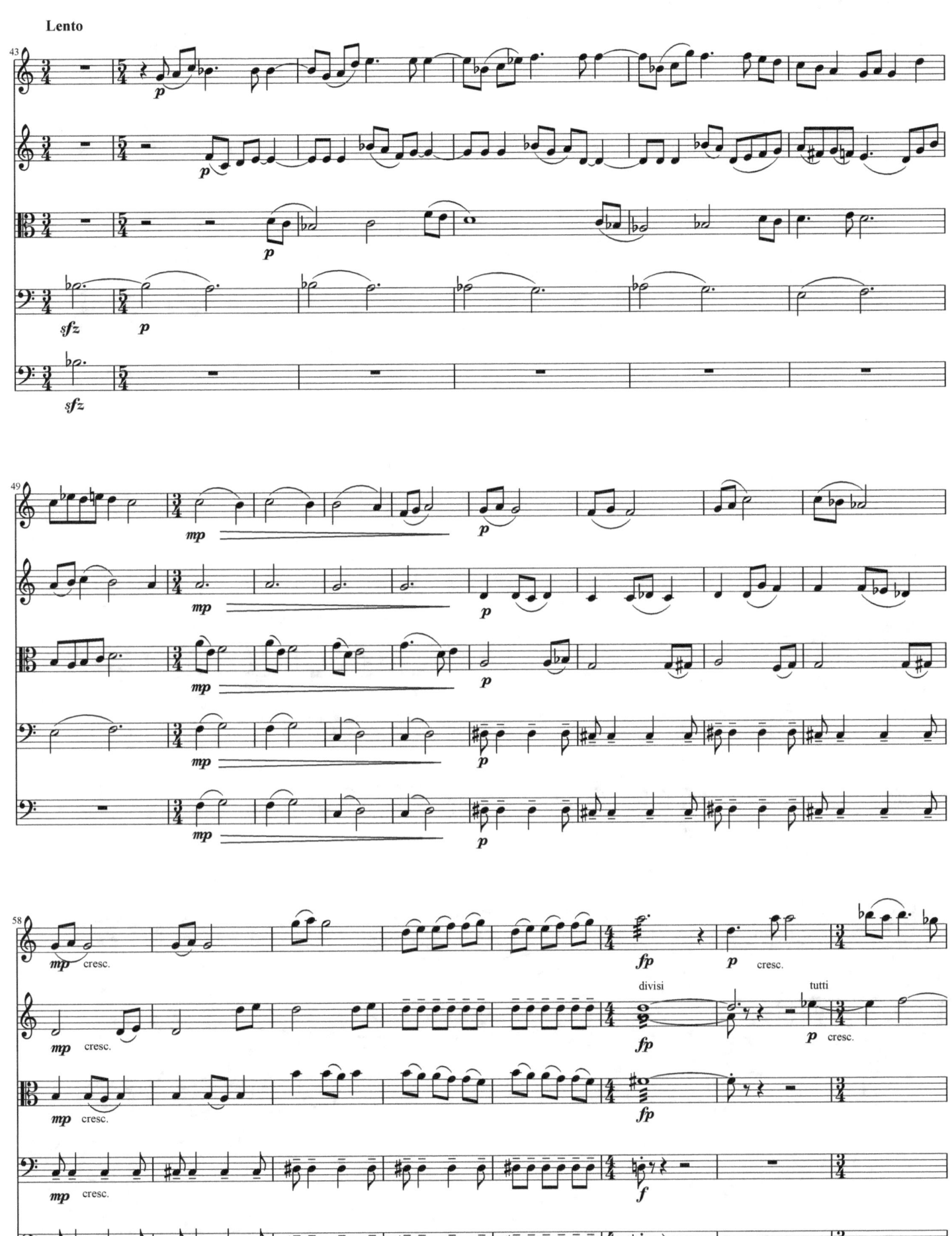

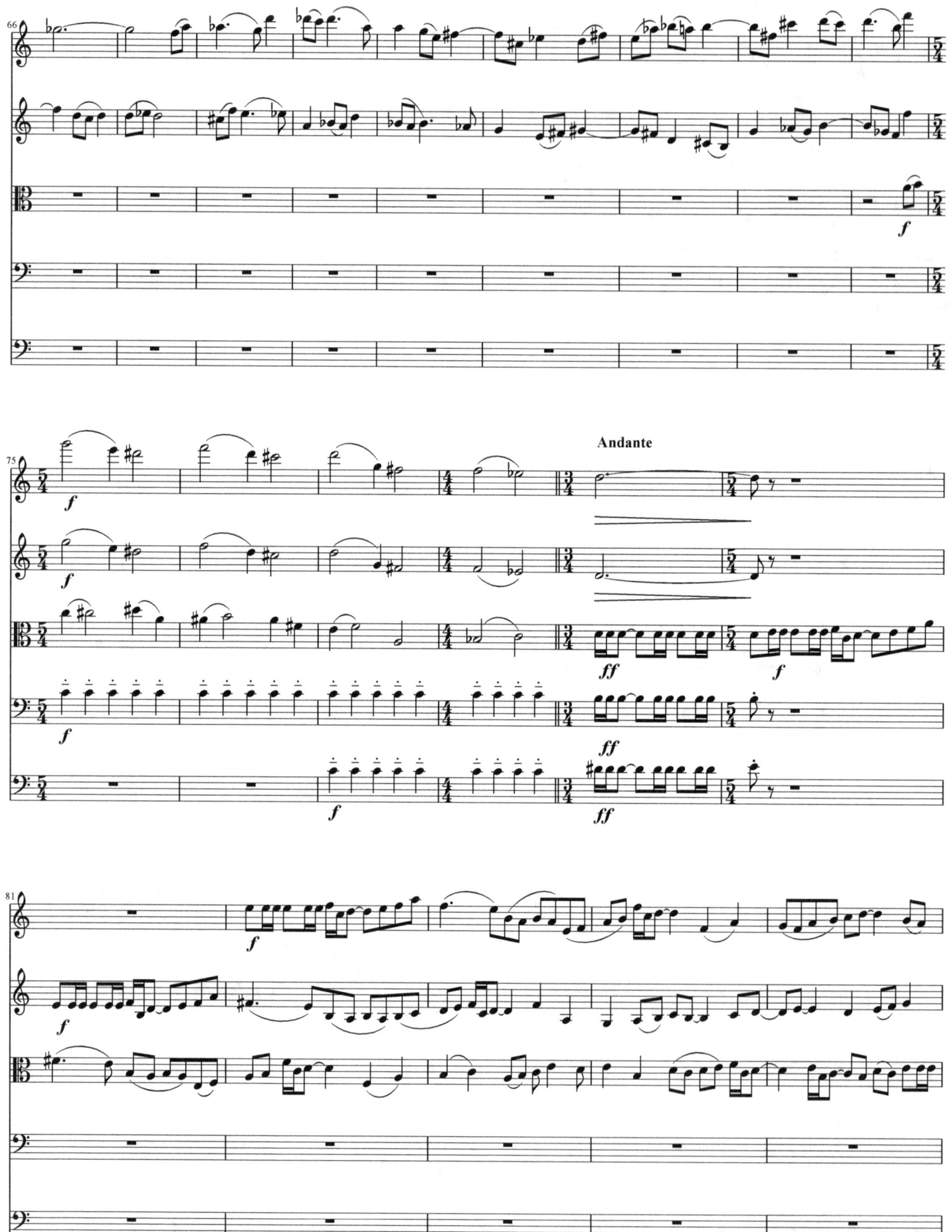

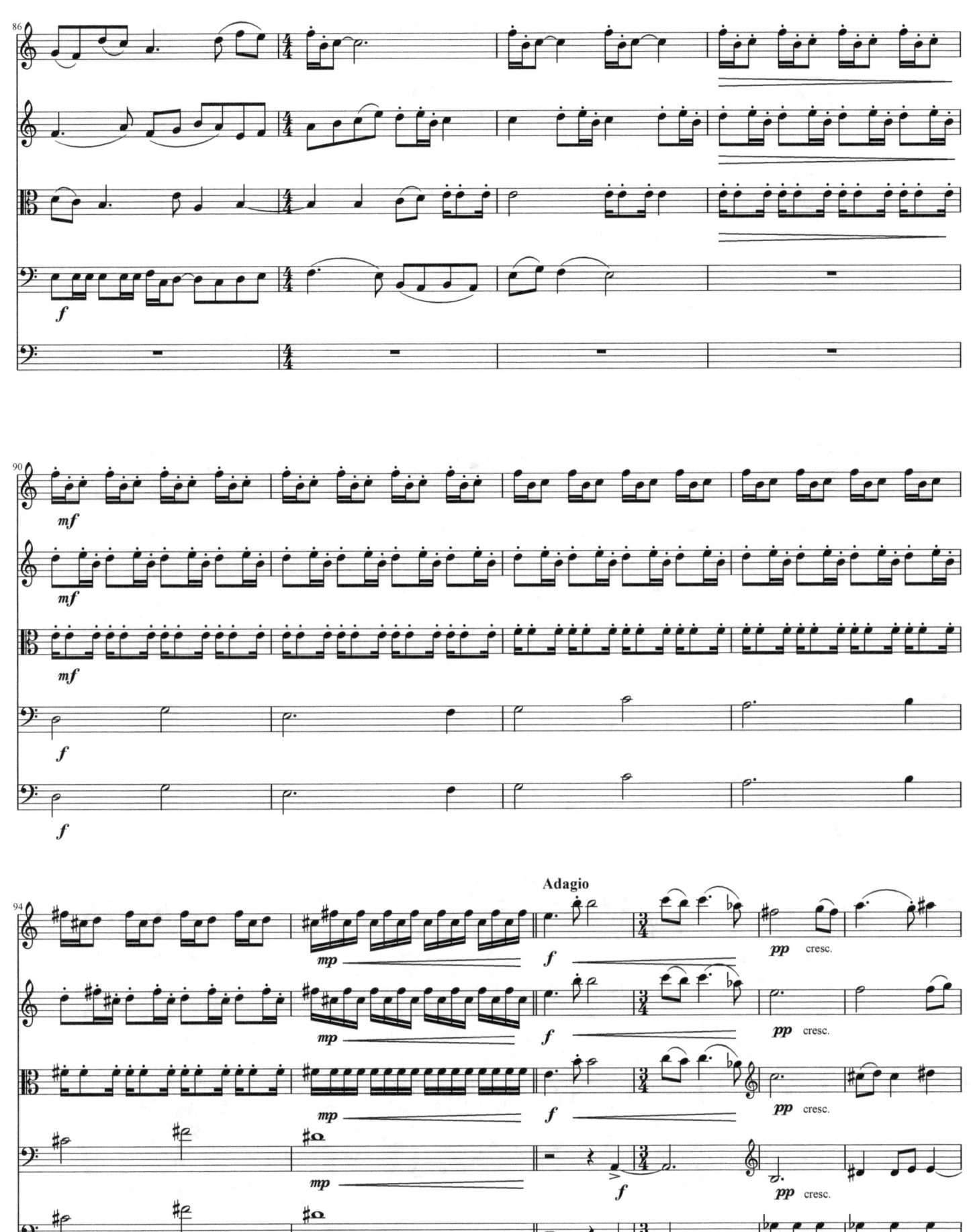

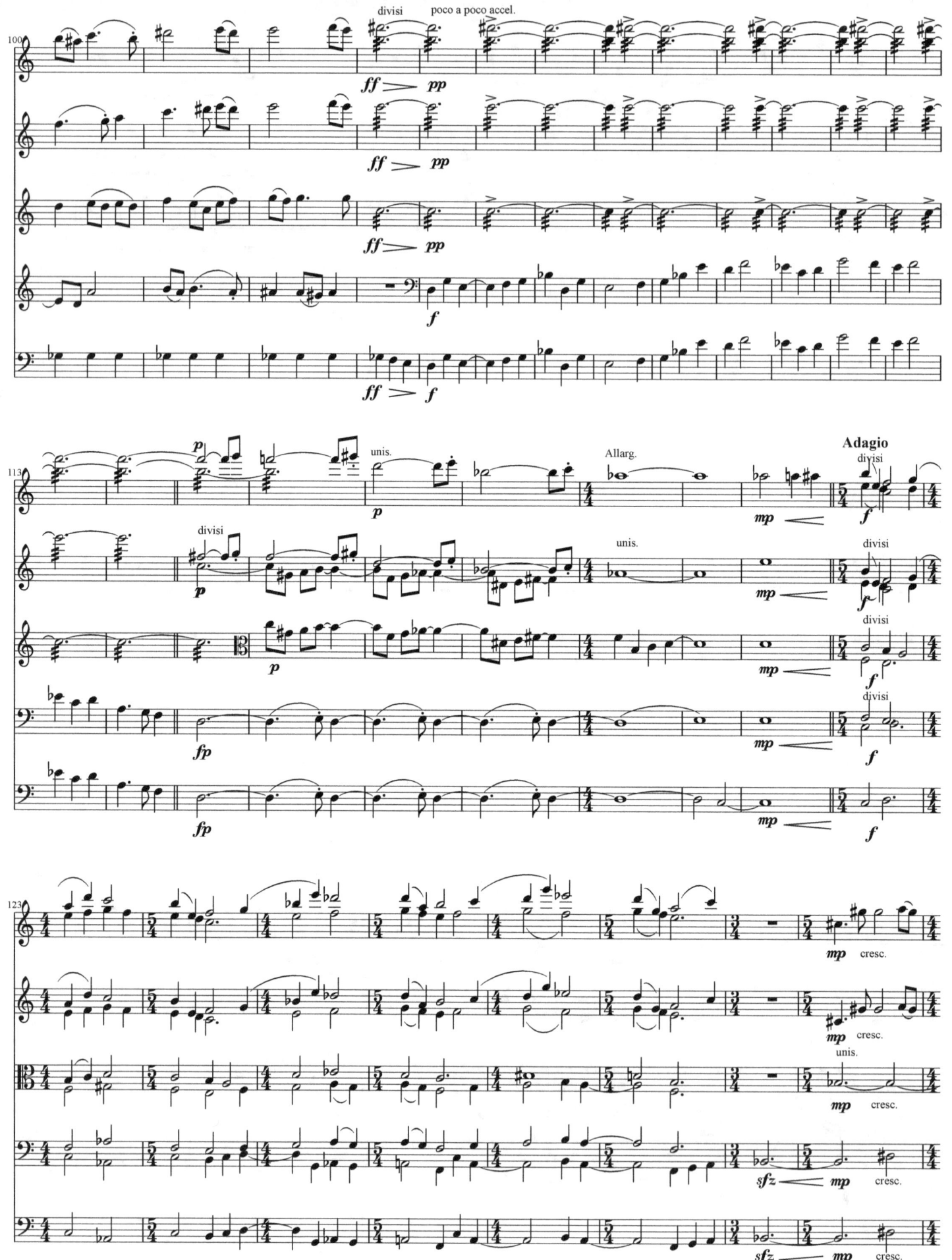

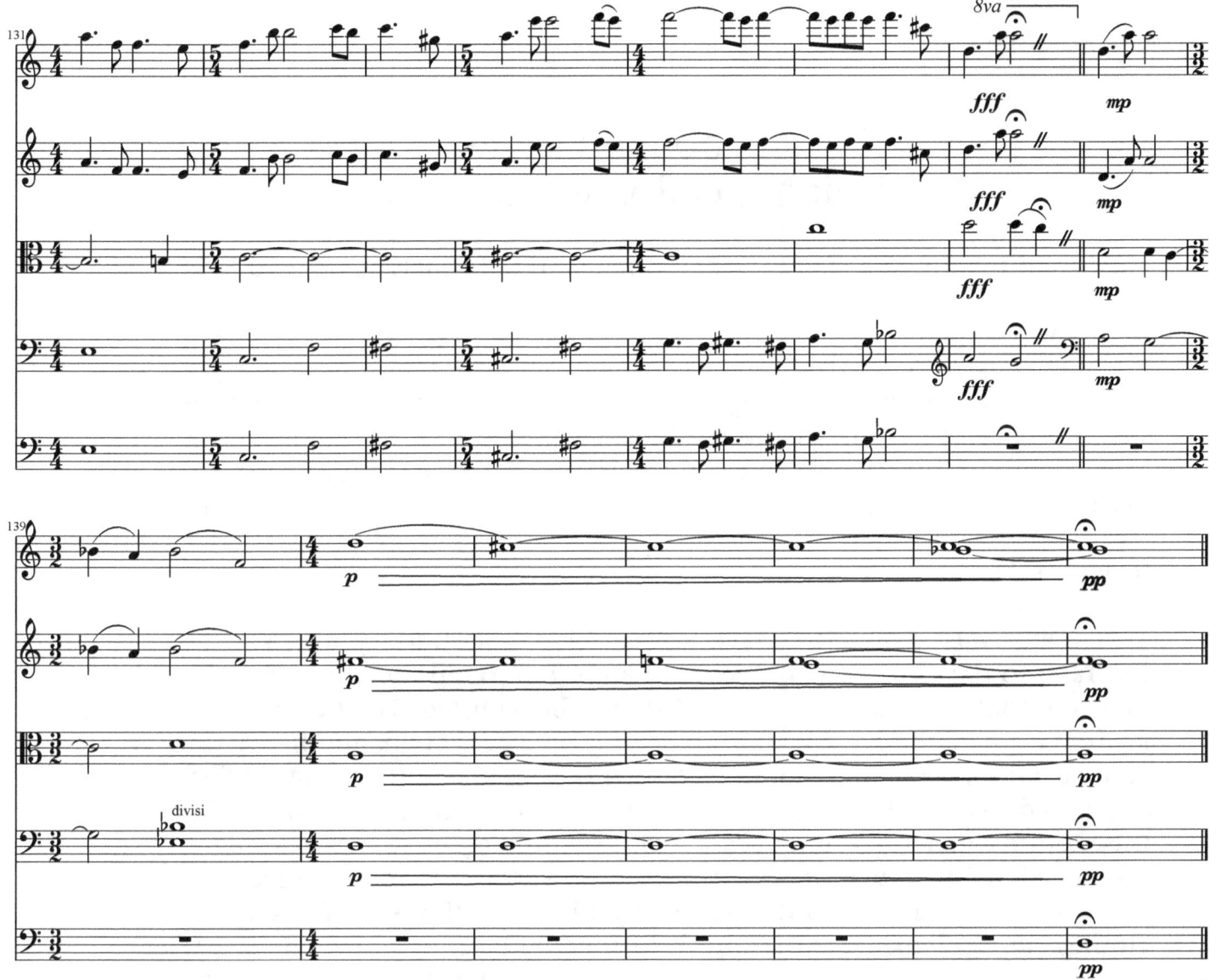

The Foolish Fiddler
for violin, cello, and narrator

Music and text by Ken Langer adopted from an old American legend.

Narrator:

This is a legend from a region that was once known as New Sweden which was comprised of Delaware and parts of Pennsylvania and New Jersey. The legend centers around a fiddle player who was brave but foolhardy. He became known as the Foolish Fiddler.

(Duet no. 1)

One evening, at a local tavern, a certain young fiddle player sat listening to the local gossip. One old man began to tell the story about a mansion that was nearby which was said to be haunted. The fiddle player scoffed at the old man. The story teller continued, though, and he tried to convince the young man that indeed the house was haunted. The fiddler continued to mock him. Then the old man proclaimed that he would offer the skeptic a generous sum of money if he would agree to stay overnight in the mansion. The musician, full of pride and short of money, agreed.

The next day the fiddler packed up his bag with his fiddle, some clothes, some blankets, and a supply of food and left for the mansion. After arriving, he went inside and picked a corner in one of the many great rooms. He swept away the cobwebs and the dust, set out his blankets and other belongings, and then built himself a fire. As it got darker in that big mansion, he began to get frightened. What if the old man was right? To calm his fears he pulled out his fiddle and played himself to sleep.

(Duet no. 2)

When the fiddler awoke, it was still dark and the dwindling fire left an eerie glow in the room. The fiddler saw shadows dancing on the wall. Suddenly from the shadows a tall figure appeared and approached the young man. It was a spirit and he was dressed very elegantly. The sight of the spirit struck fear into the heart of the young man and he was unable to move or speak. The spirit explained that he was the Master of the House and that he enjoyed listening to the fiddler's music. The spirit asked the fiddler if he would play for him. The fiddler nervously nodded his head and reached for his instrument with trembling hands but the spirit suddenly stopped him.

"No," the spirit said. "You must play for all of my guests so that we may dance. If you do this, I will reward you with great riches. However," the spirit continued, "you must promise not to speak. My guests are disturbed at the sound of a human voice. Will you agree to this?"

Once again the fiddler nodded. At this gesture, the shadows on the wall grew into a multitude of spirits dancing in formal suits and gowns. Cobwebs and dust disappeared and, instead, the room was transformed into a grandly lit ballroom. The fiddler, caught up in the excitement of the moment and the thought of all that money, forgot his fears and began to play for the ghostly entourage.

(Duet no. 3)

When the fiddler had finished playing, the Master of the House approached him and exclaimed that he had played well and that he would be greatly rewarded. Two other spirits carrying a great chest, appeared from the walls. The chest was opened and inside were thousands of gold coins and precious jewels. The fiddler opened his sack and filled it full of treasure until it could hold no more. The fiddler was so excited that he grabbed his fiddle and started playing. Once again, the spirits danced all about the floor and through the air.

(Duet no. 4)

At the end of the tune the fiddler was still leaping for joy over his new found wealth. He was so excited that he cried out "Oh this is wonderful!" At the sound of these words the spirits broke into a wild and hideous laughter. The well dressed guests turned into skeletons and all sorts of ghoulish creatures. The fiddler realized that he had just broke his promise.

The next day the story teller from the tavern came to the mansion to see how the fiddler had made out. In a corner of one of the dusty cobweb-filled rooms, the old man found the fiddler dead on the floor - his hand still clutching the empty sack. The fiddle, though, was not there. Then, in the distance, the old man heard faint music.

(Duet no. 5)

It is said that often times, in the dark of that old mansion, the fiddler can still be heard playing his sad tunes. Such is the legend of the Foolish Fiddler.

(Duet no. 6)

The Foolish Fiddler
Duet no. 1

Ken Langer

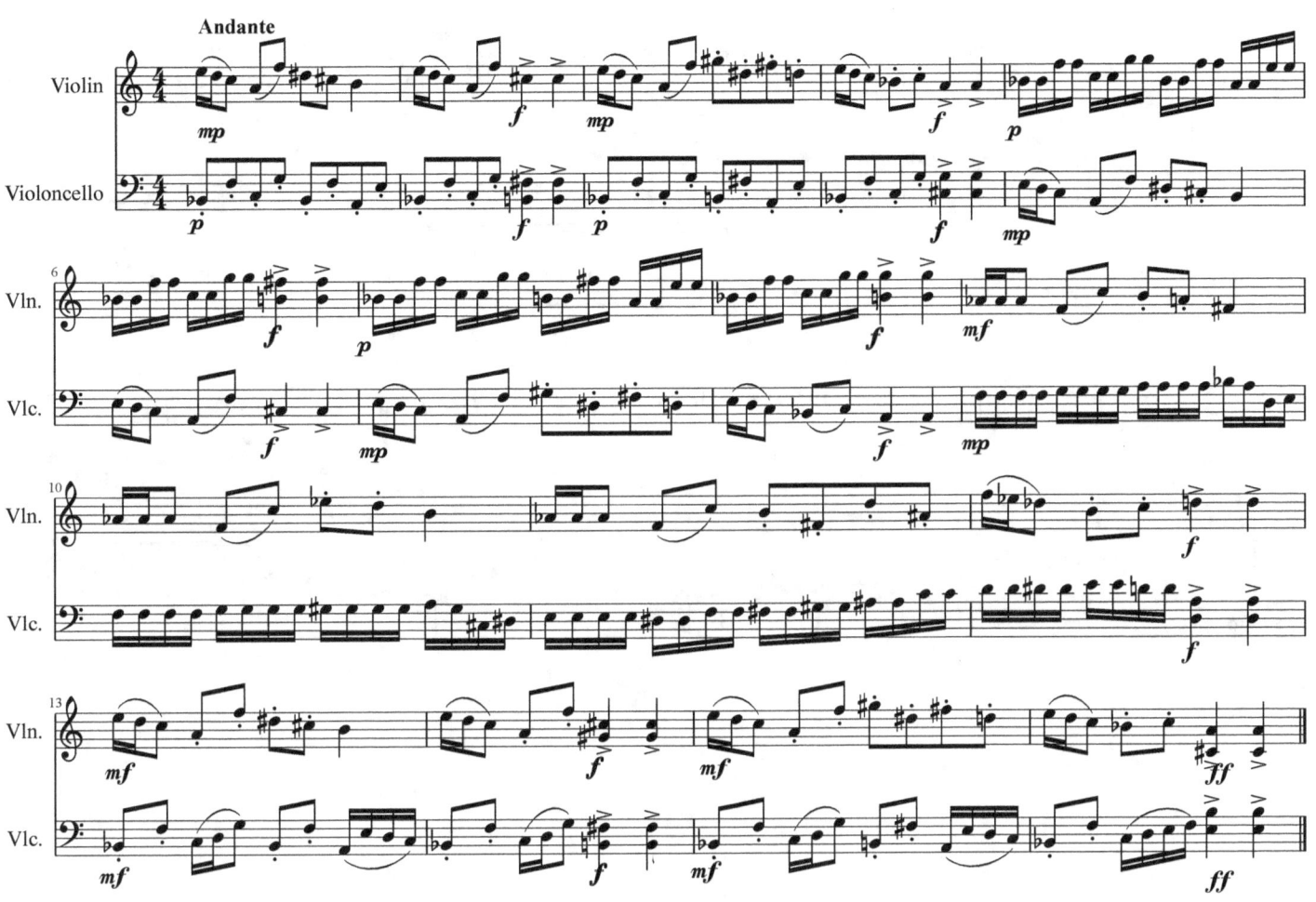

The Foolish Fiddler
Duet no. 2

Ken Langer

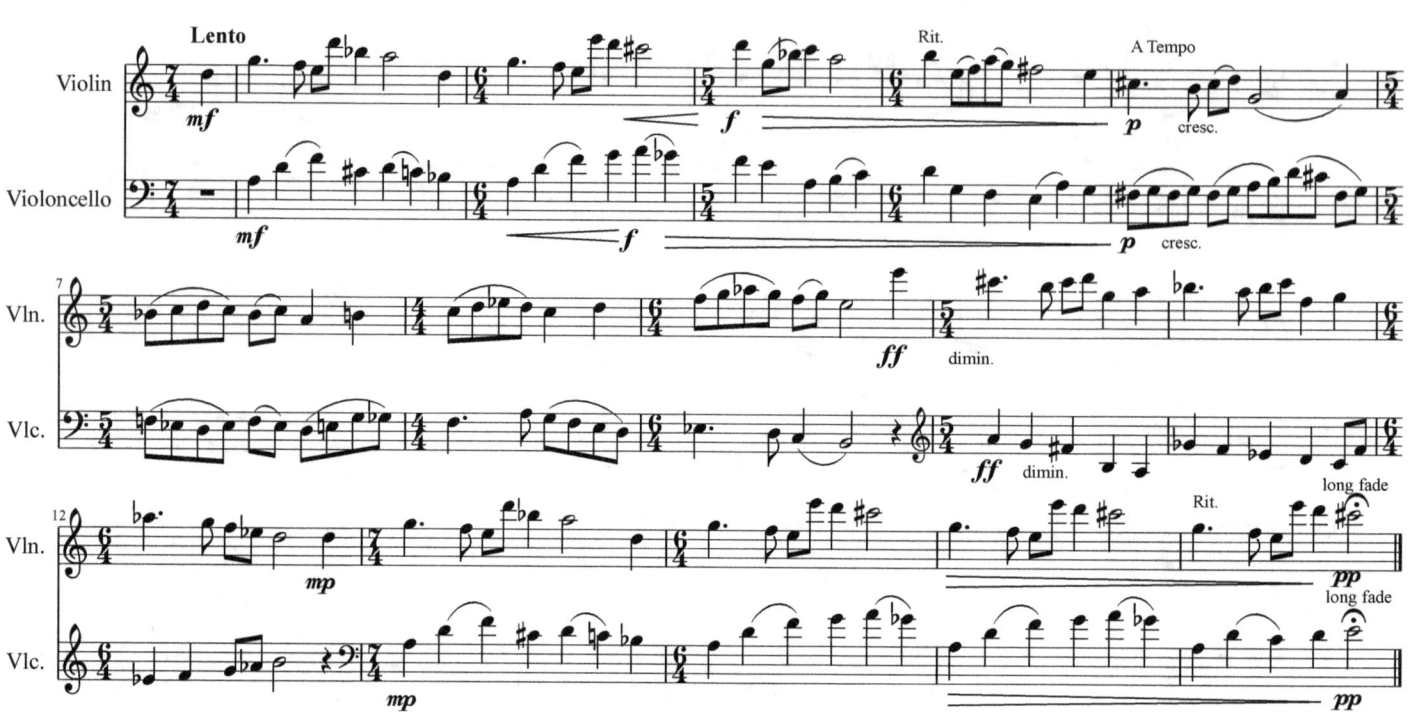

The Foolish Fiddler
Duet no. 3

Ken Langer

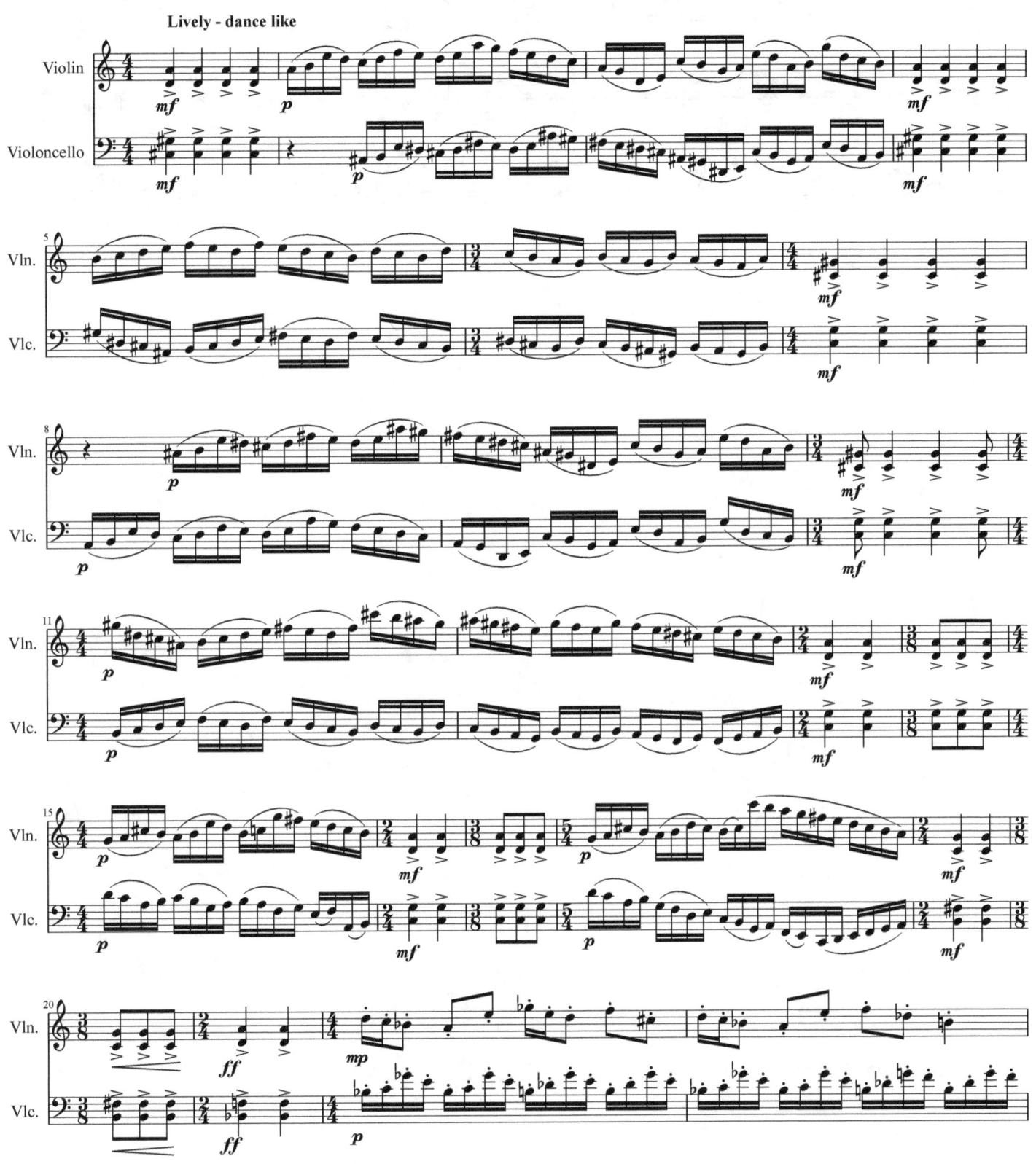

49

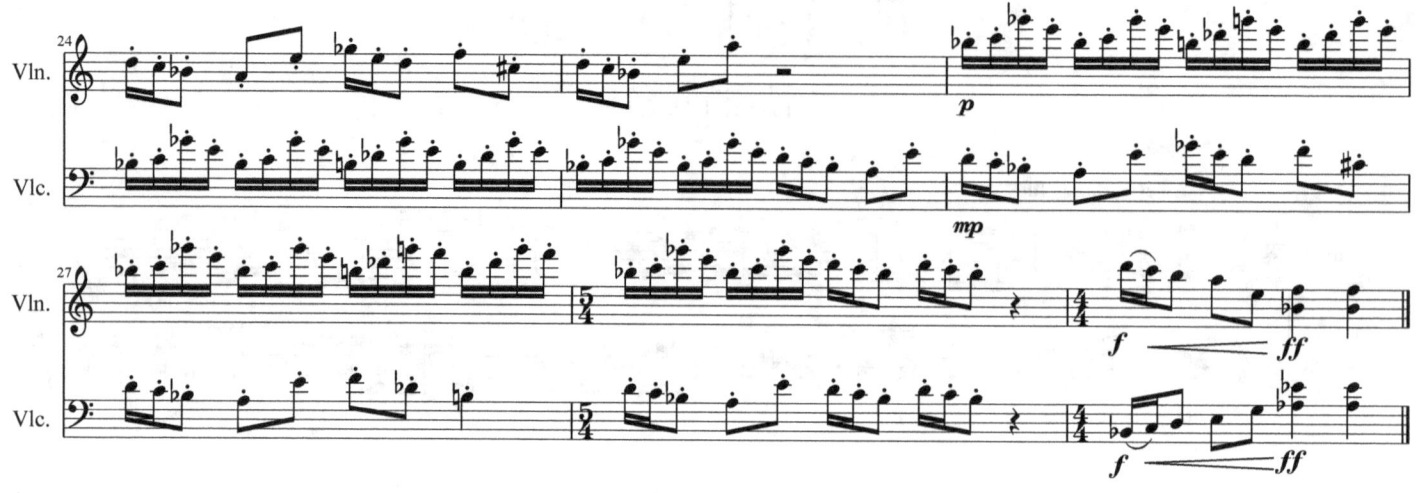

The Foolish Fiddler
Duet no. 4

Ken Langer

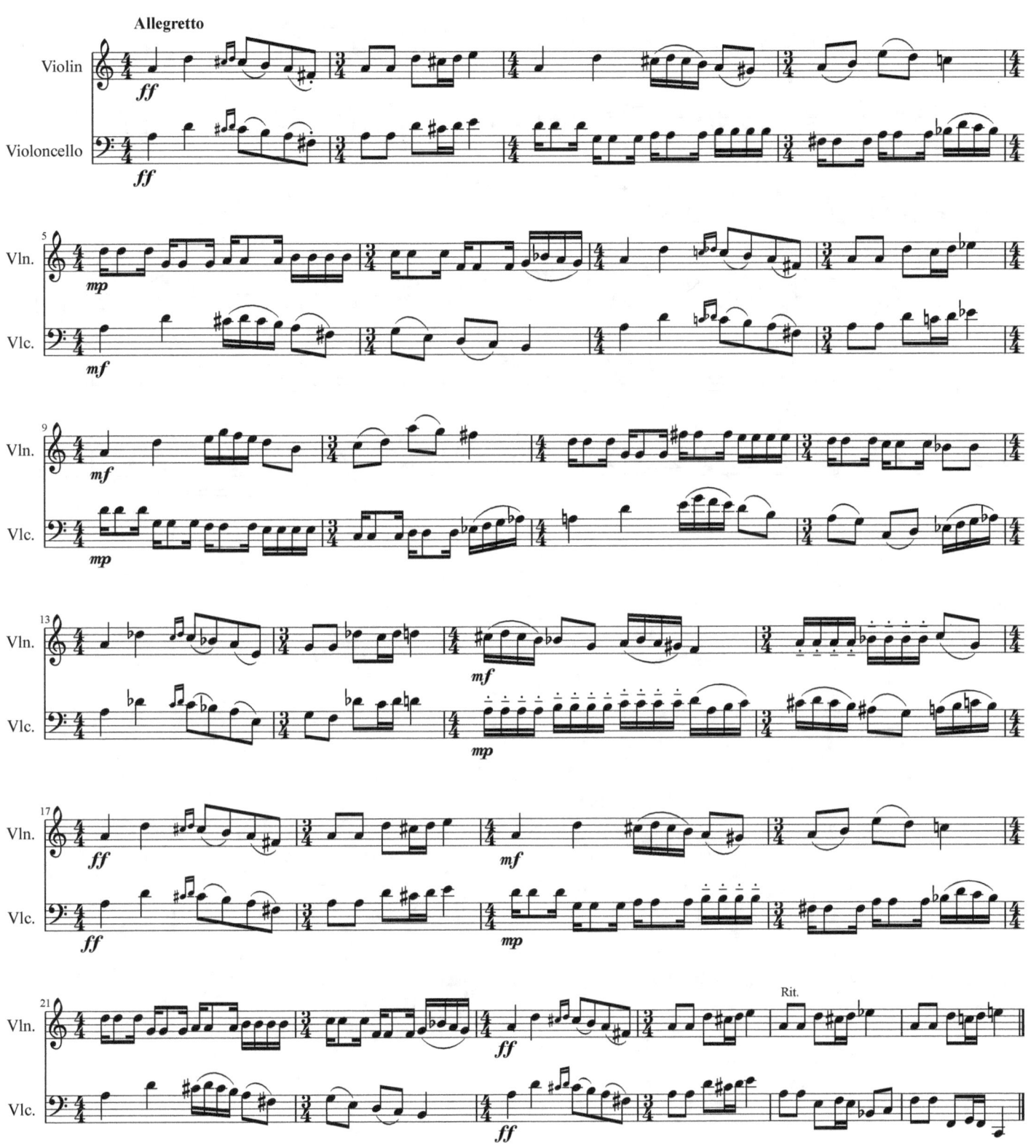

The Foolish Fiddler
Duet no. 5

Ken Langer

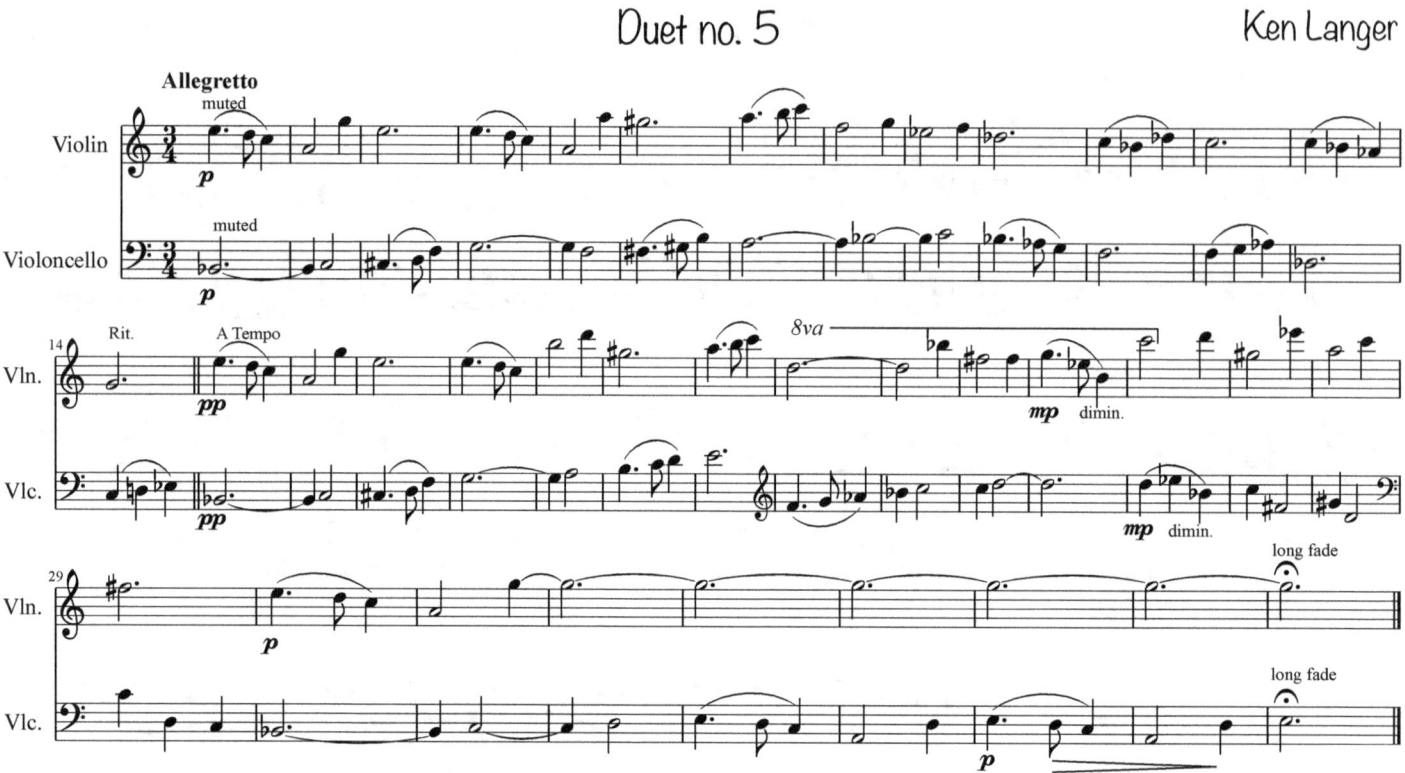

52

The Foolish Fiddler
Duet no. 6

Ken Langer

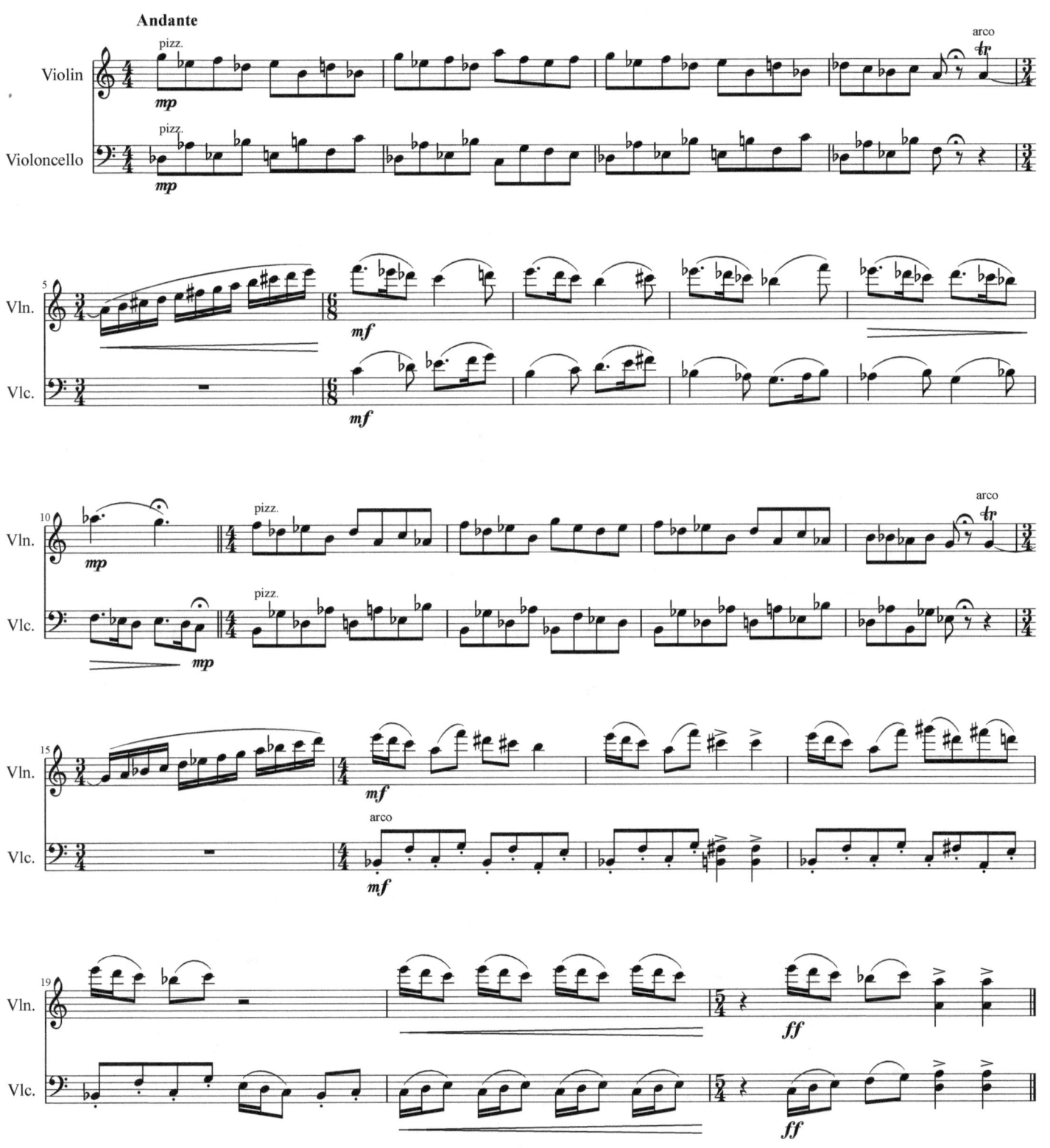

Lyrical Poems

1. Since Feeling Is First

Ken Langer

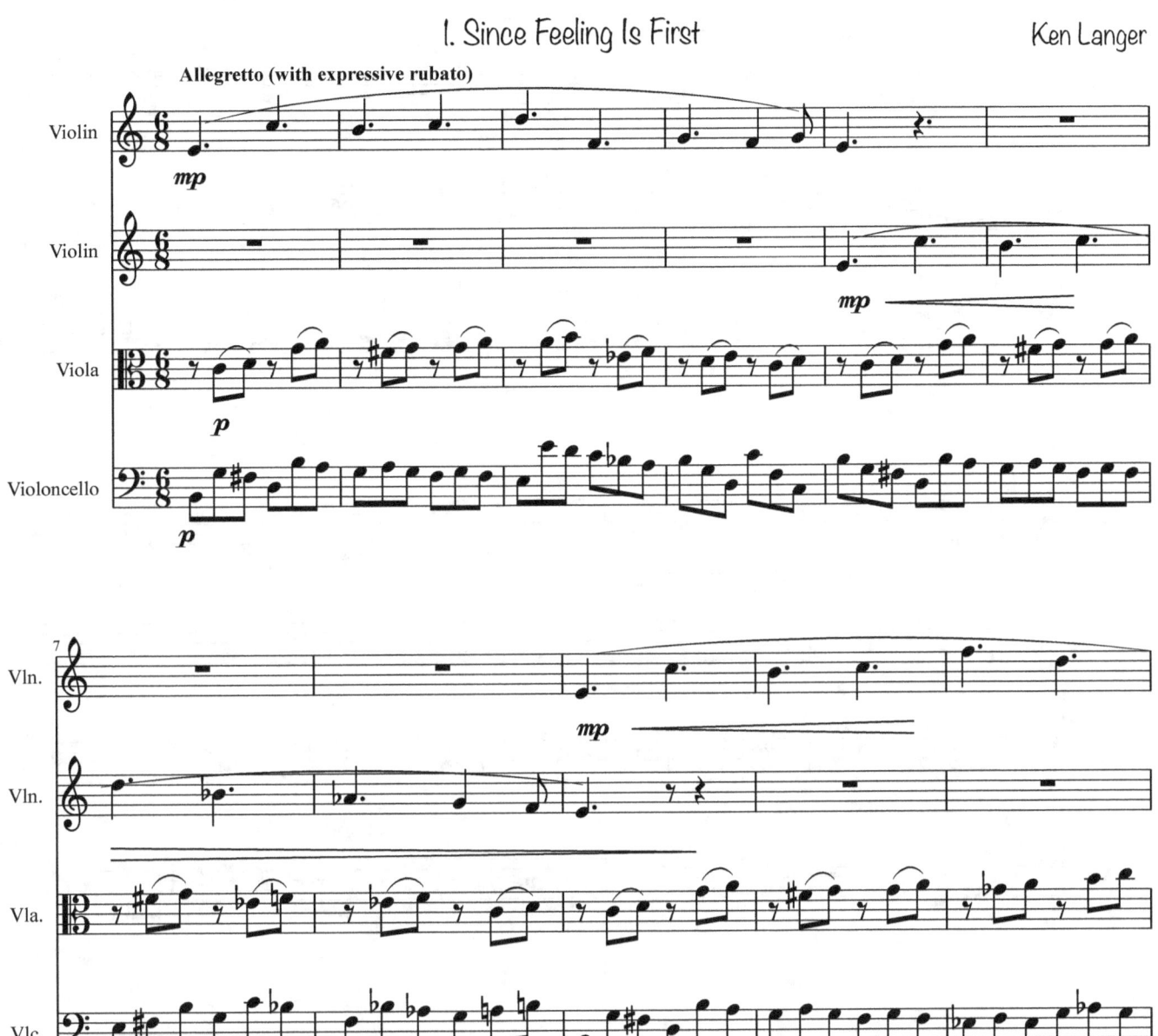

55

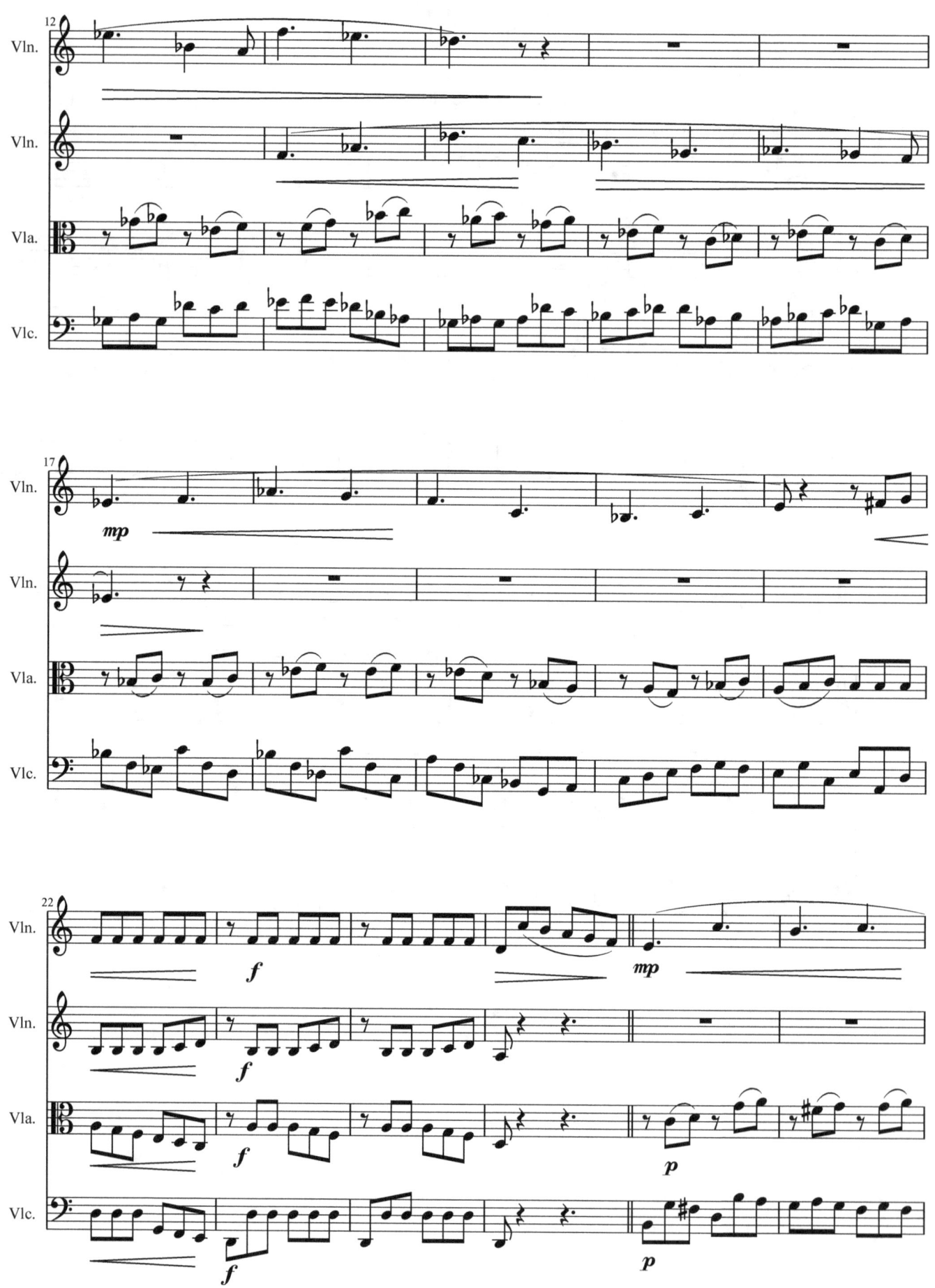

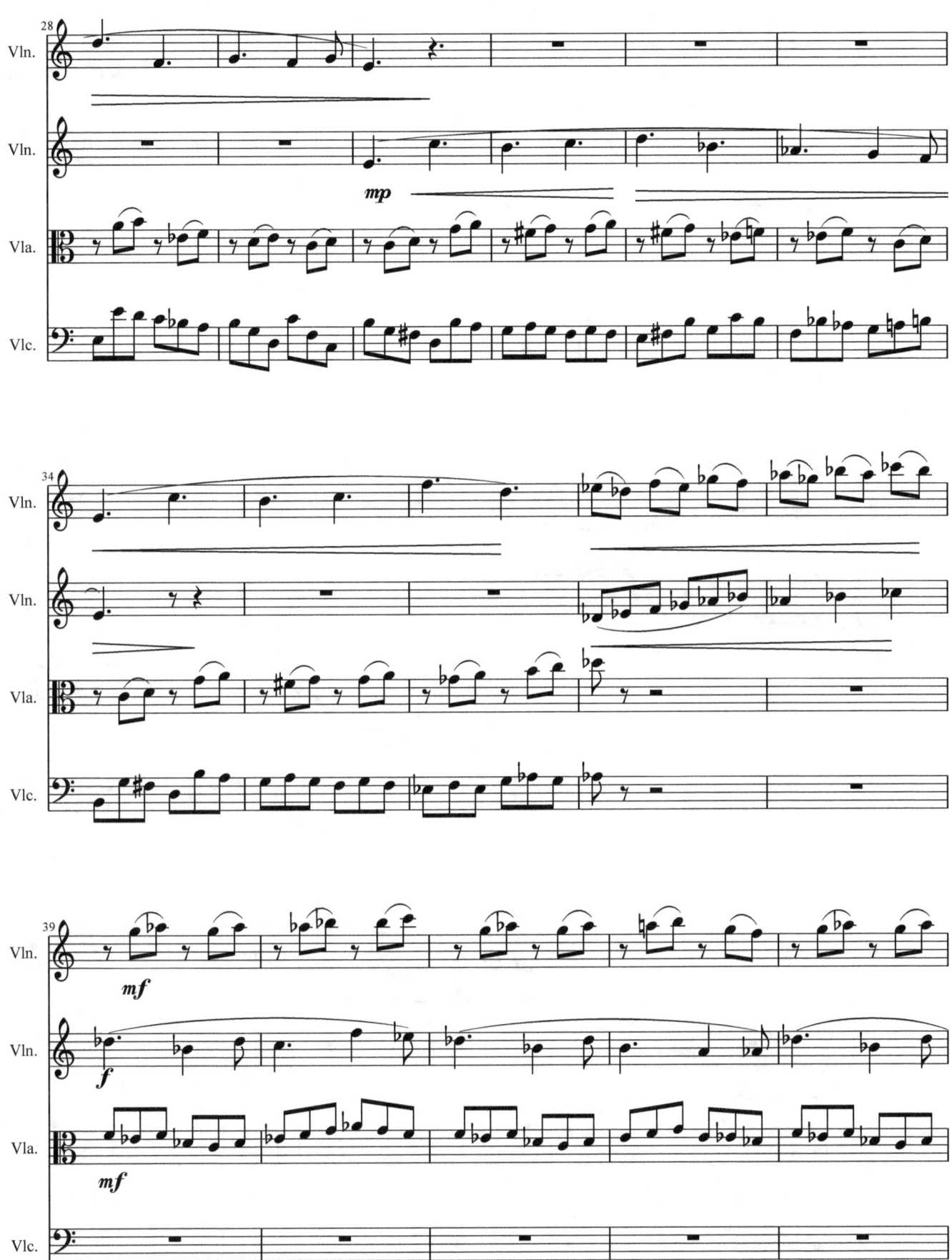

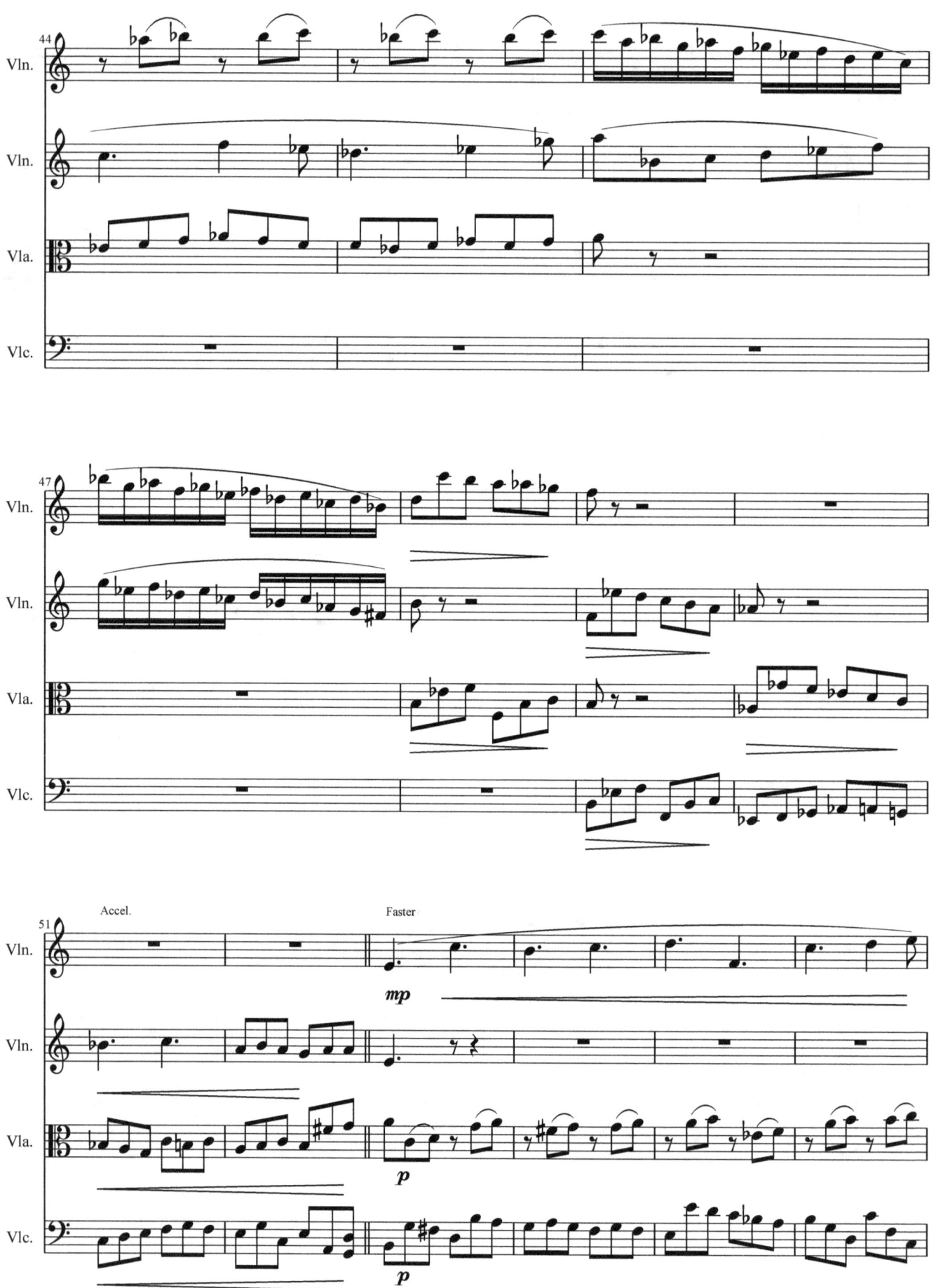

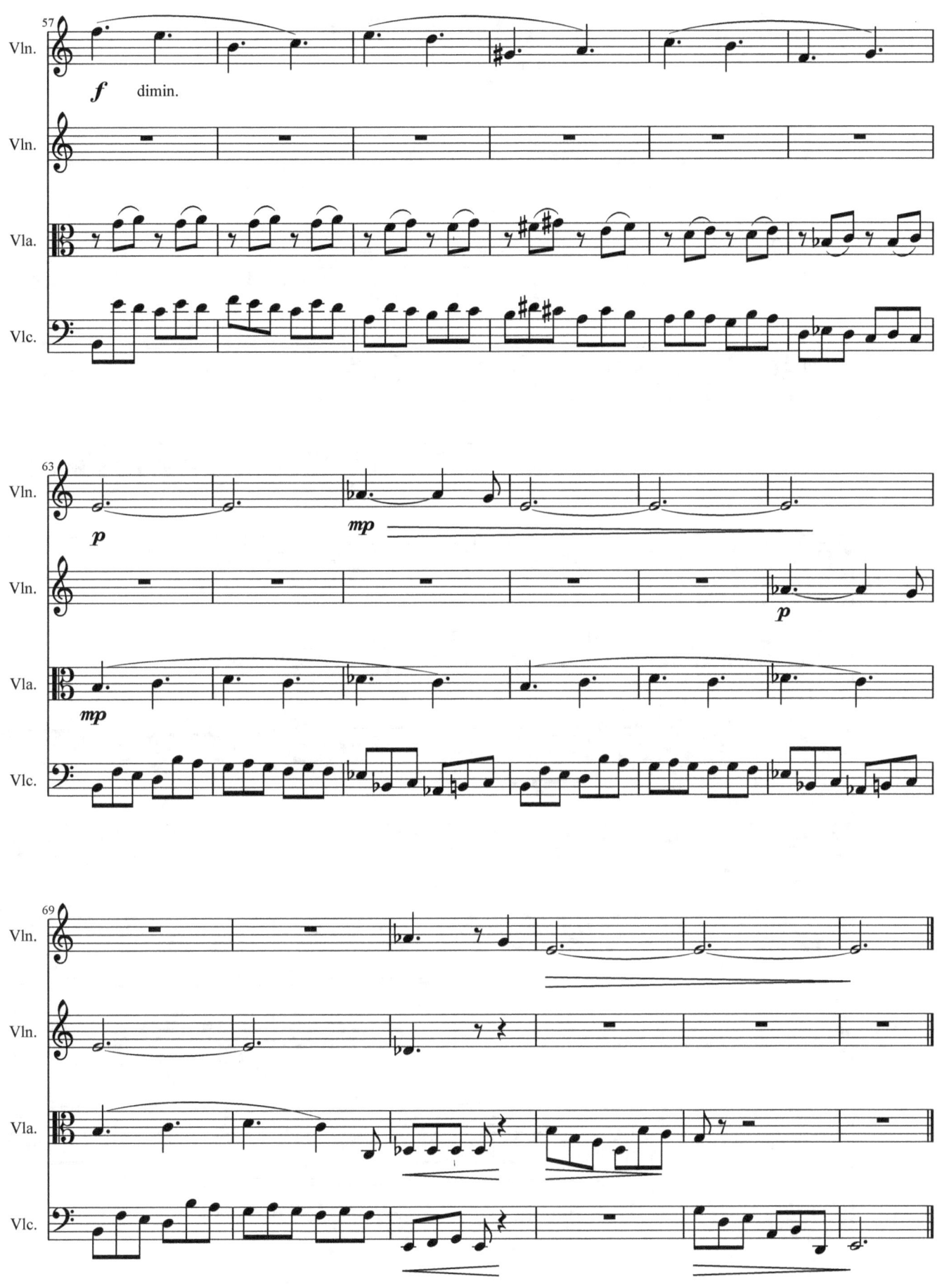

Lyrical Poems
2. I Go To This Window

Ken Langer

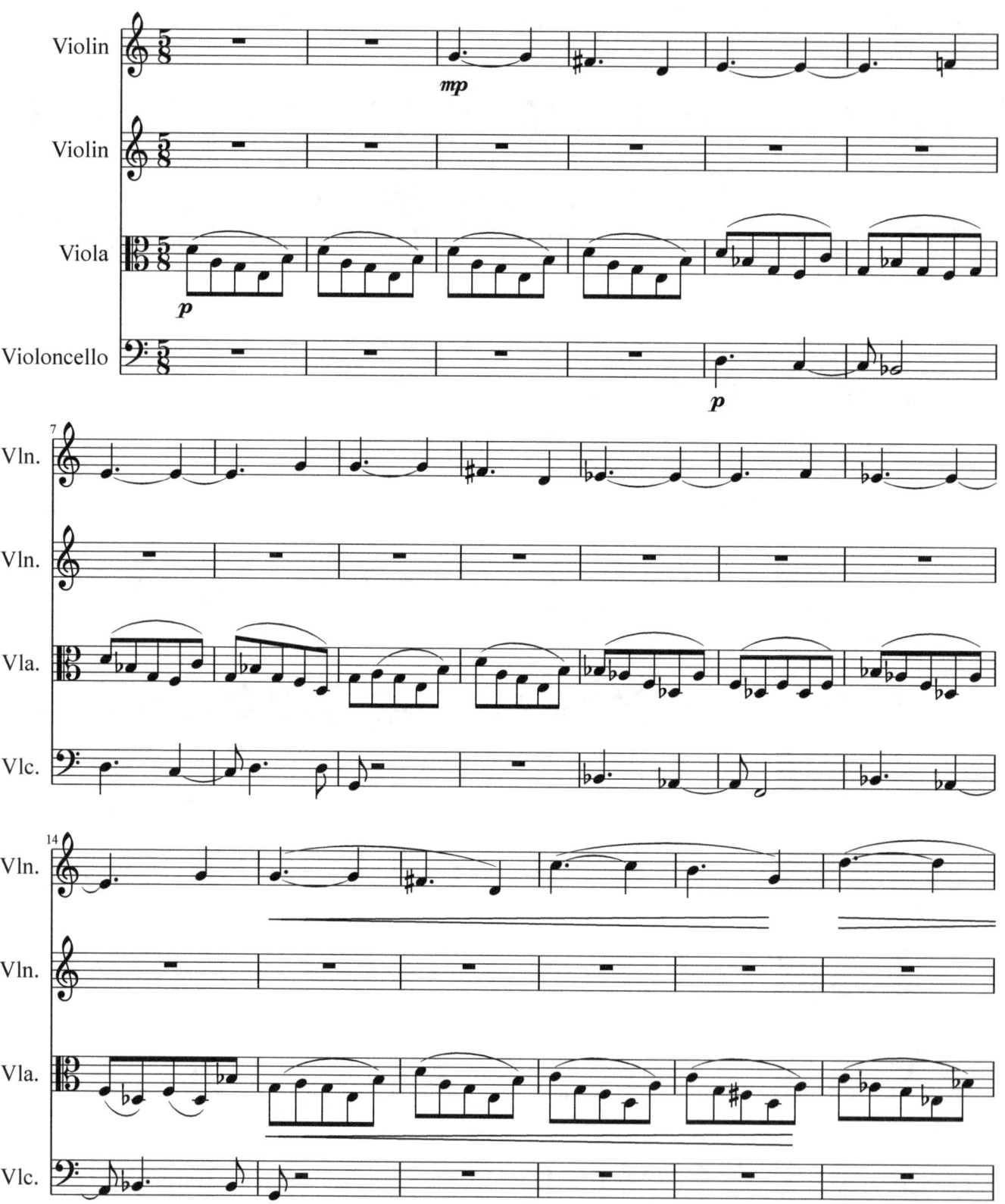

60

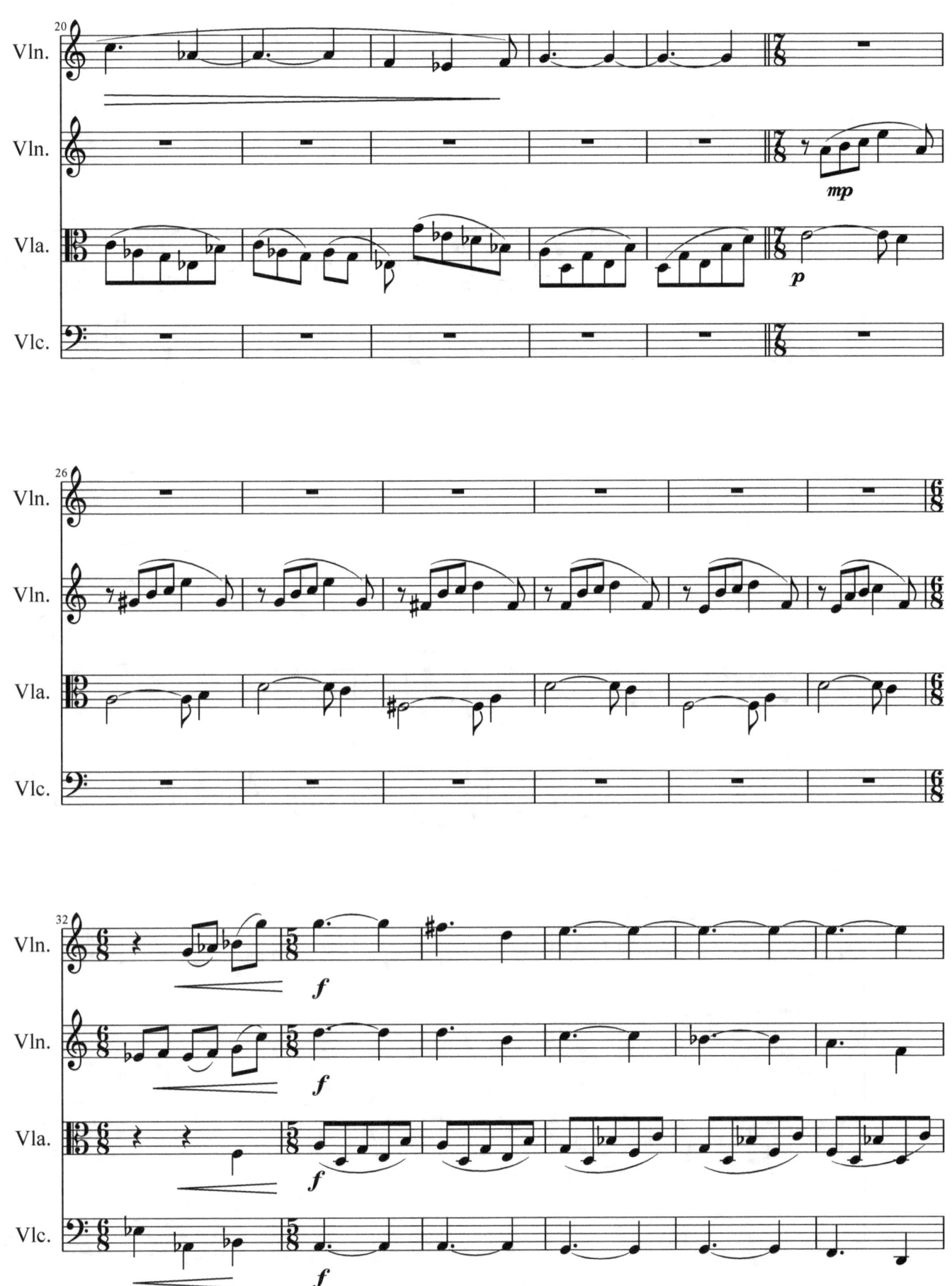

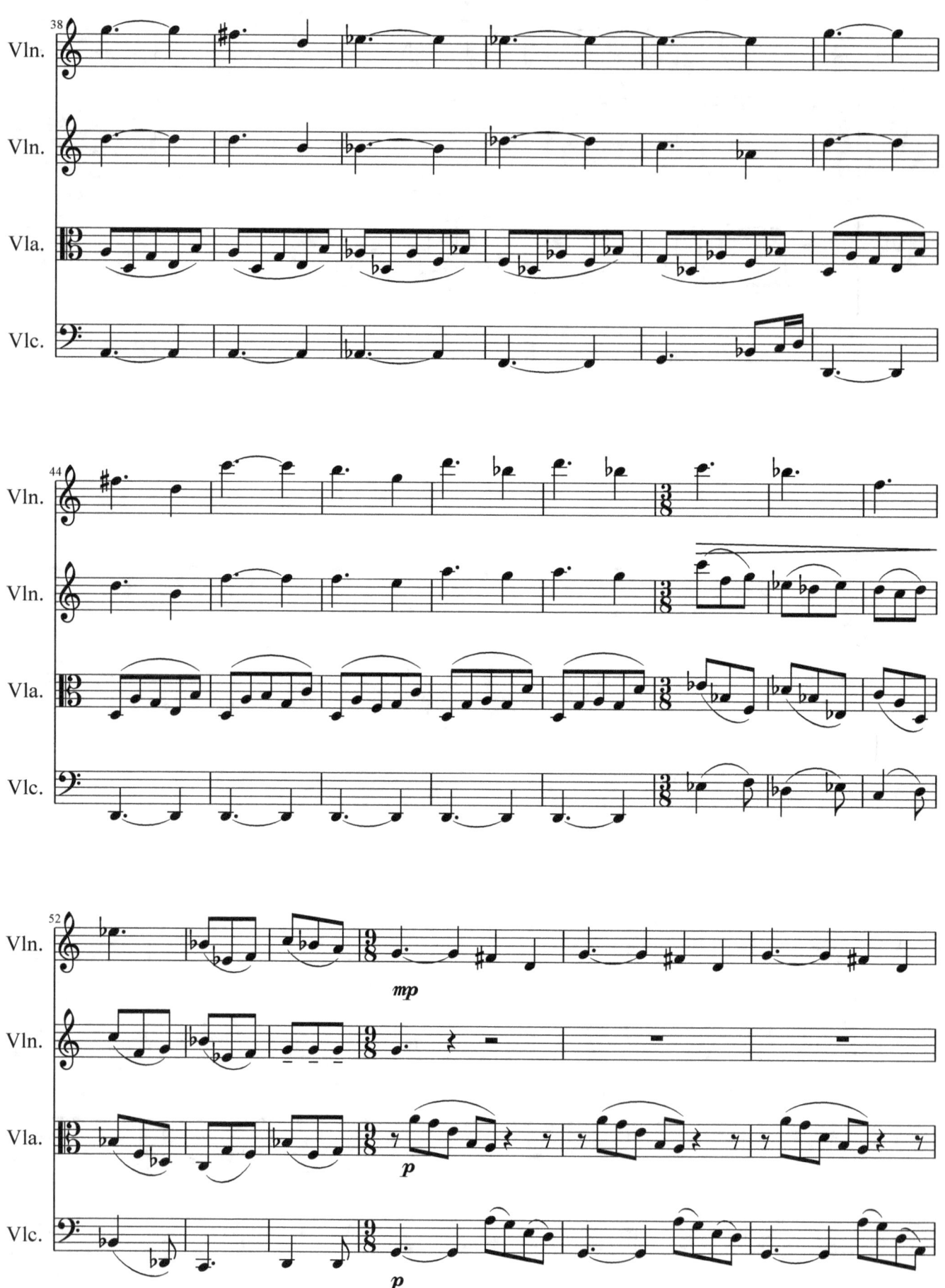

62

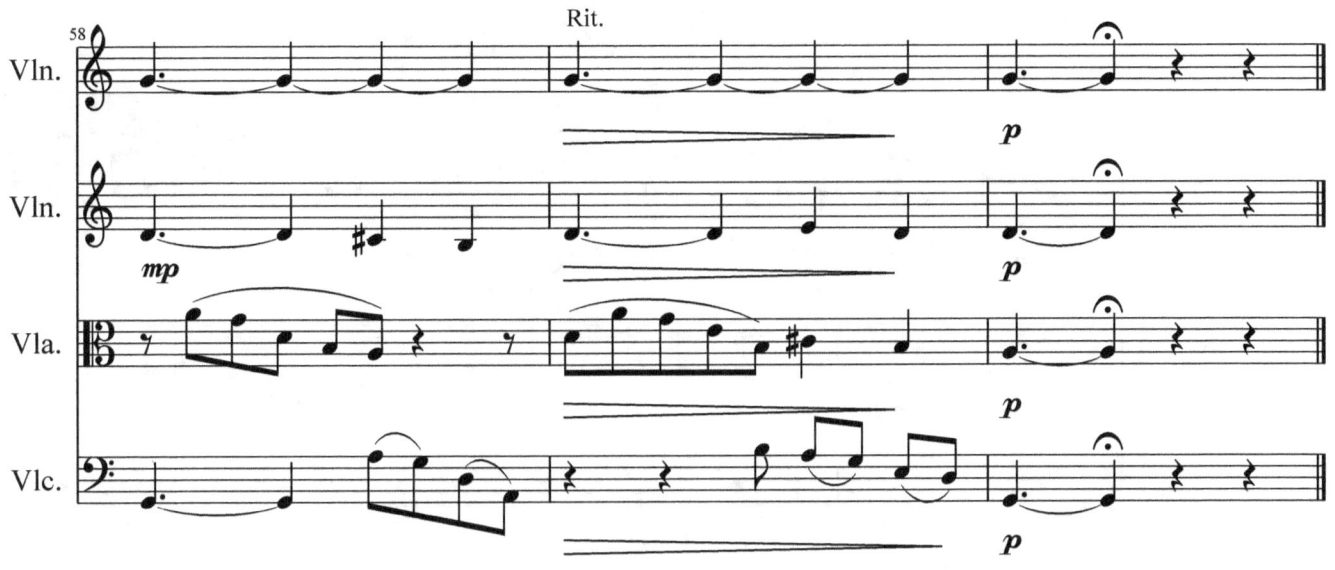

Lyrical Poems
3. Let's Take The Train

Ken Langer

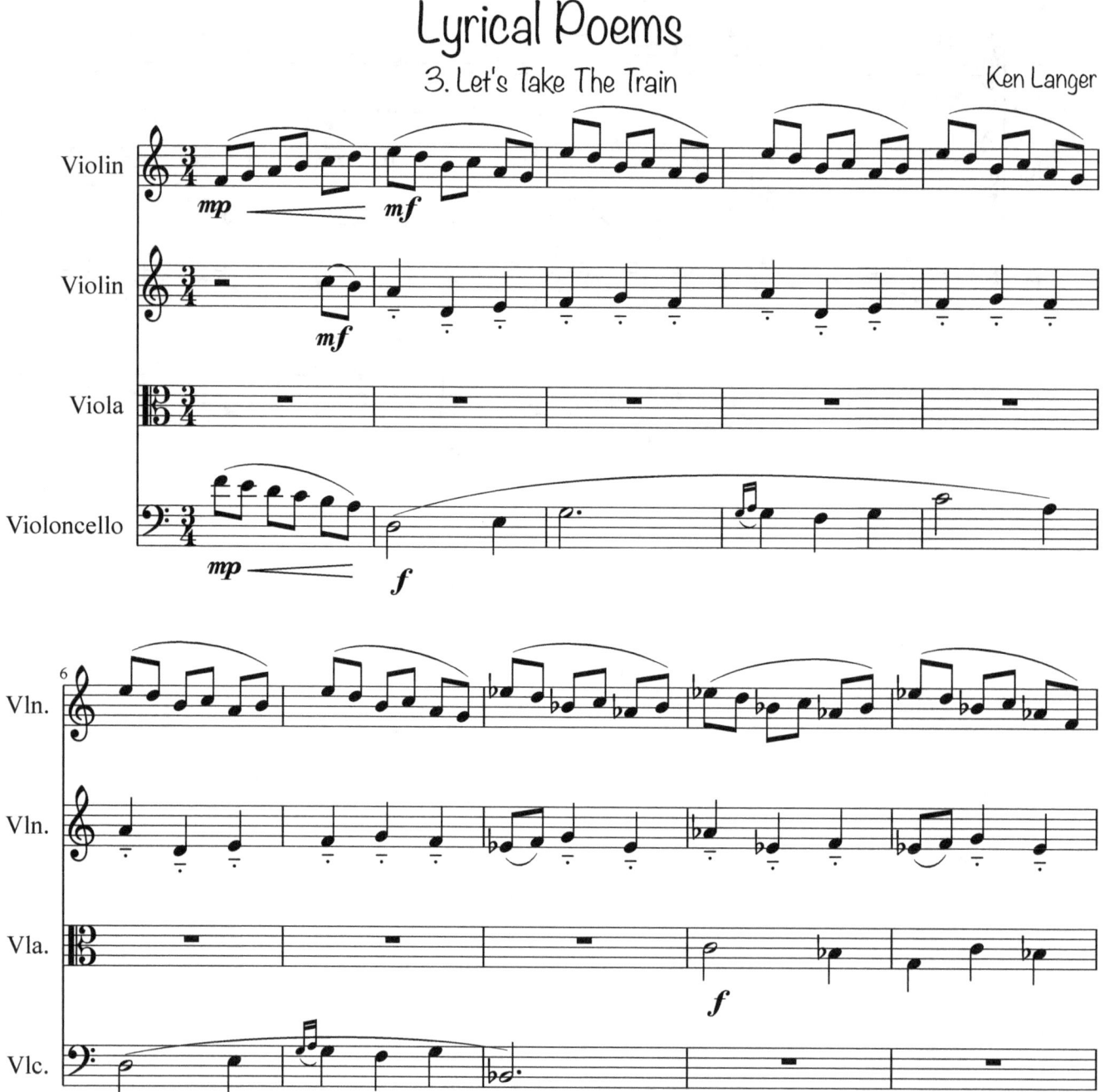

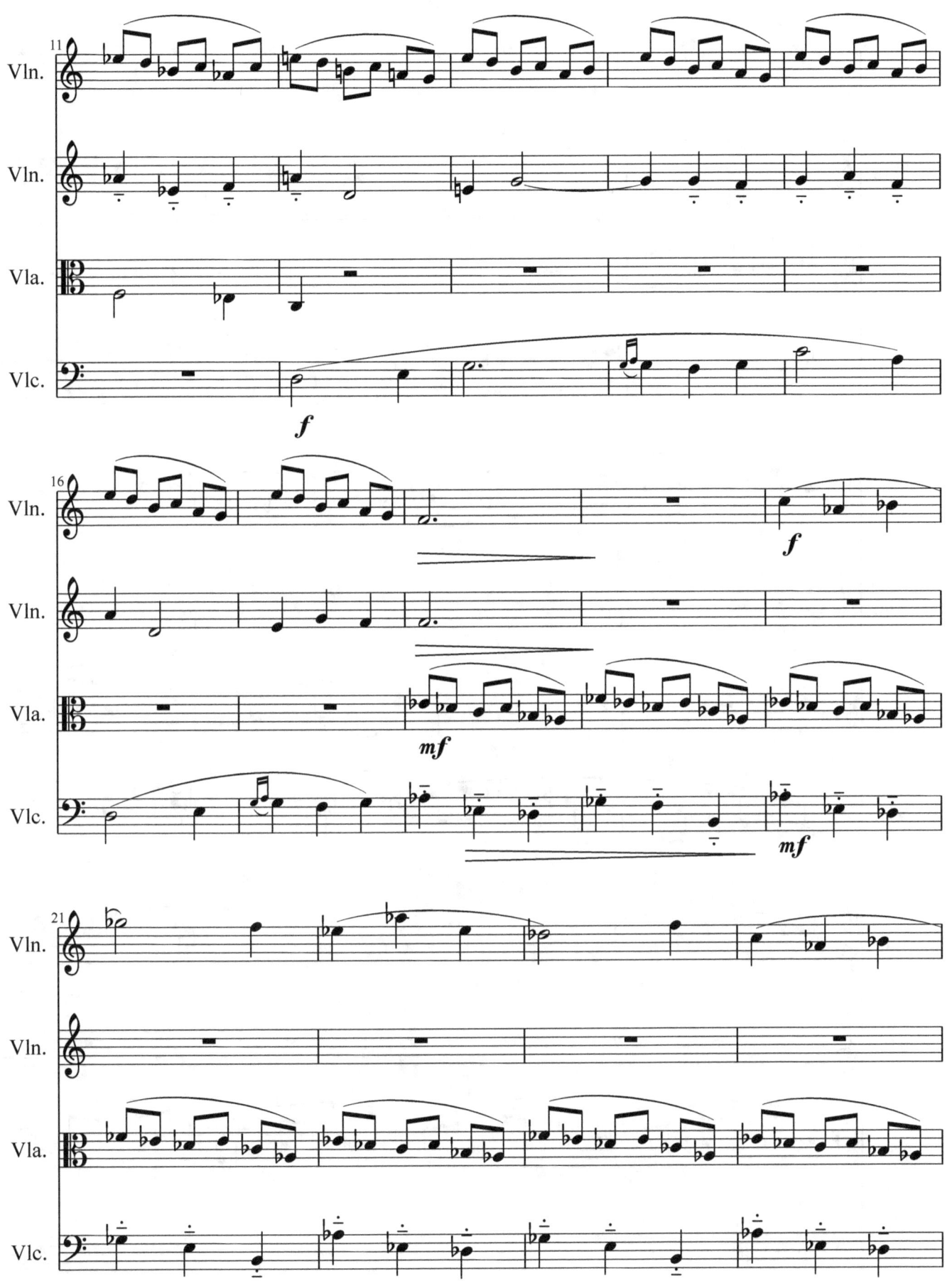

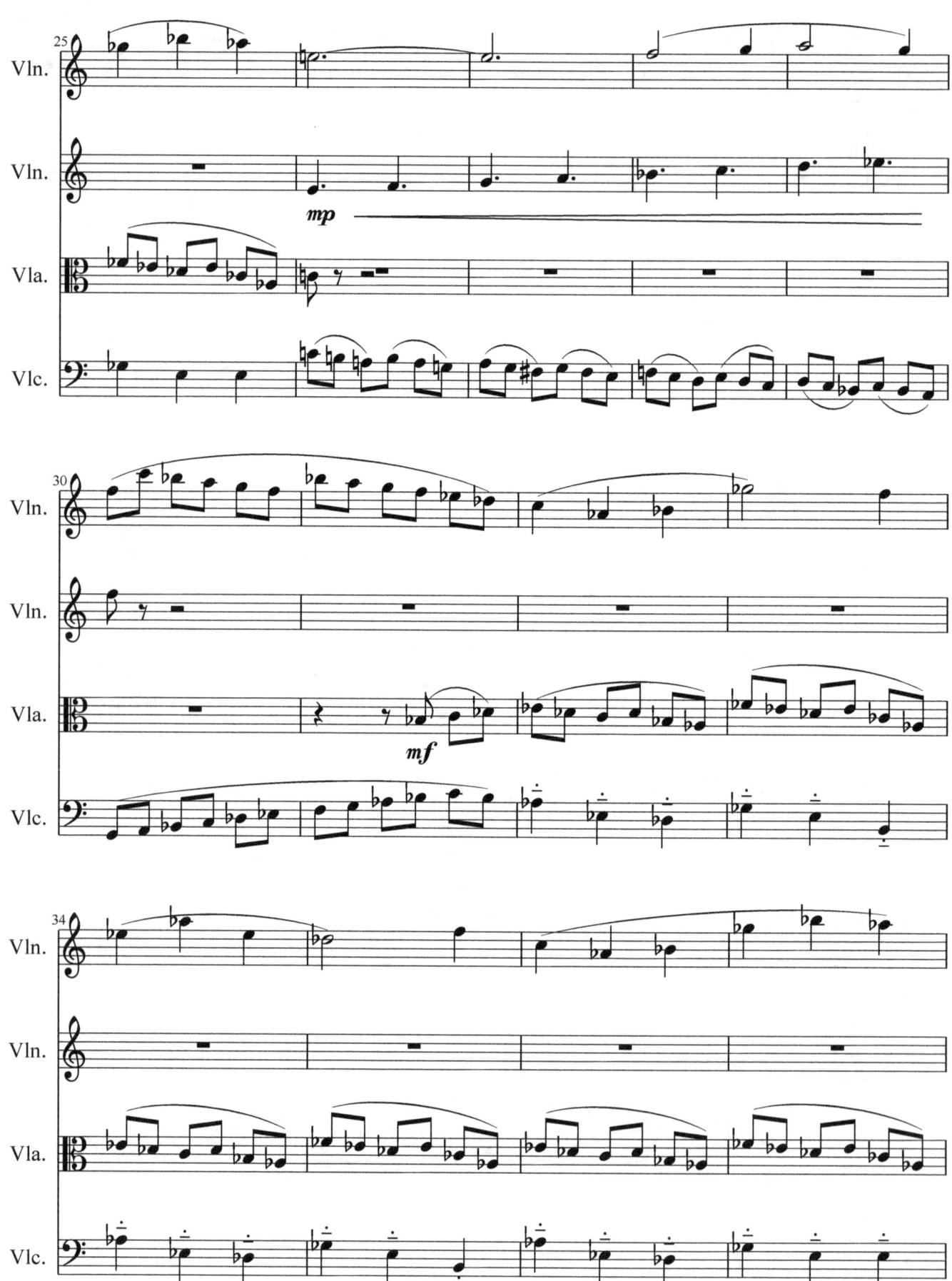

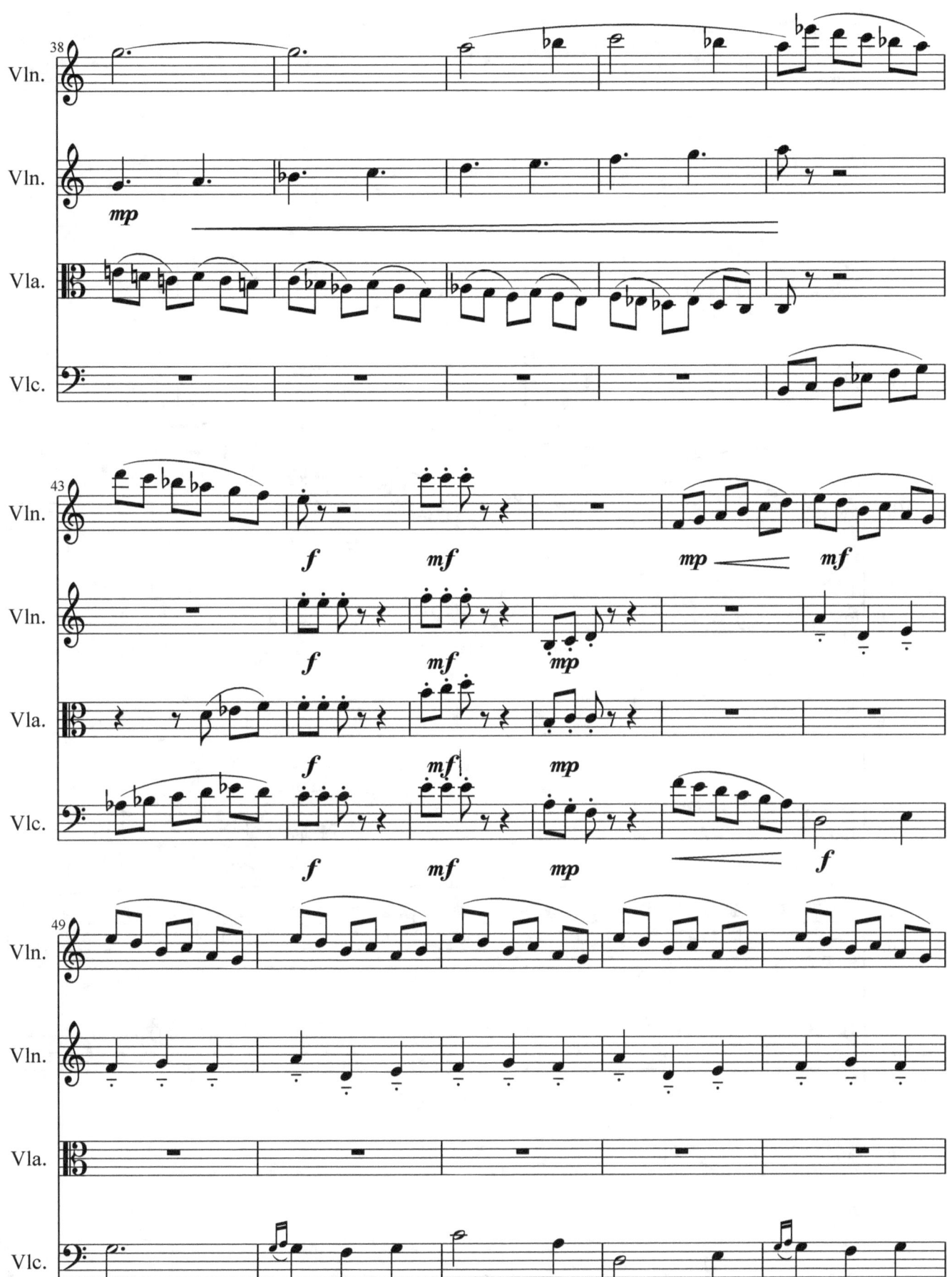

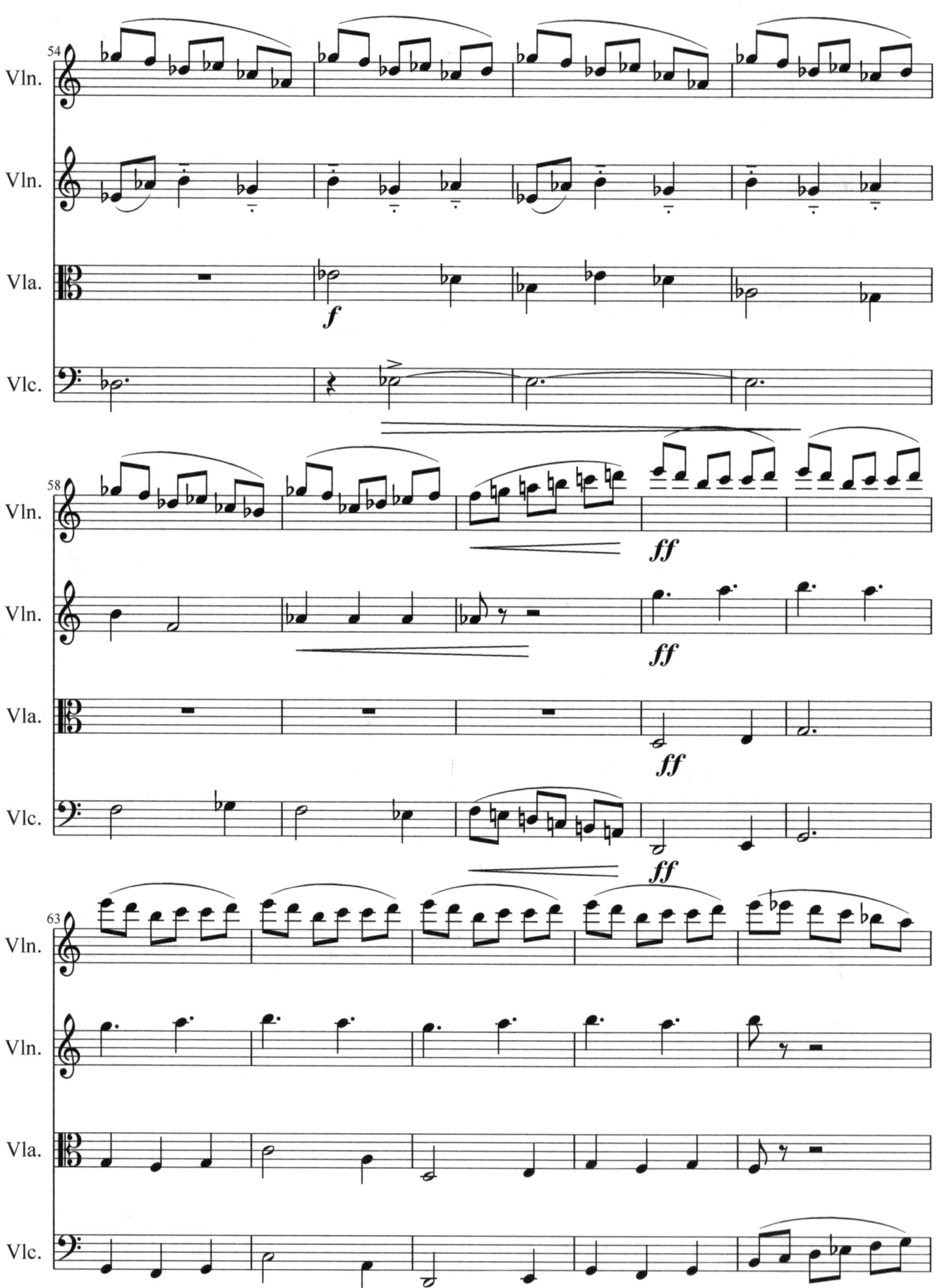

68

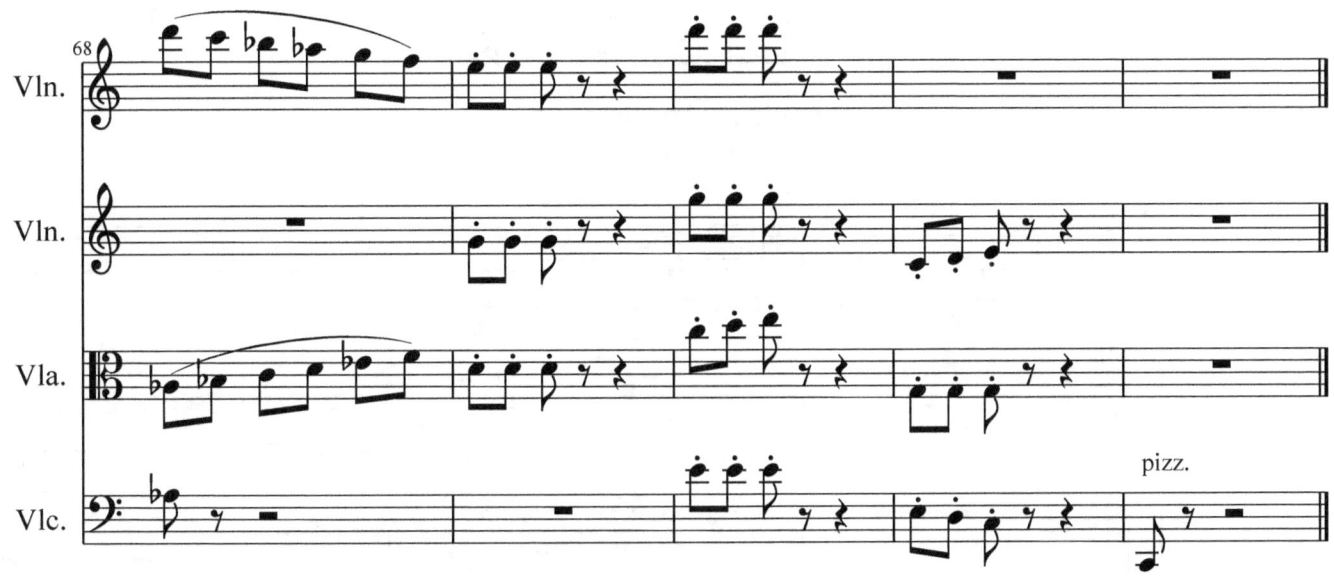

Lyrical Poems
4. Knitting The Structure of Sunset

Ken Langer

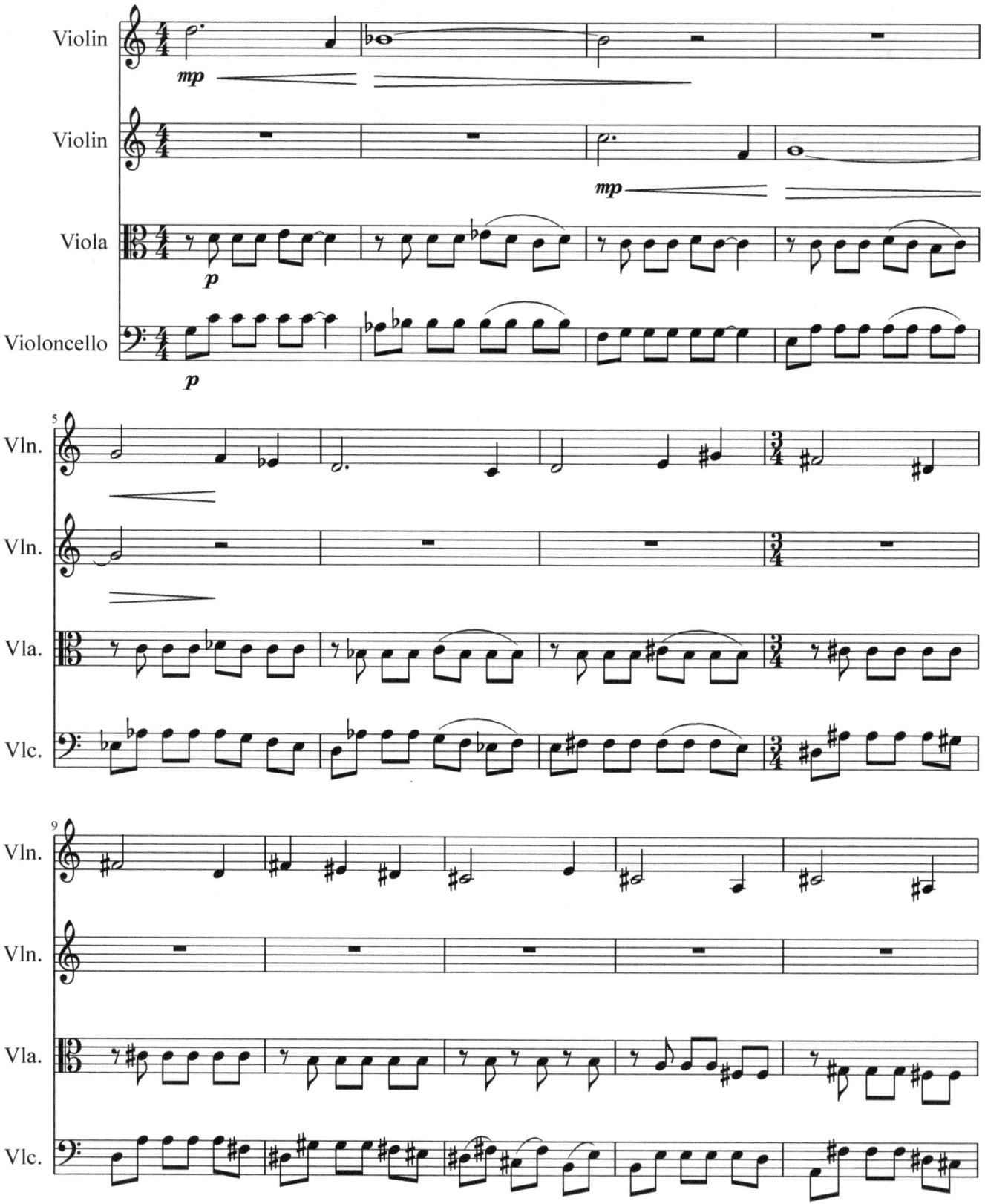

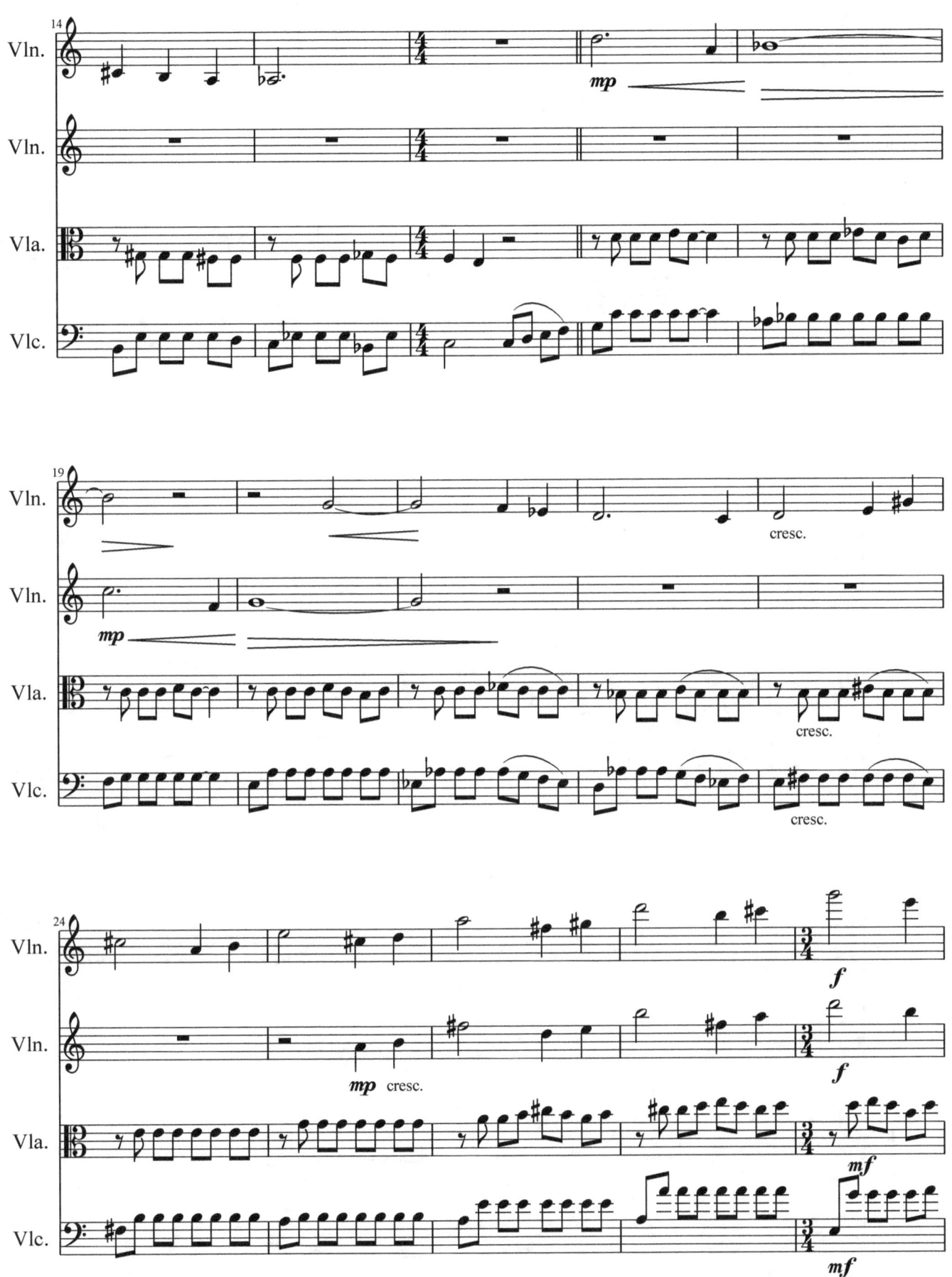

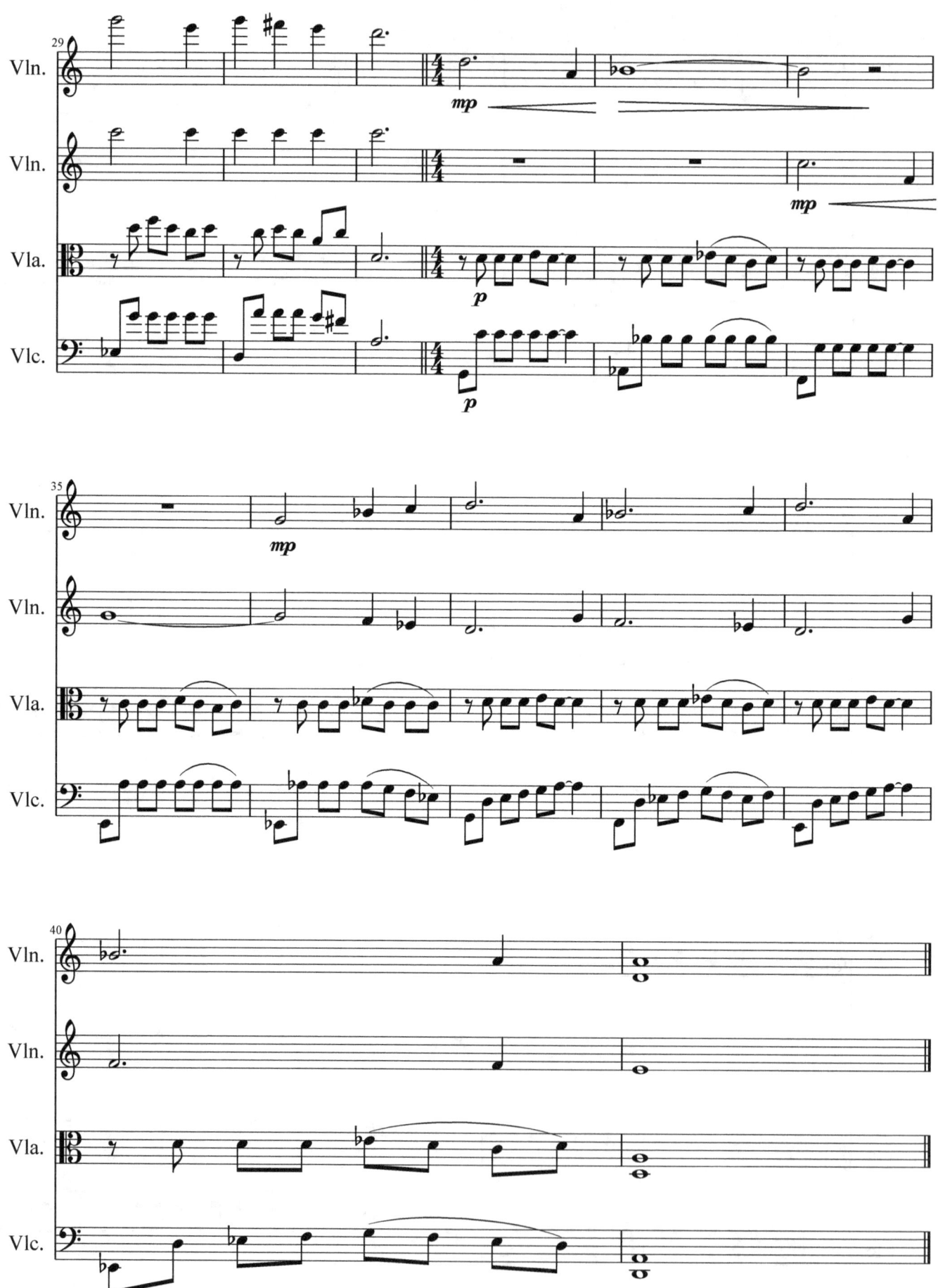

Lyrical Poems
5. Of This Wilting Wall

Ken Langer

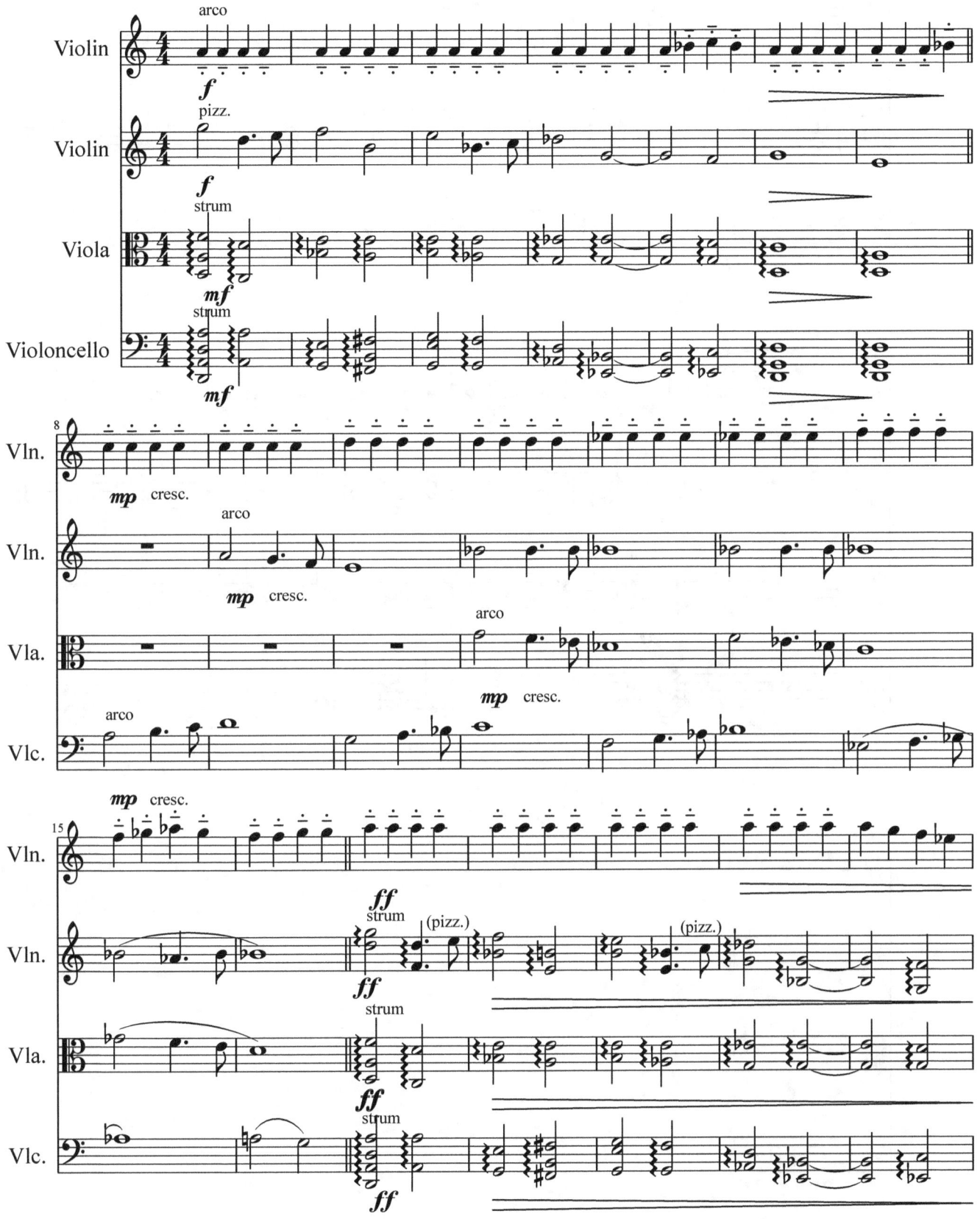

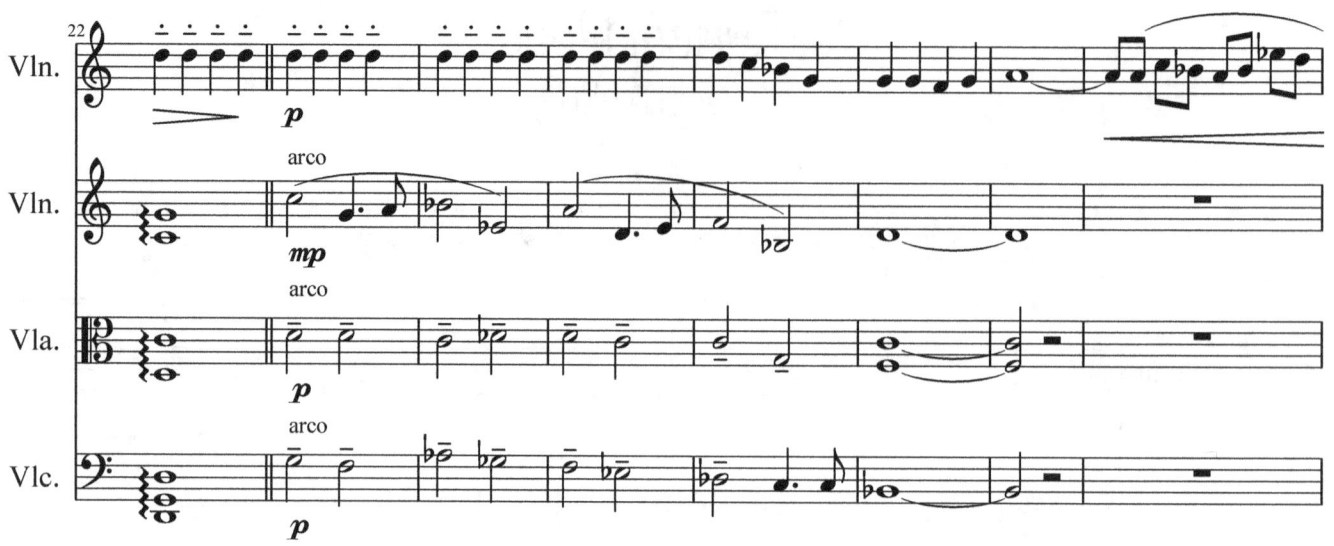
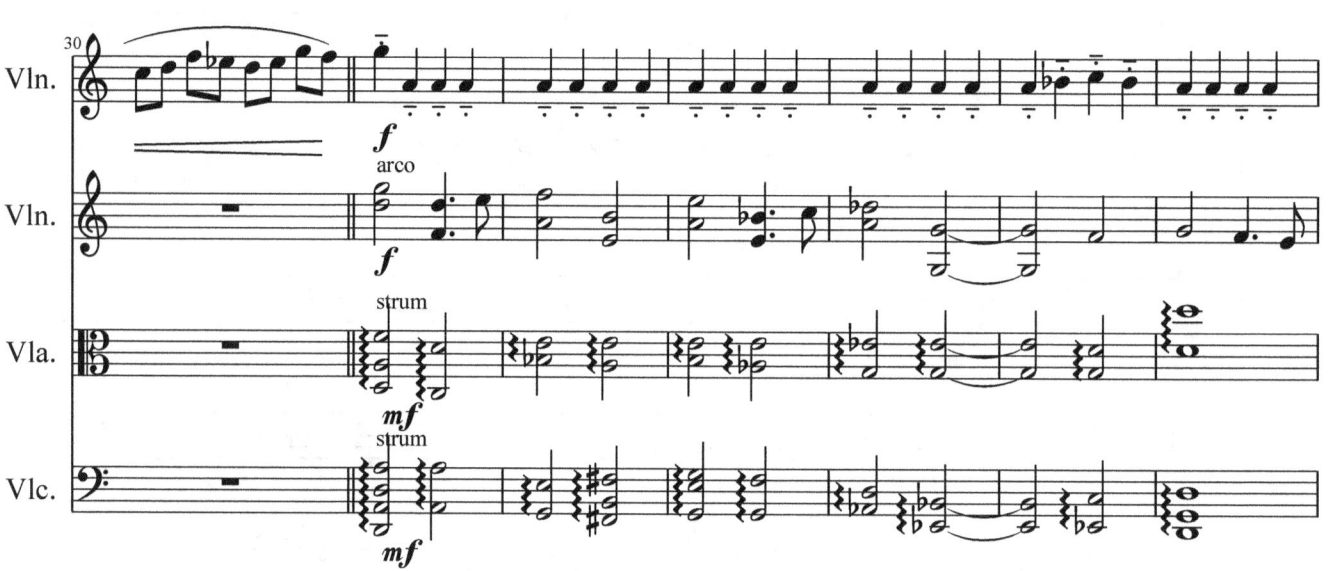
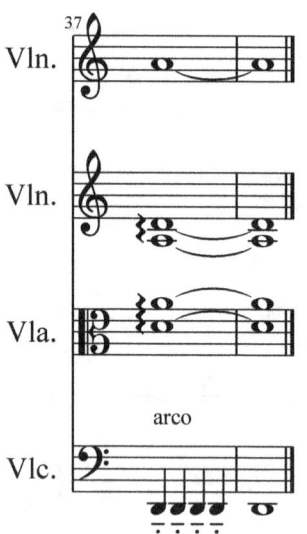

Lyrical Poems

6. Tapping Toe Hippopotamus

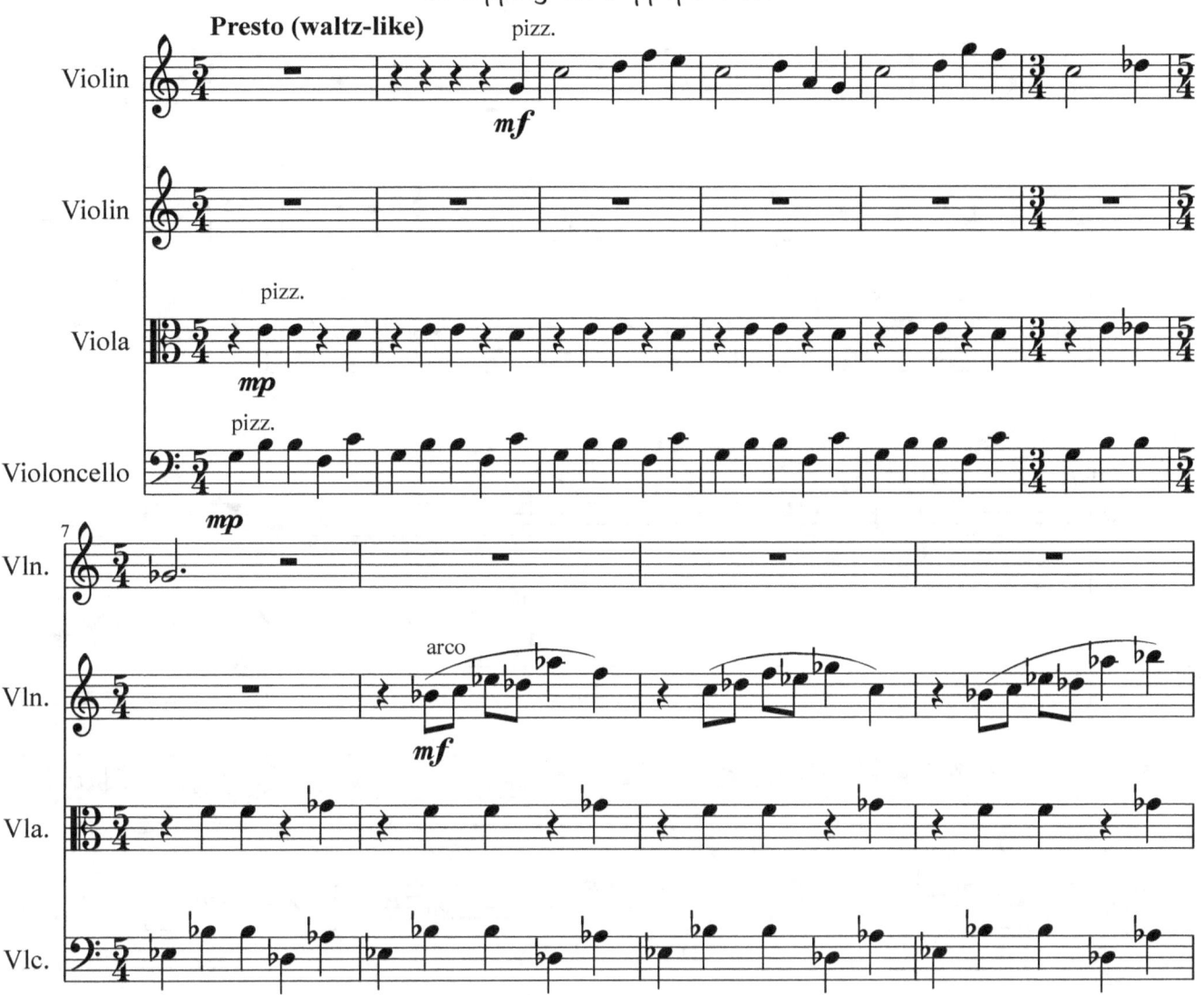

75

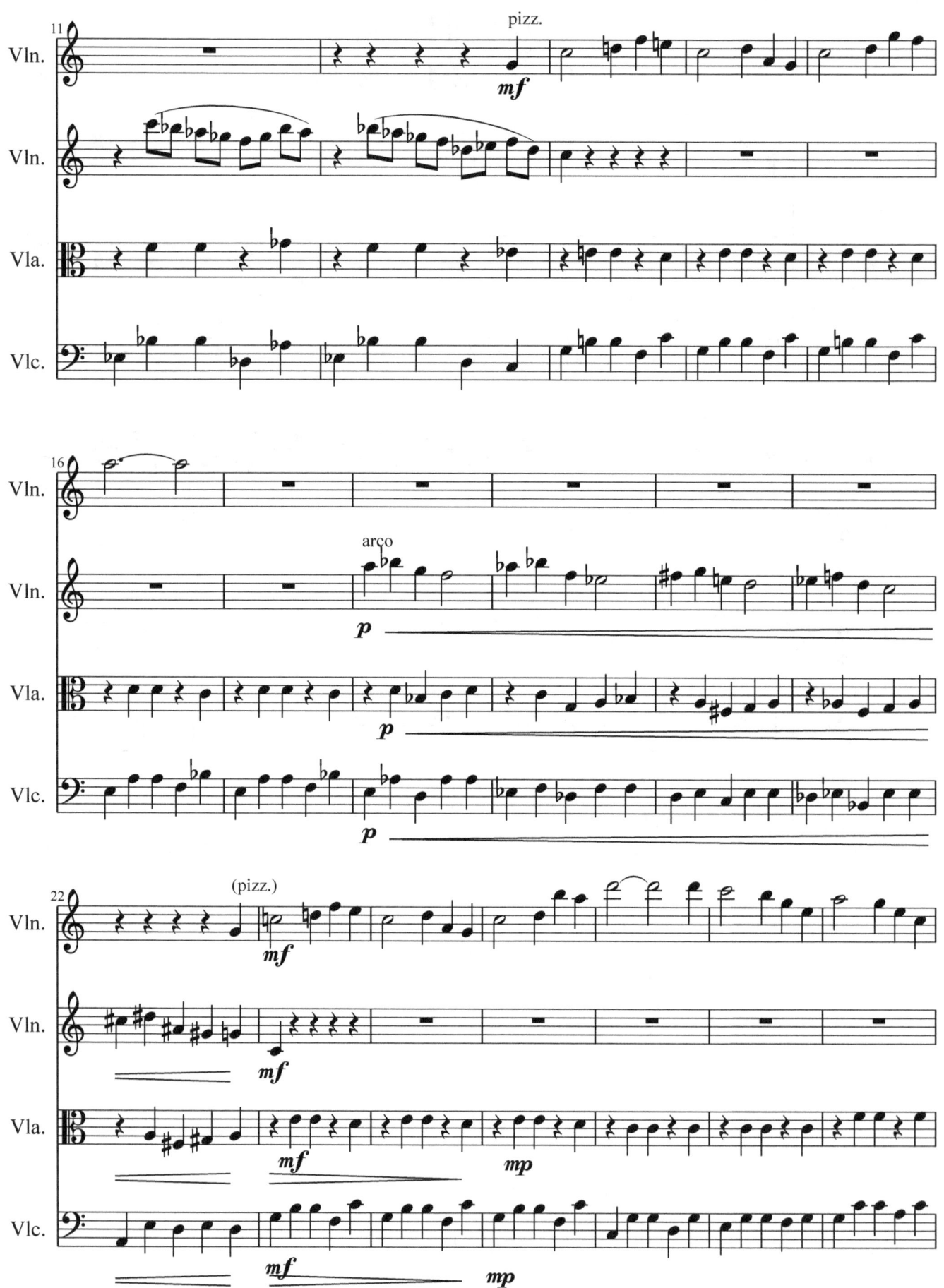

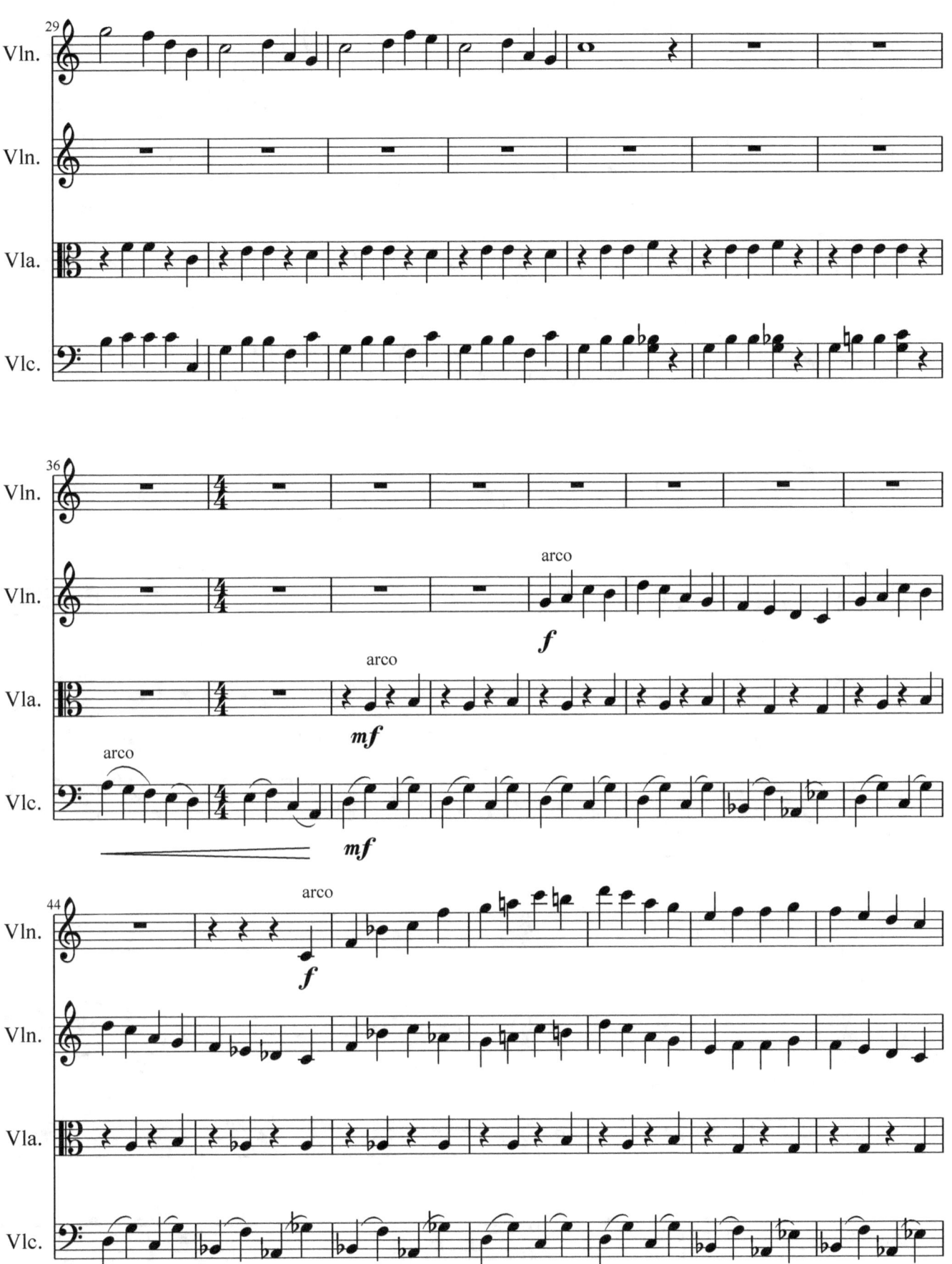

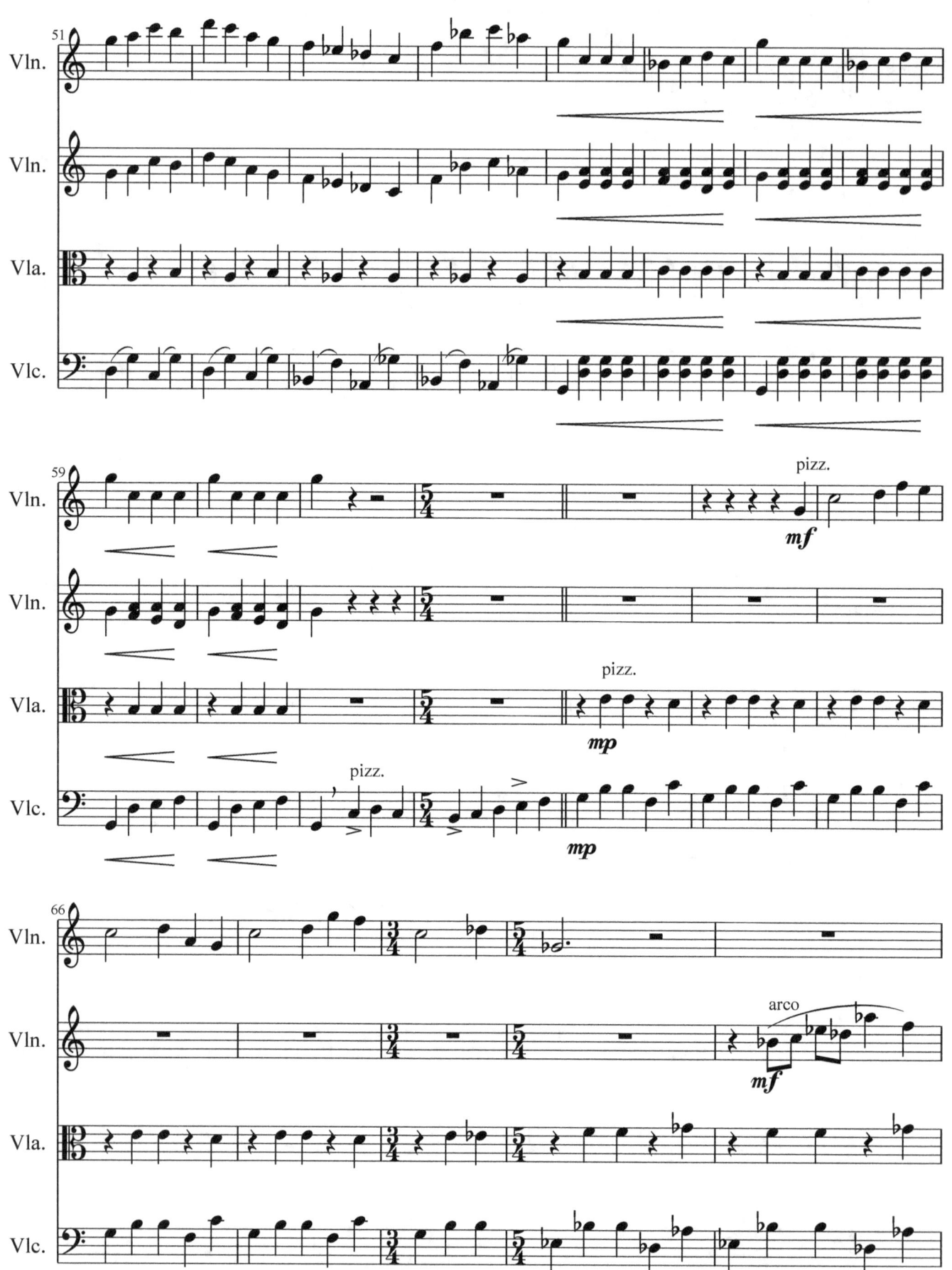

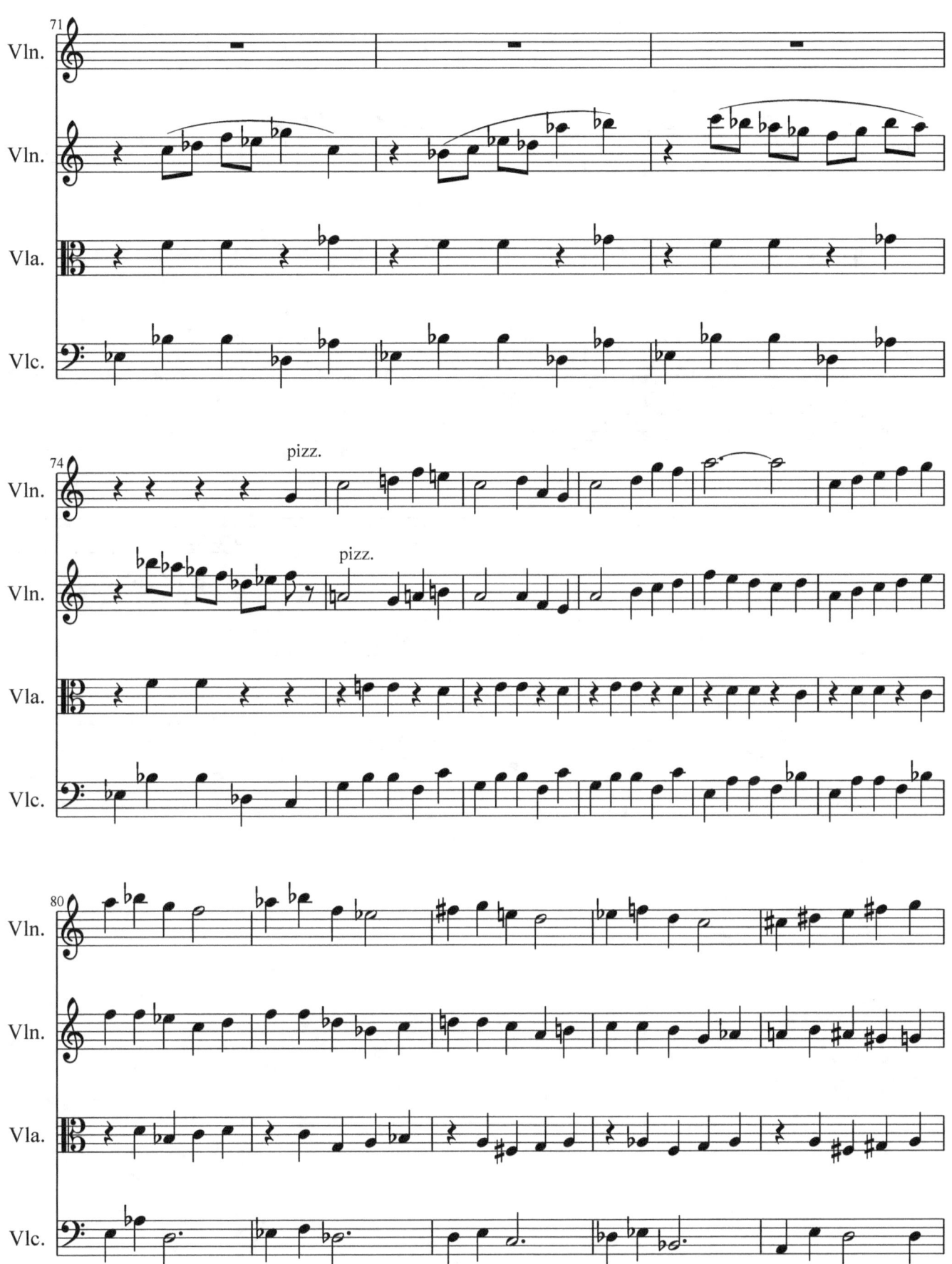

79

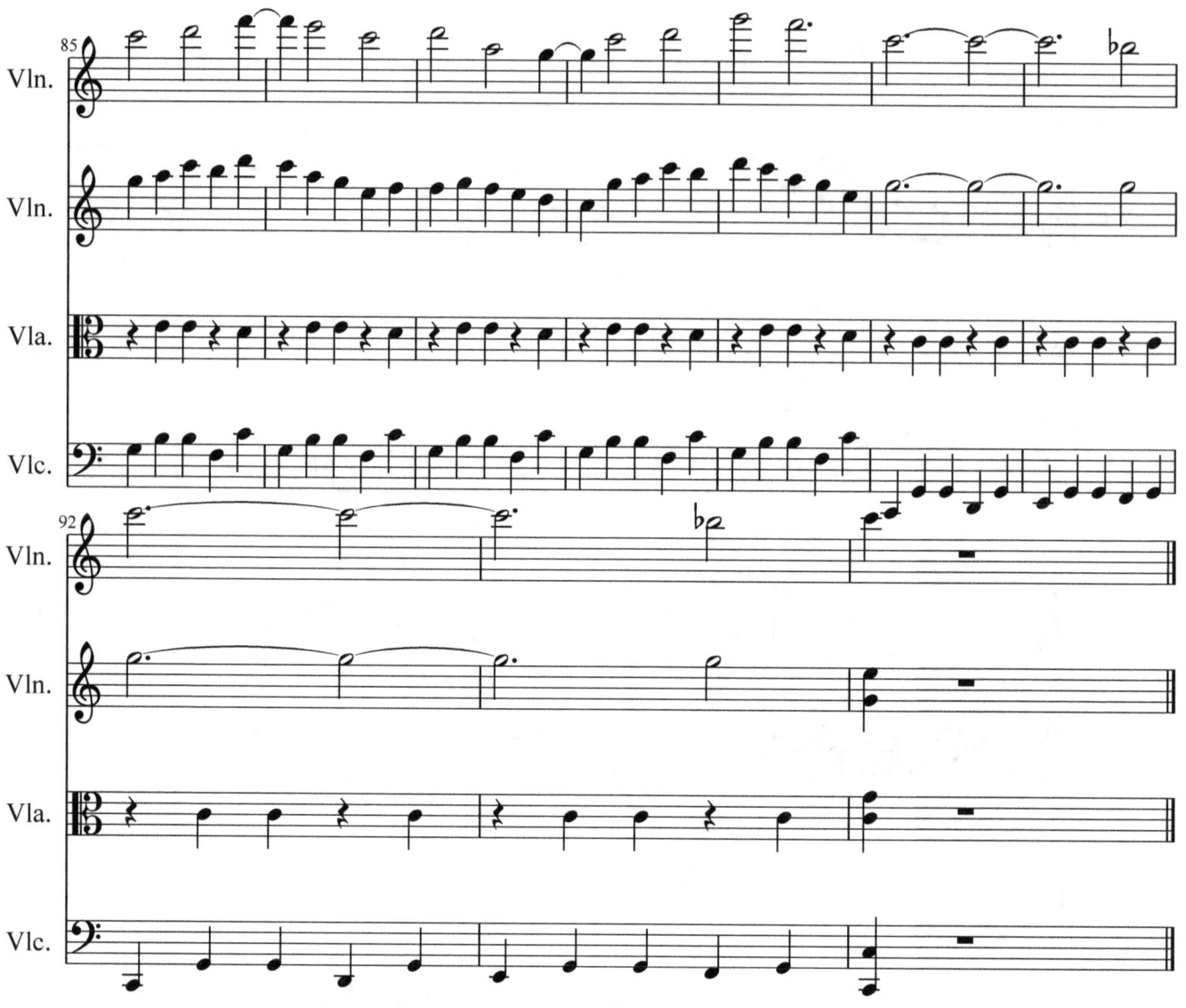

Lyrical Poems
7. Oh Yeah, But Listen Here

Ken Langer

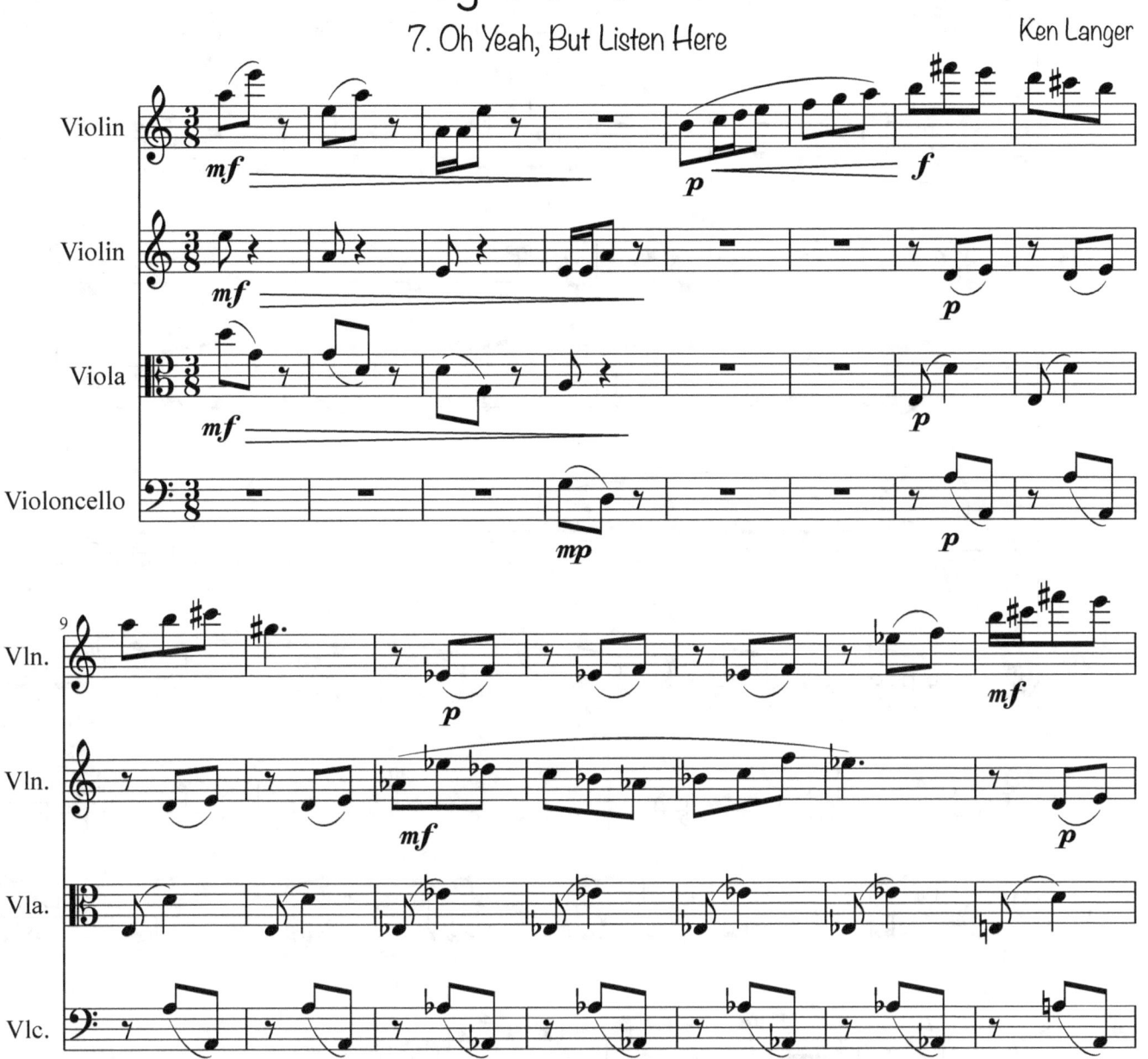

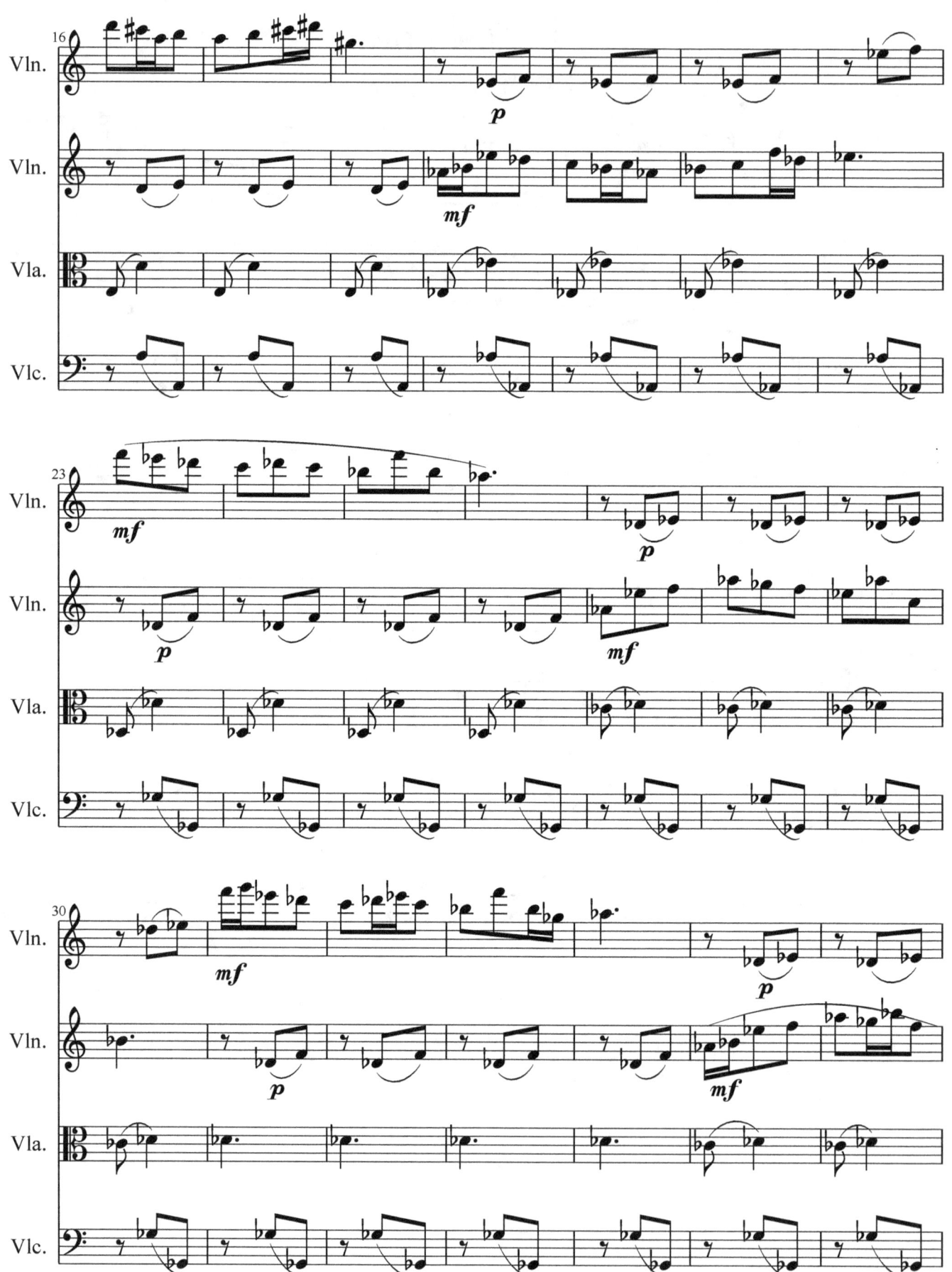

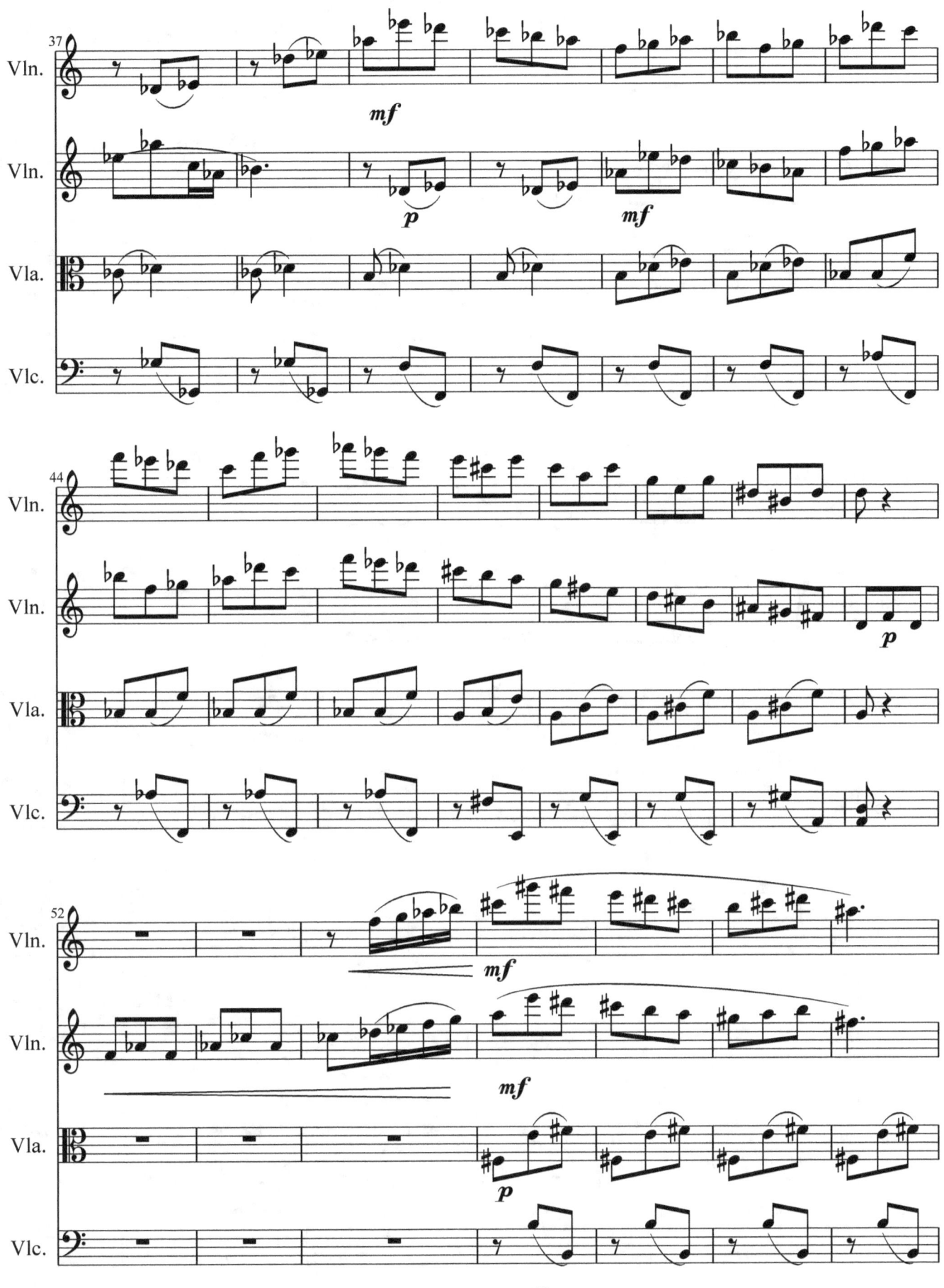

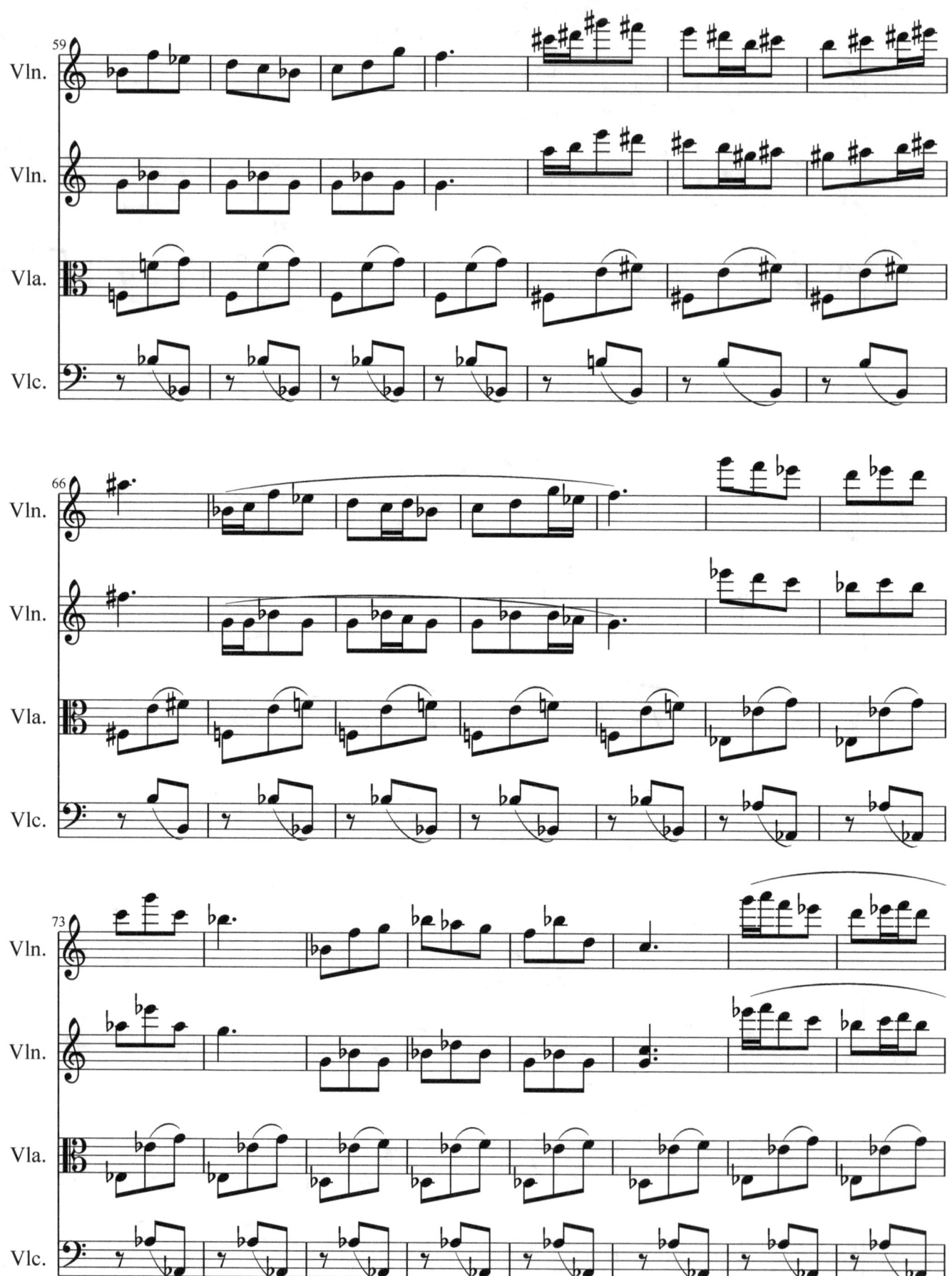

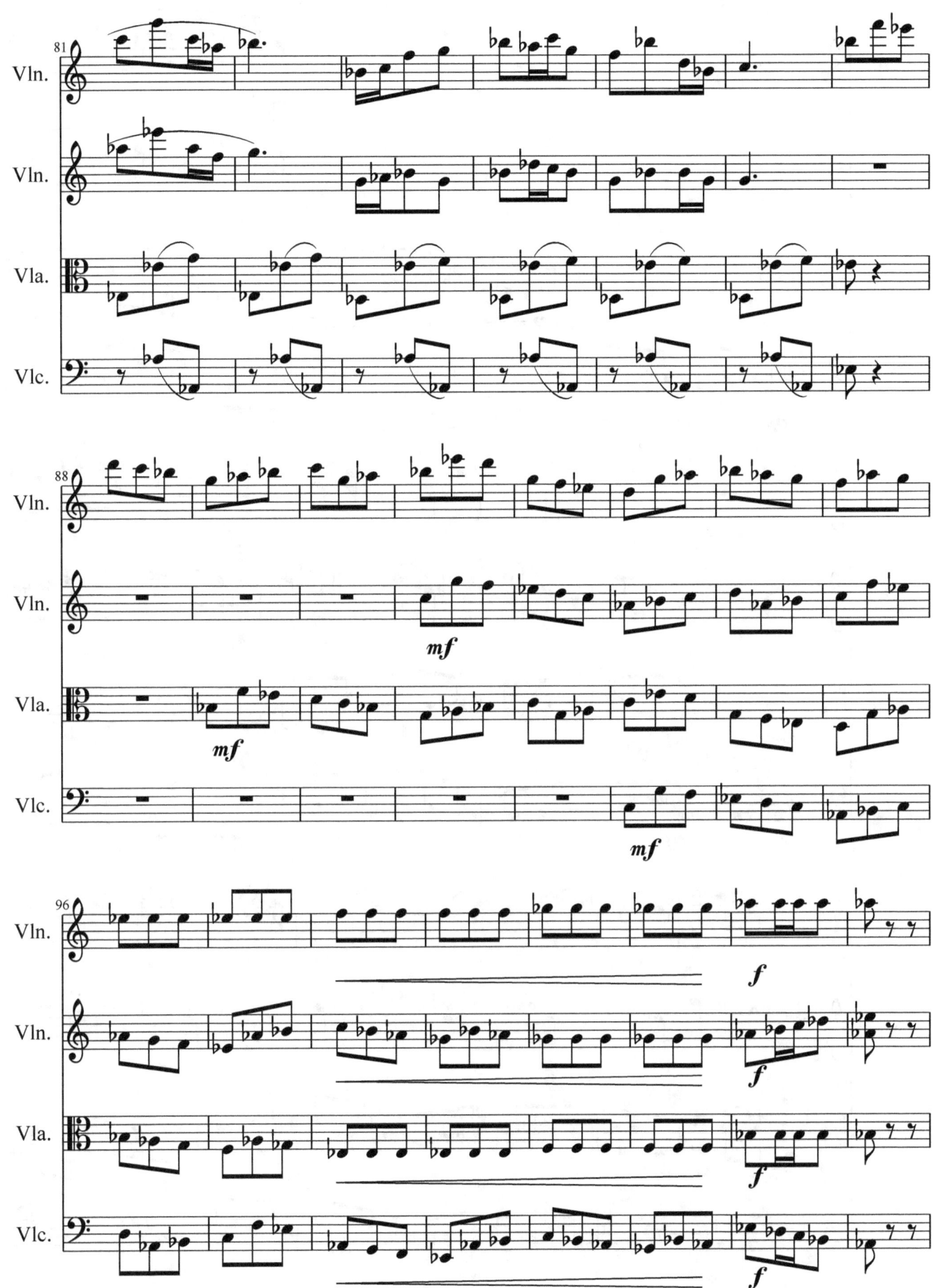

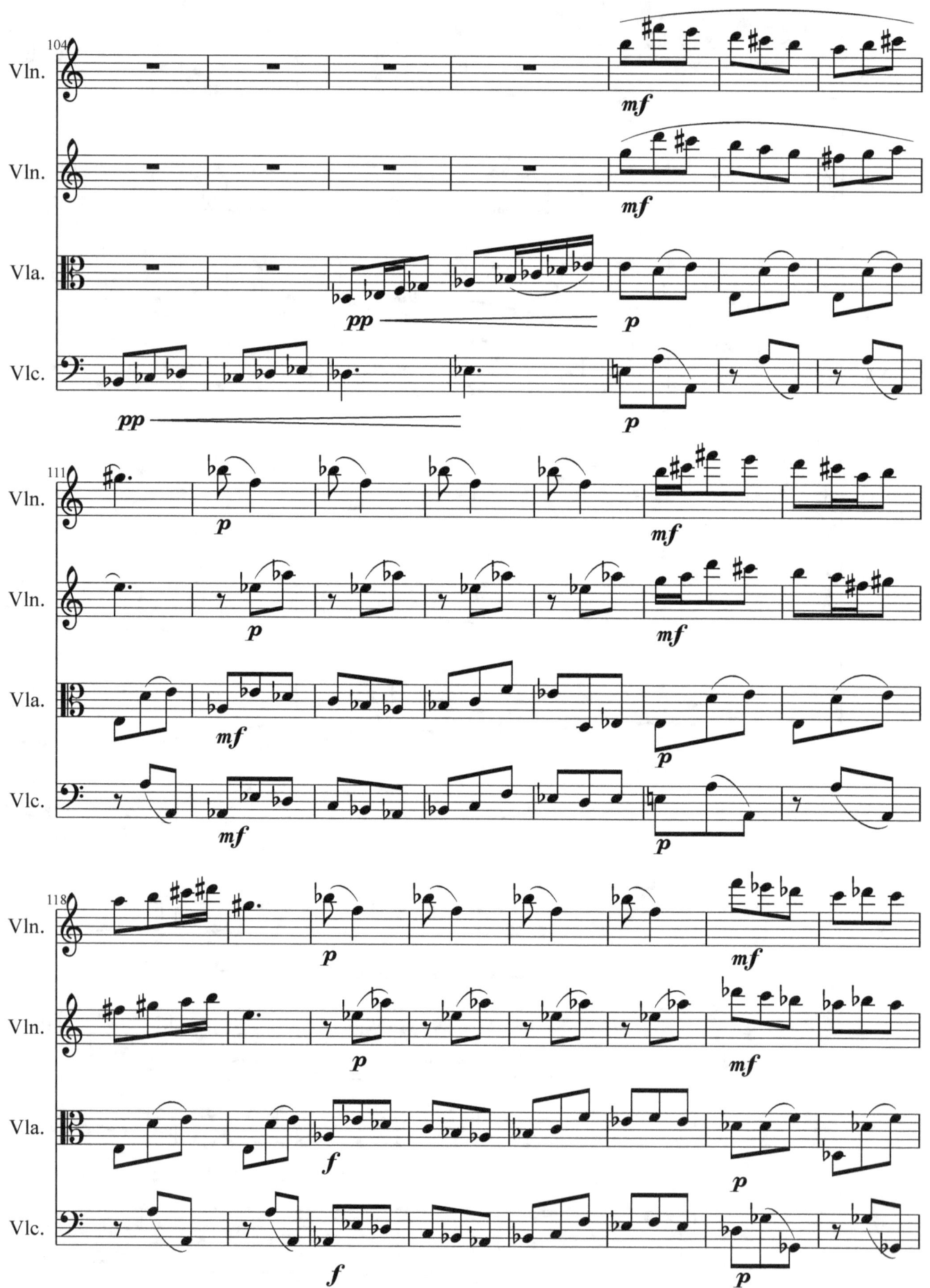

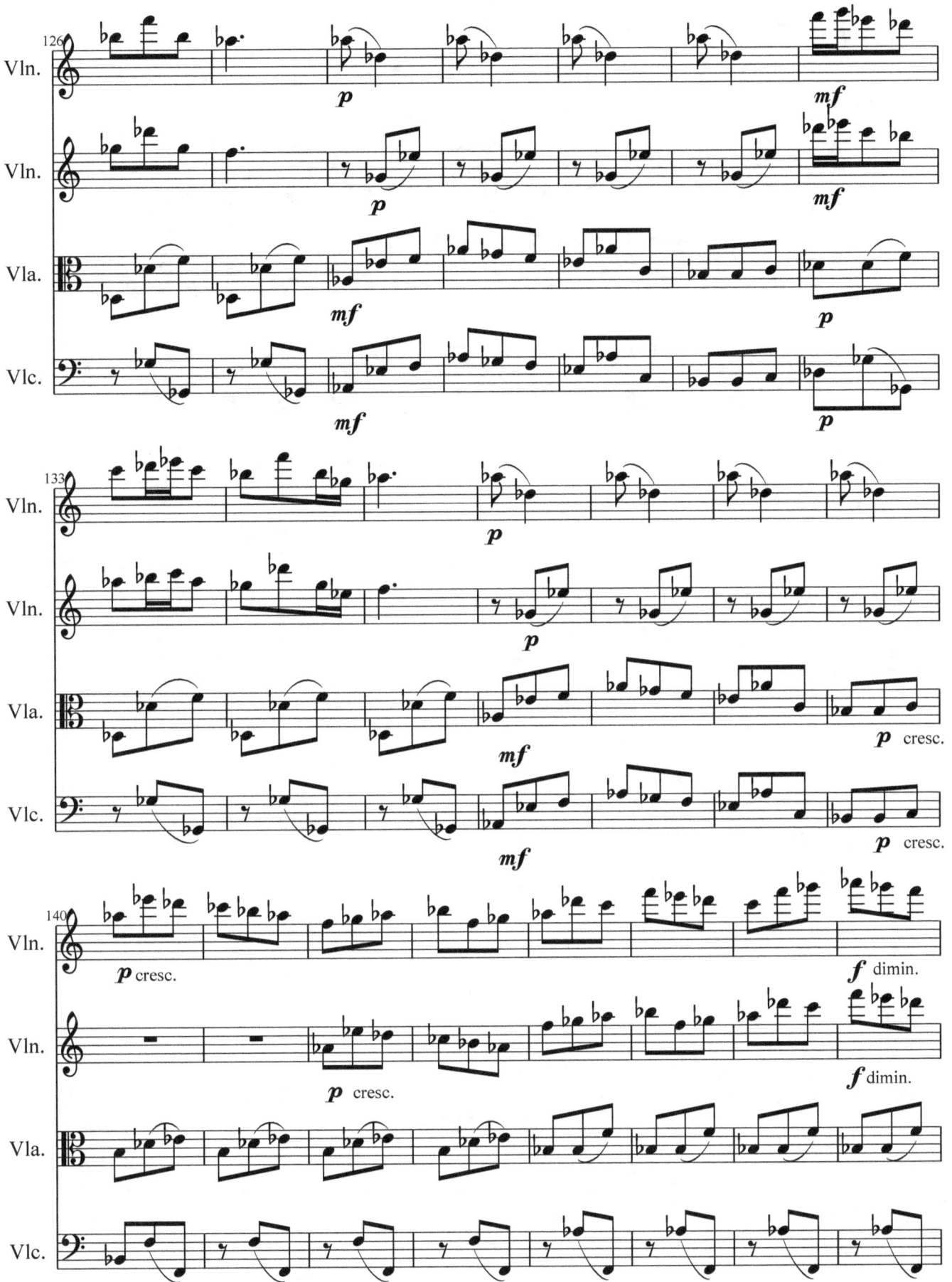

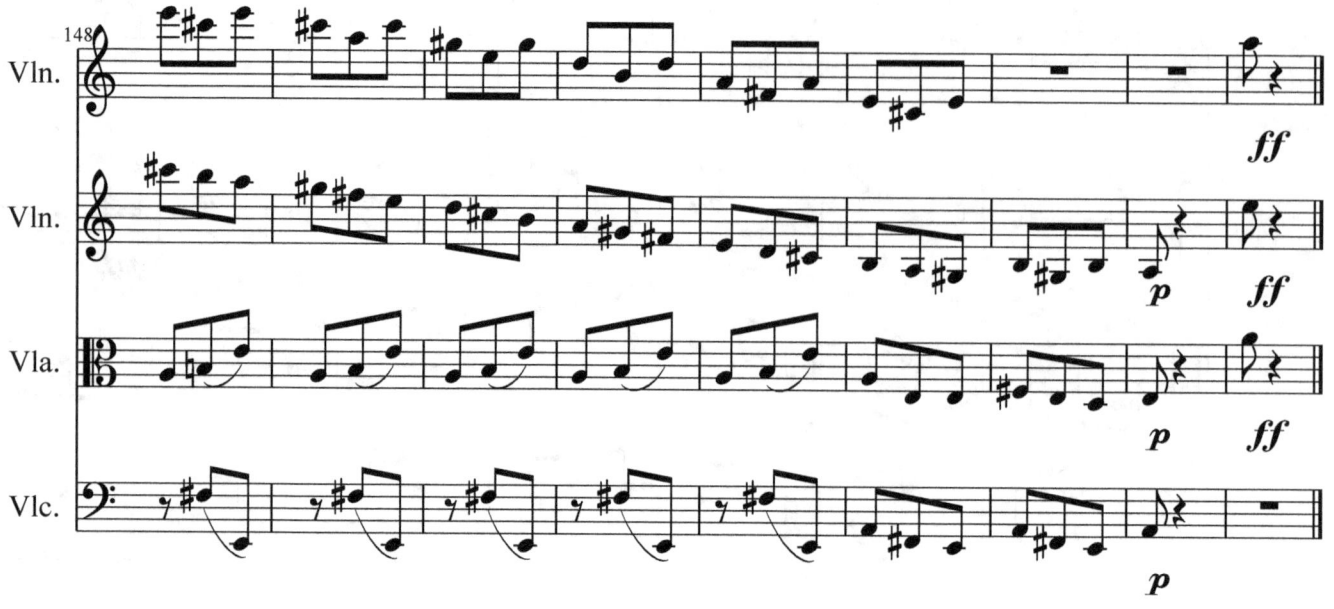

Lyrical Poems
8. Rain Fell In Ropes of Silver

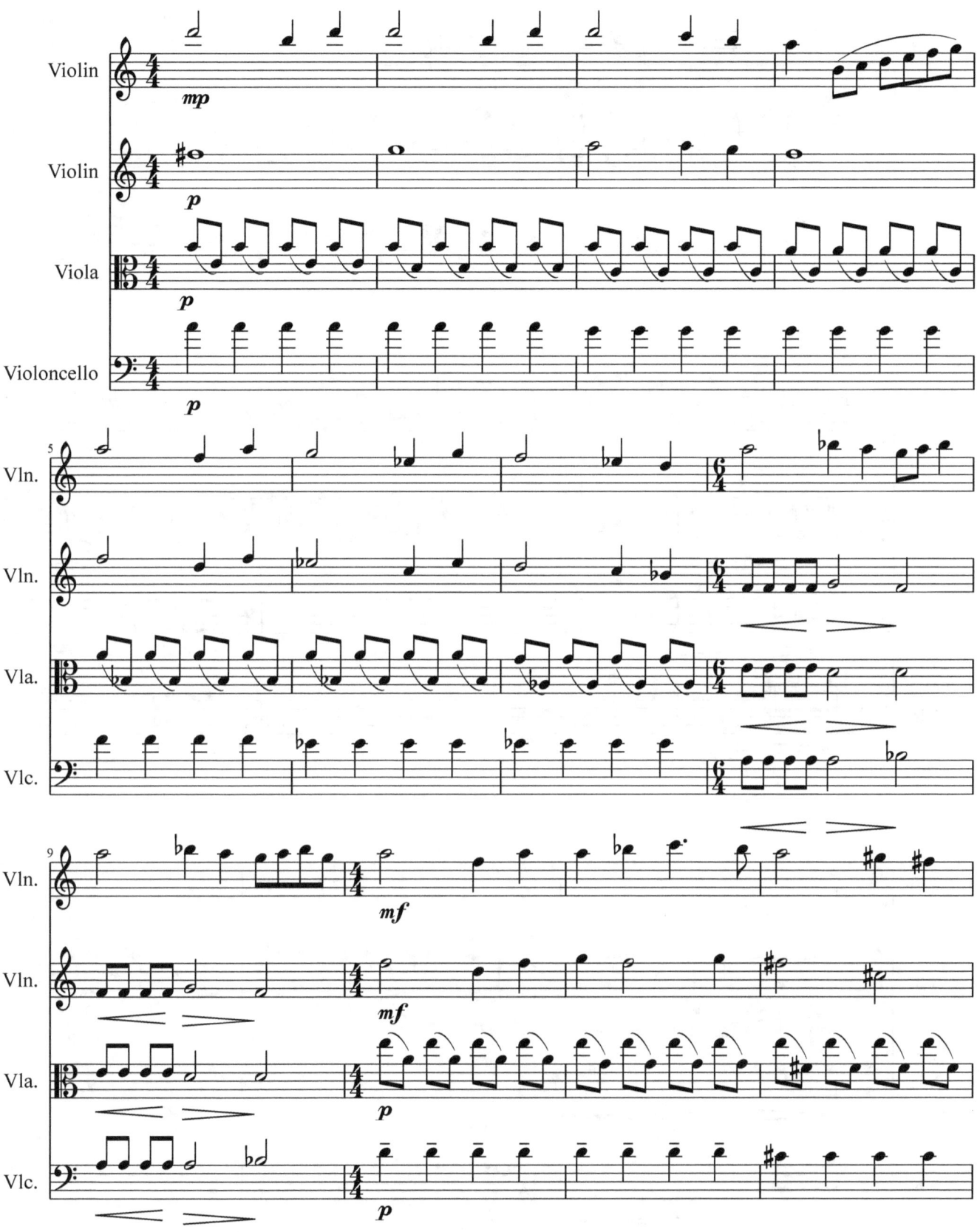

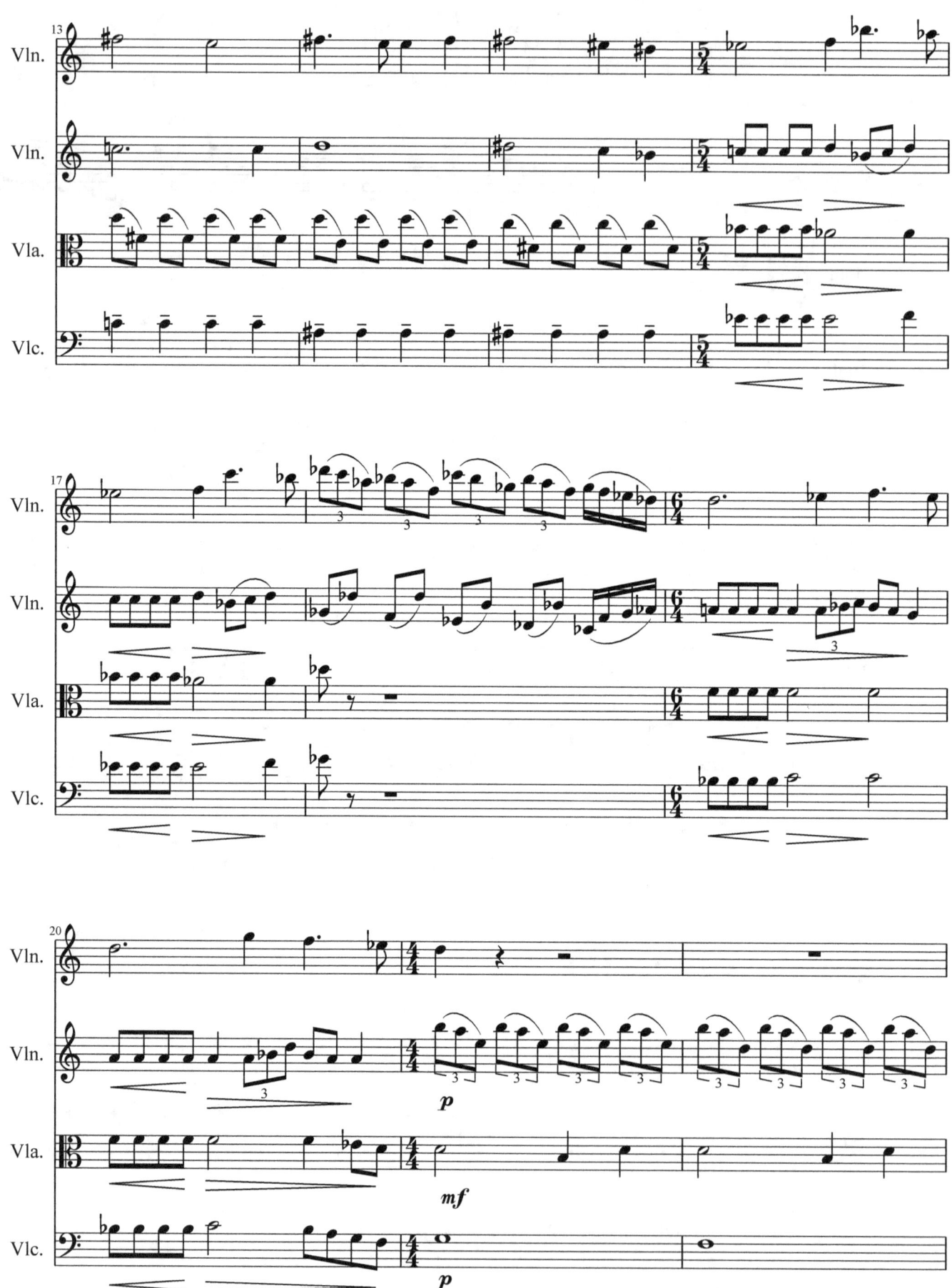

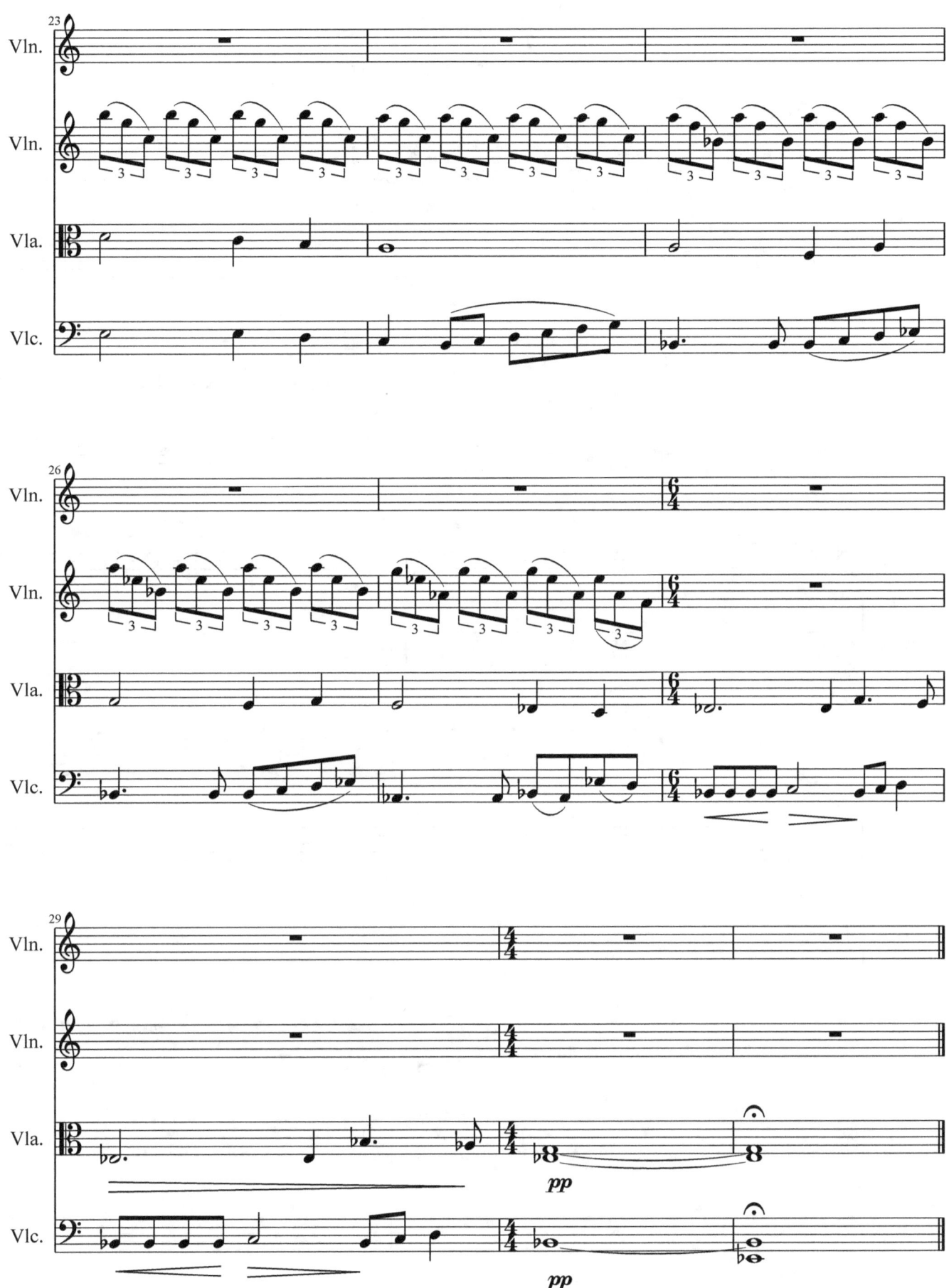

Lyrical Poems
9. Birds Inventing Air

Ken Langer

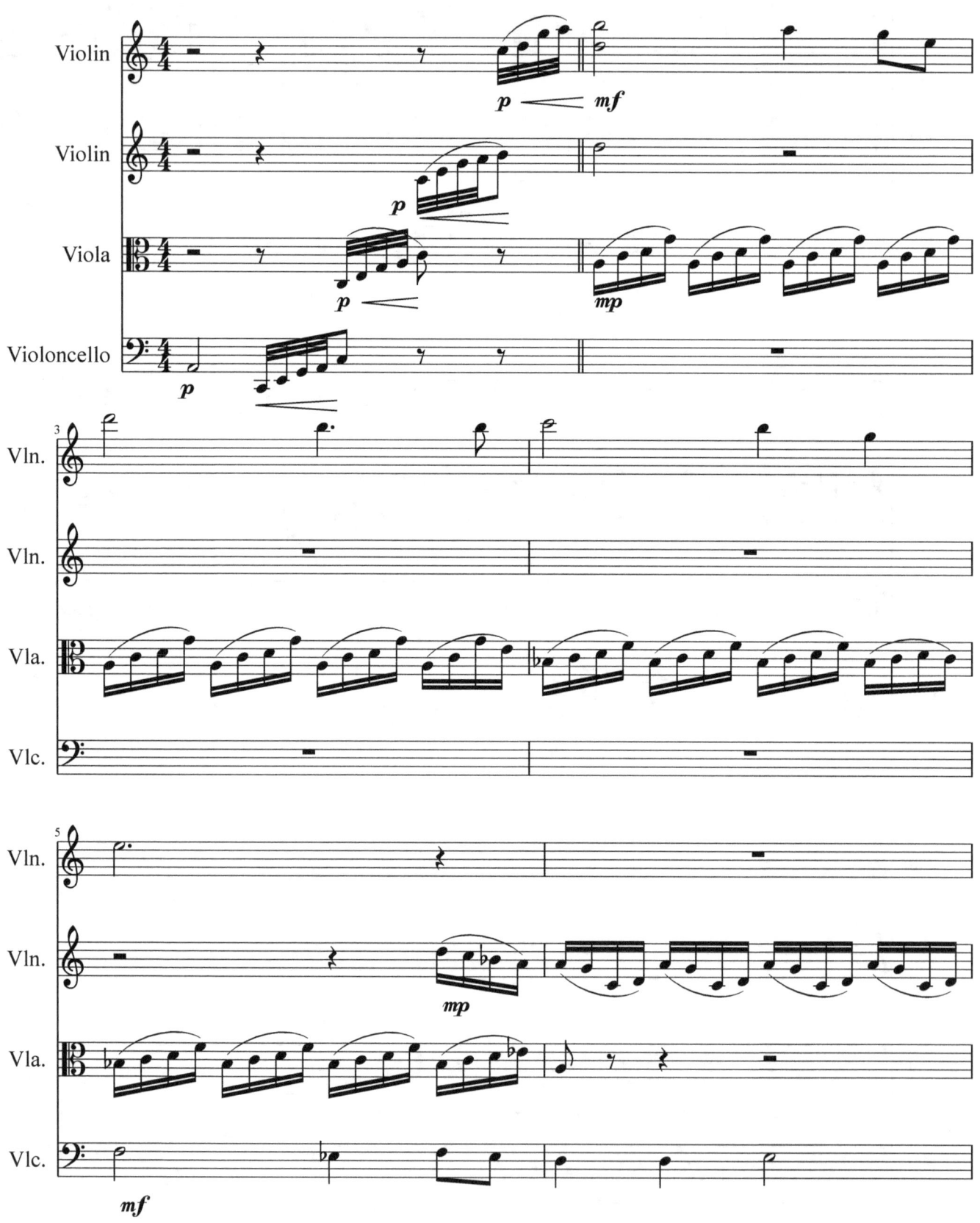

92

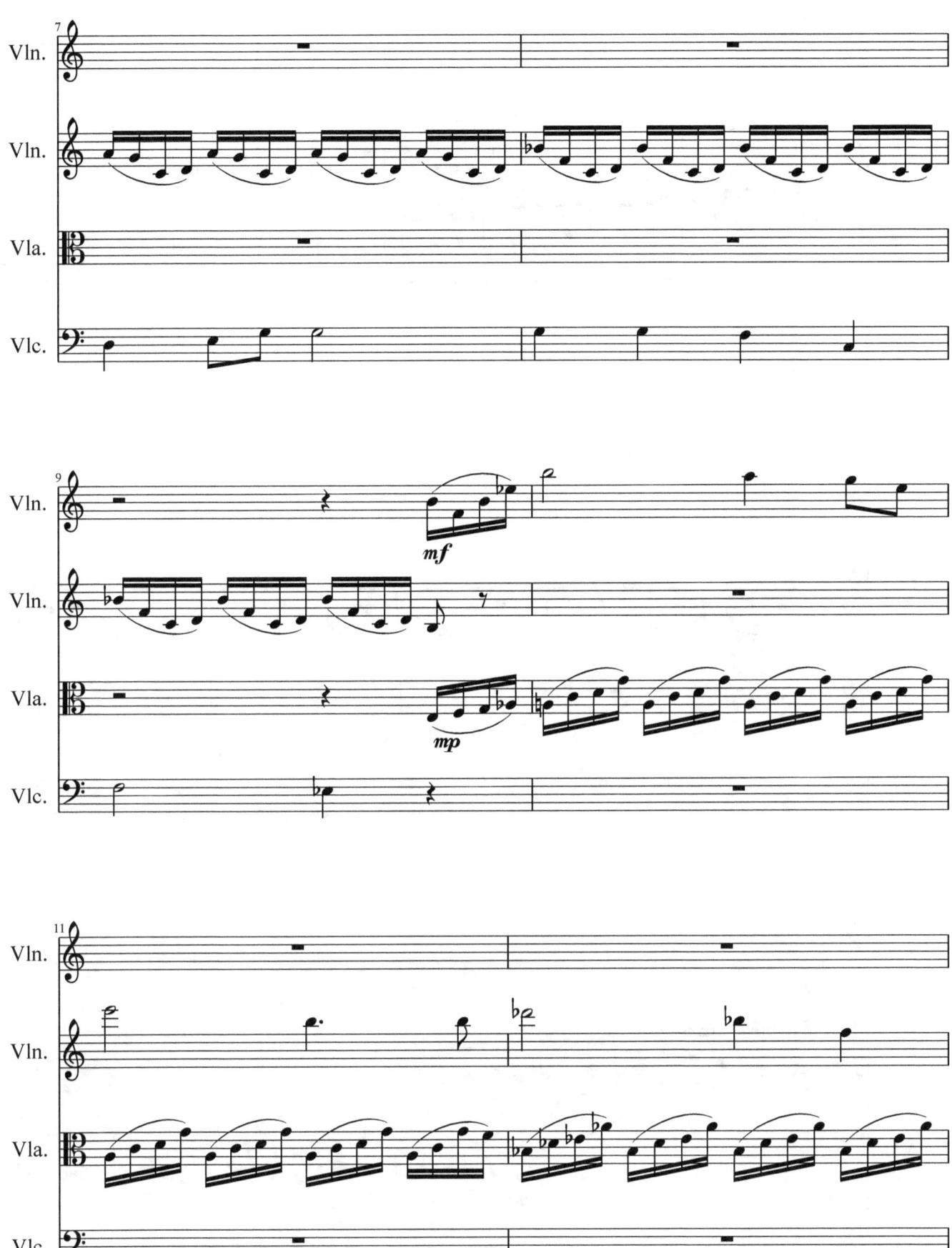

93

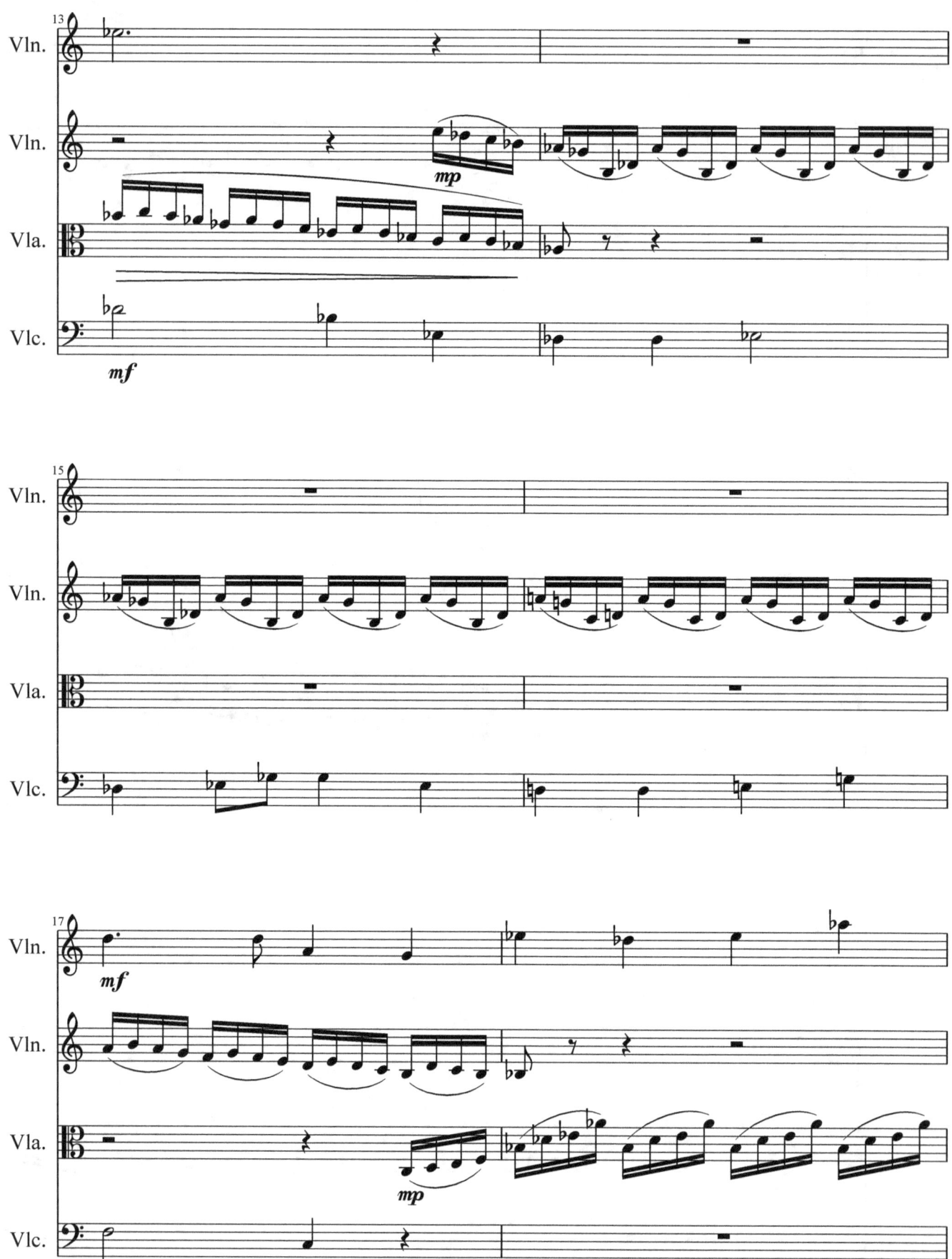

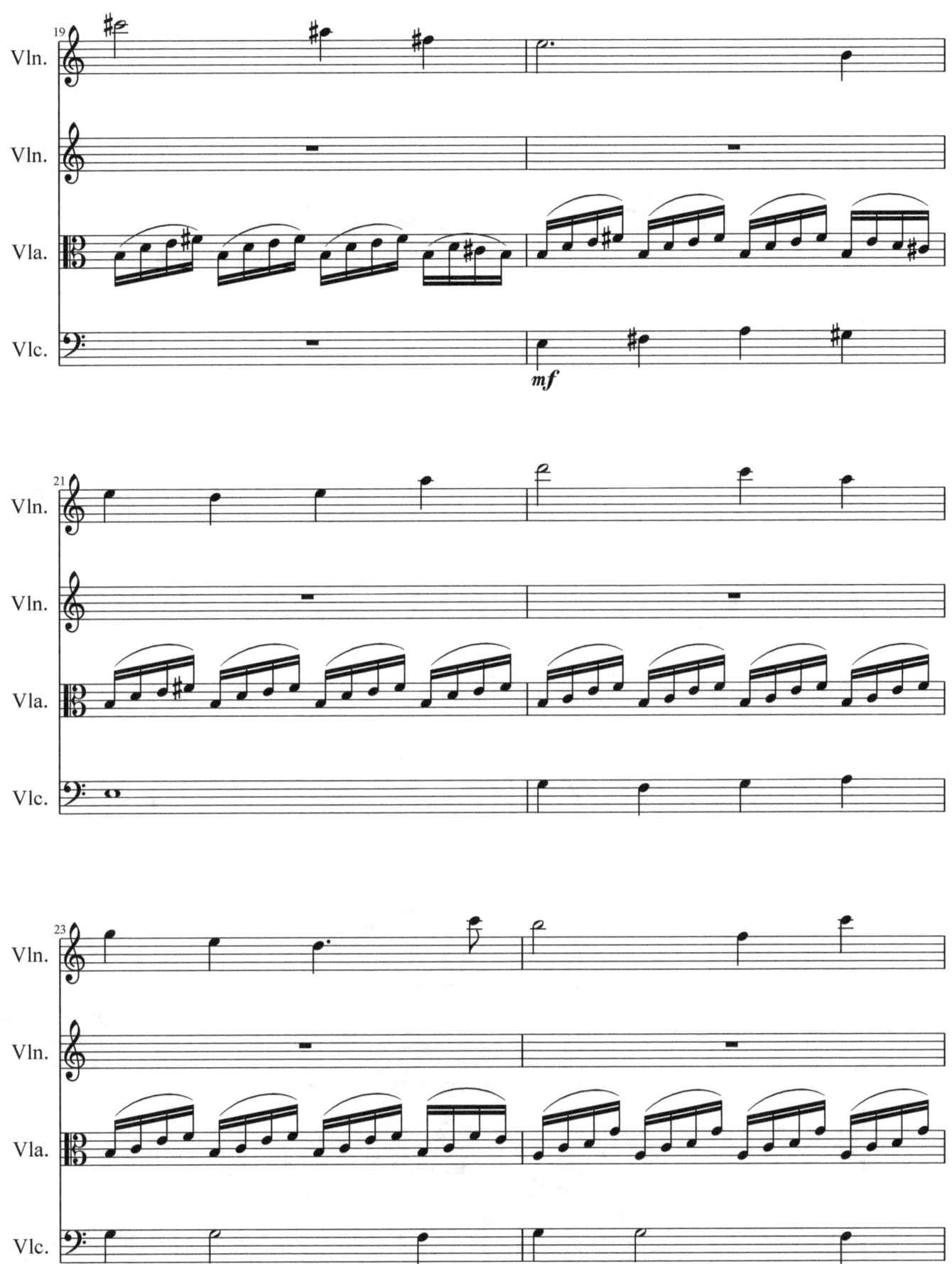

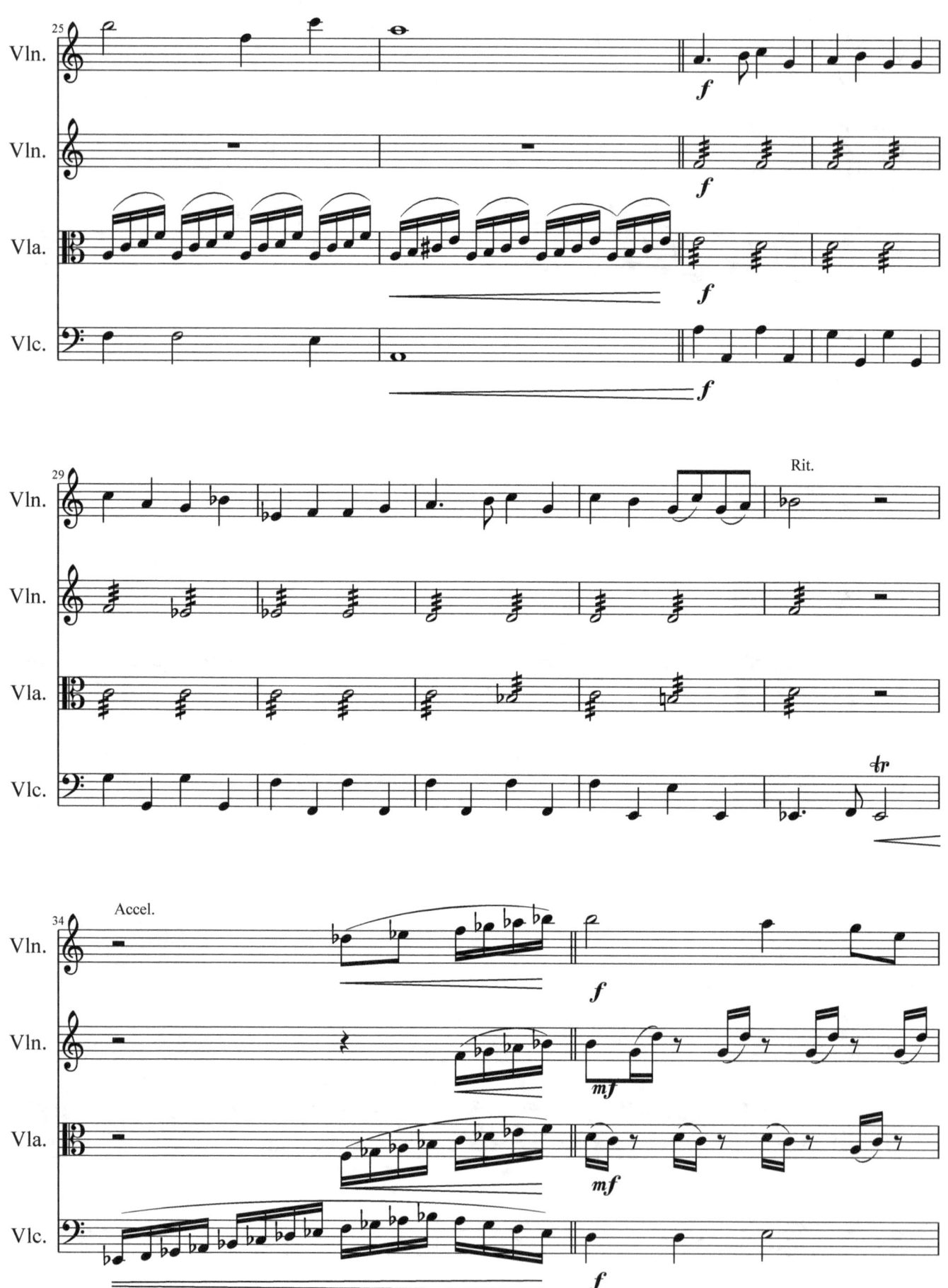

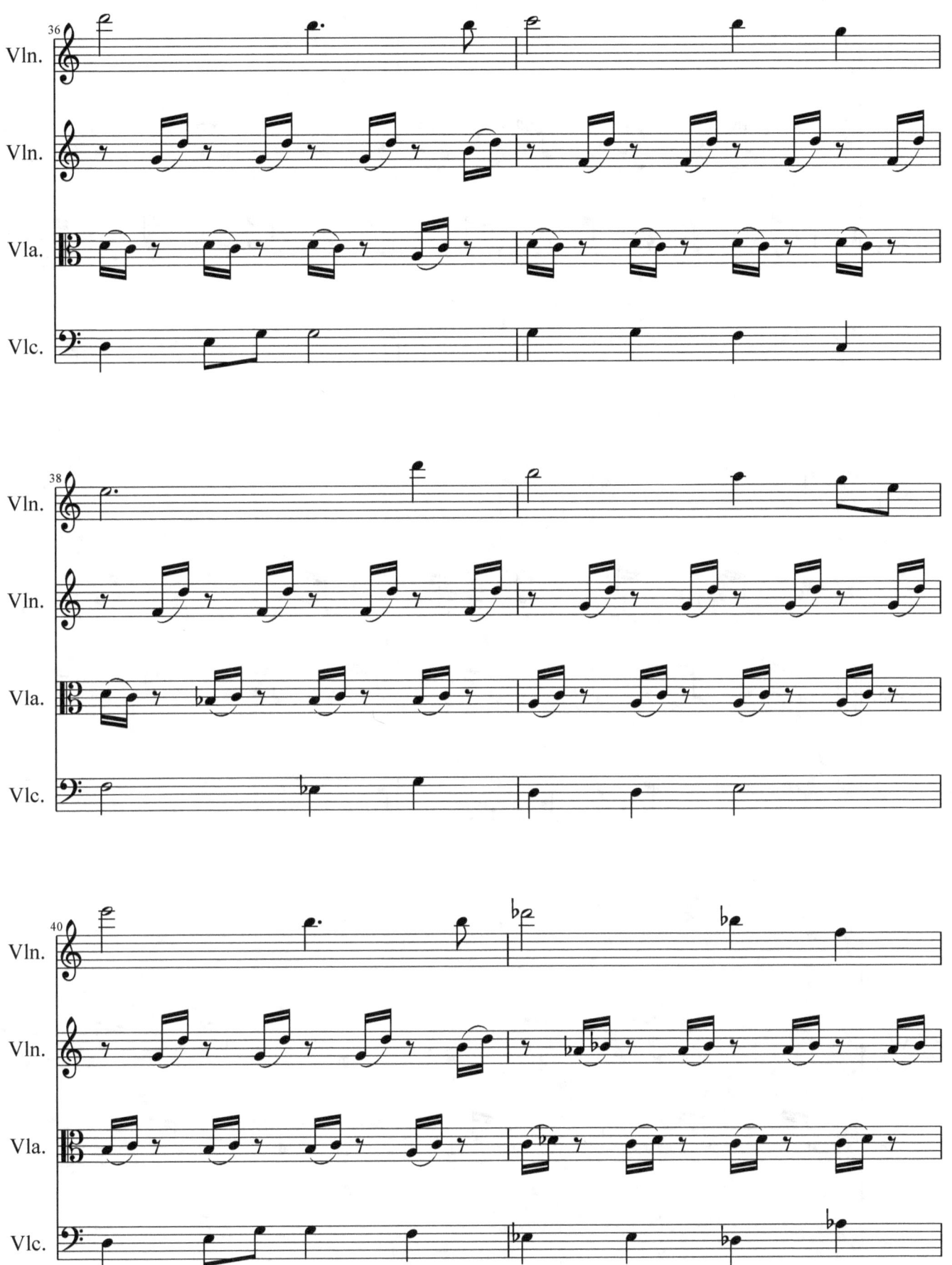

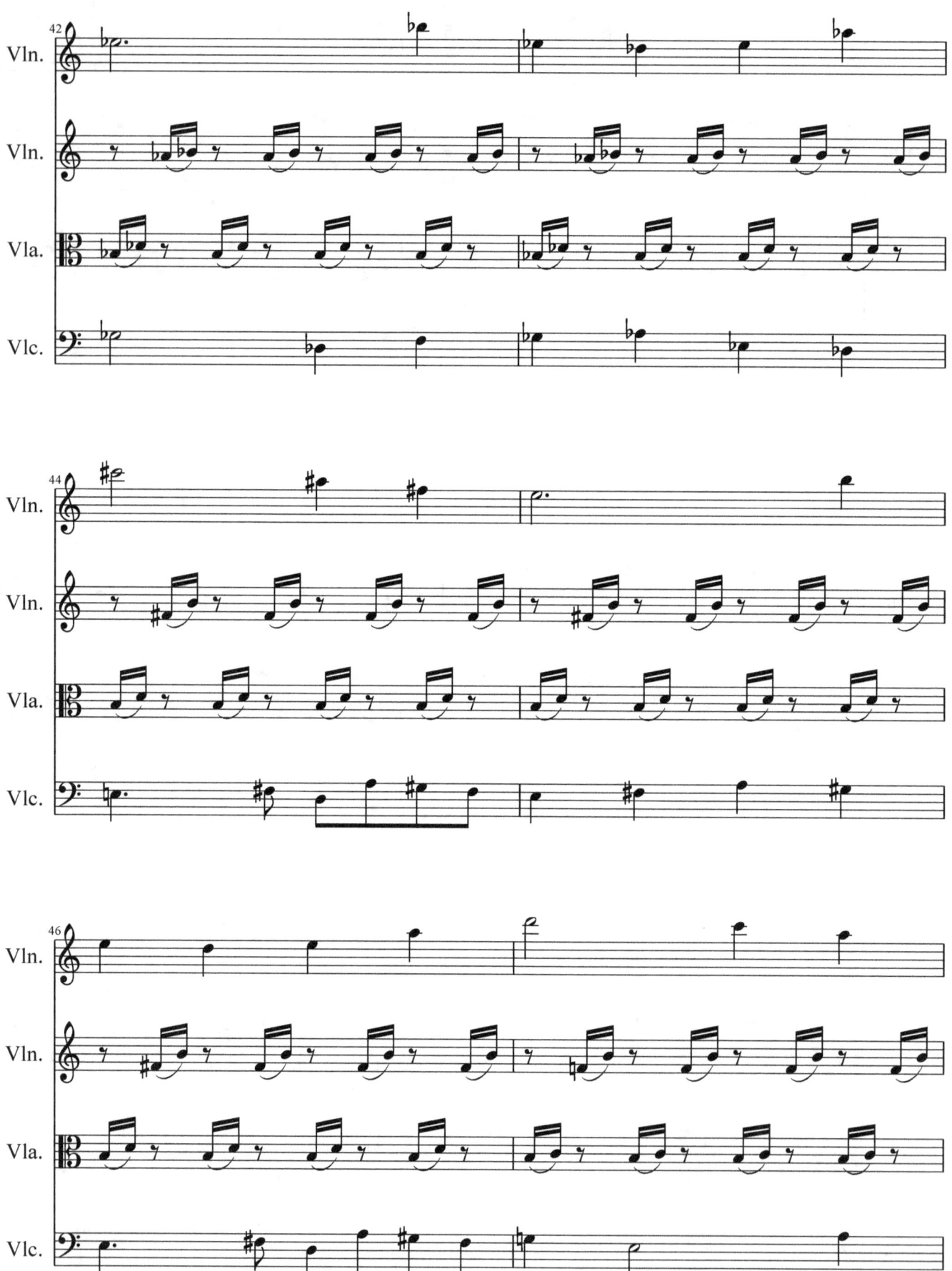

Lyrical Poems
10. Love Is A Place

Ken Langer

103

Lyrical Poems
11. When My Body Is With Your Body

Ken Langer

105

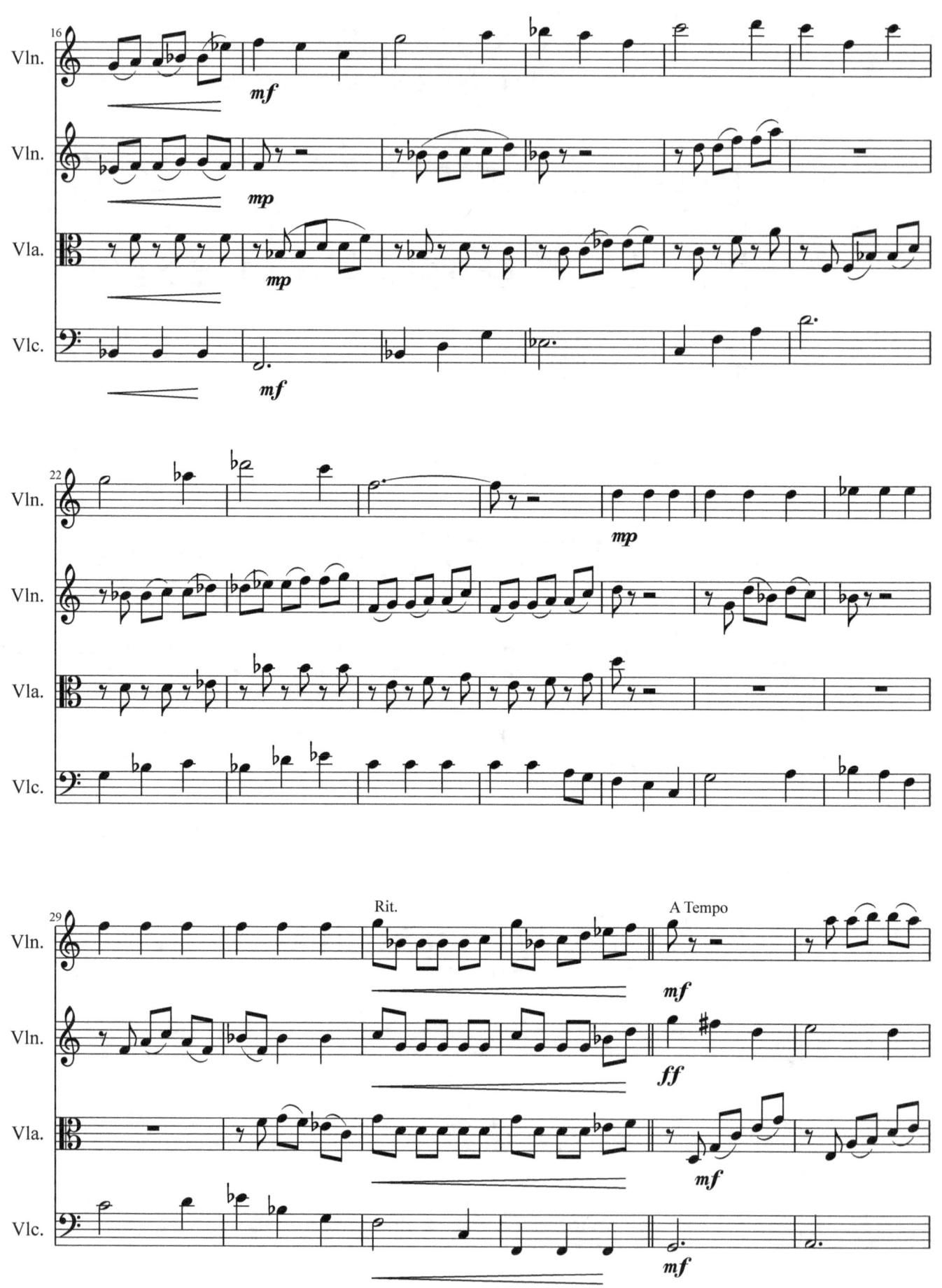

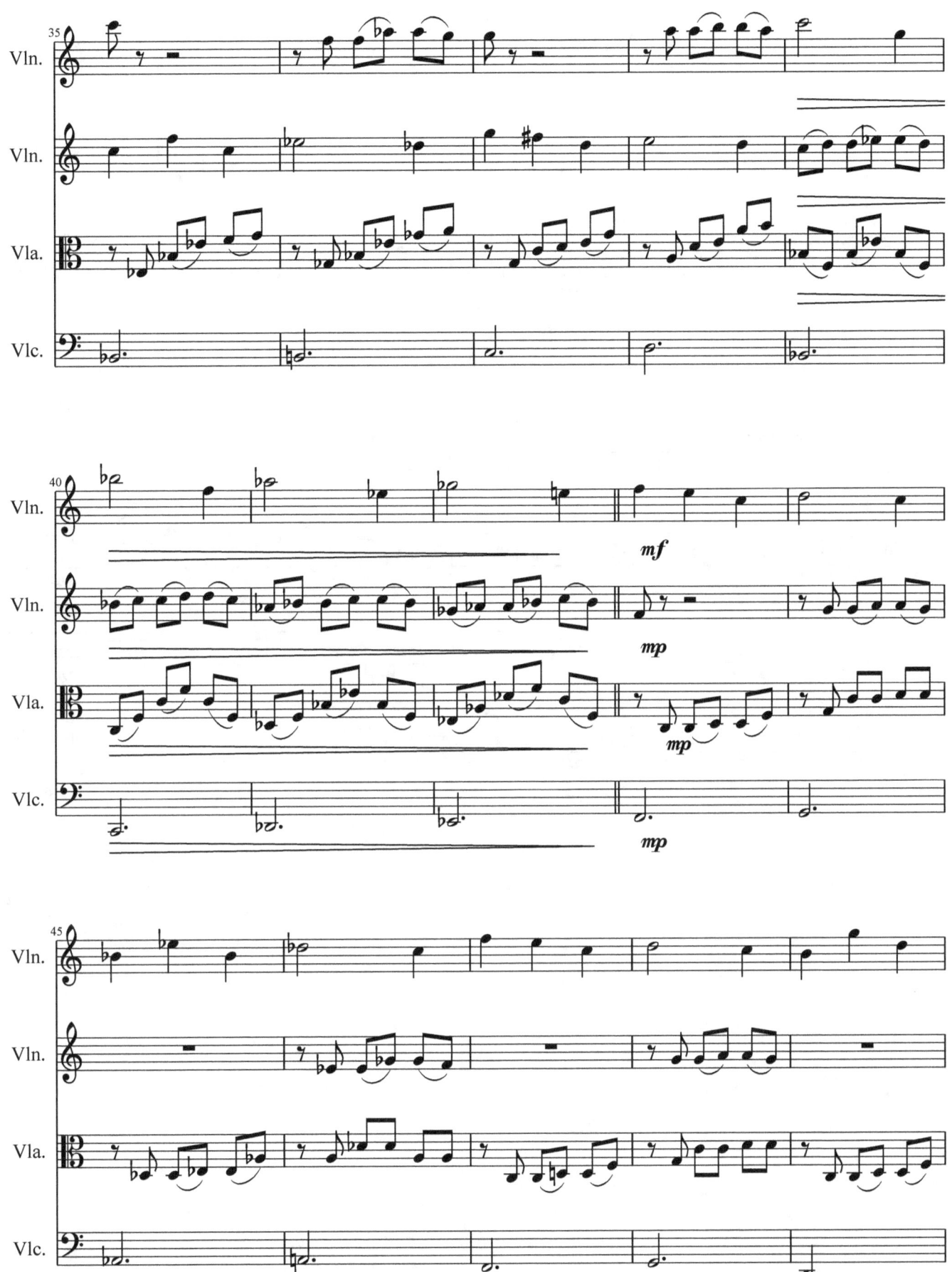

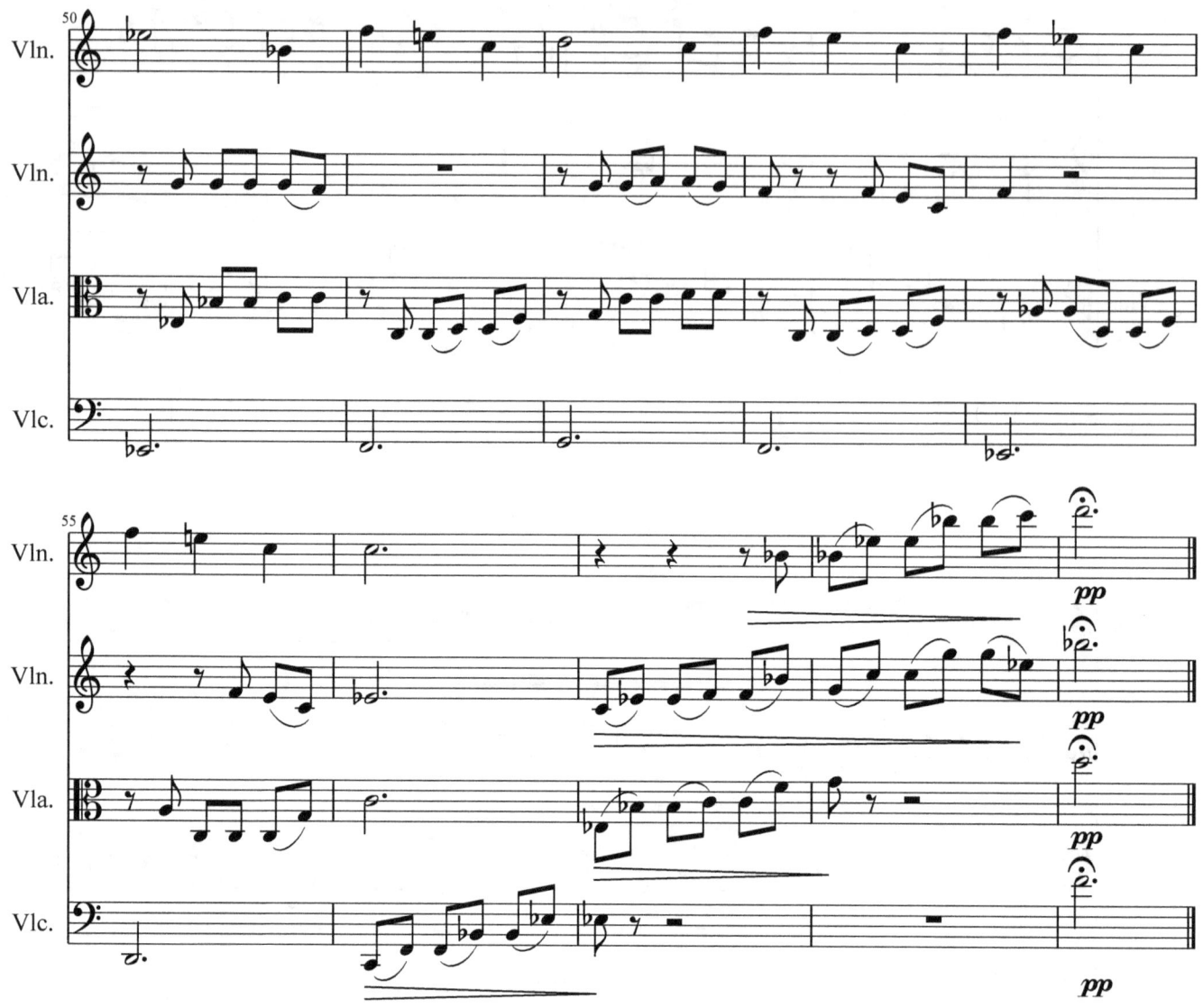

Lyrical Poems
12. Go To Perpetual Adventuring

Ken Langer

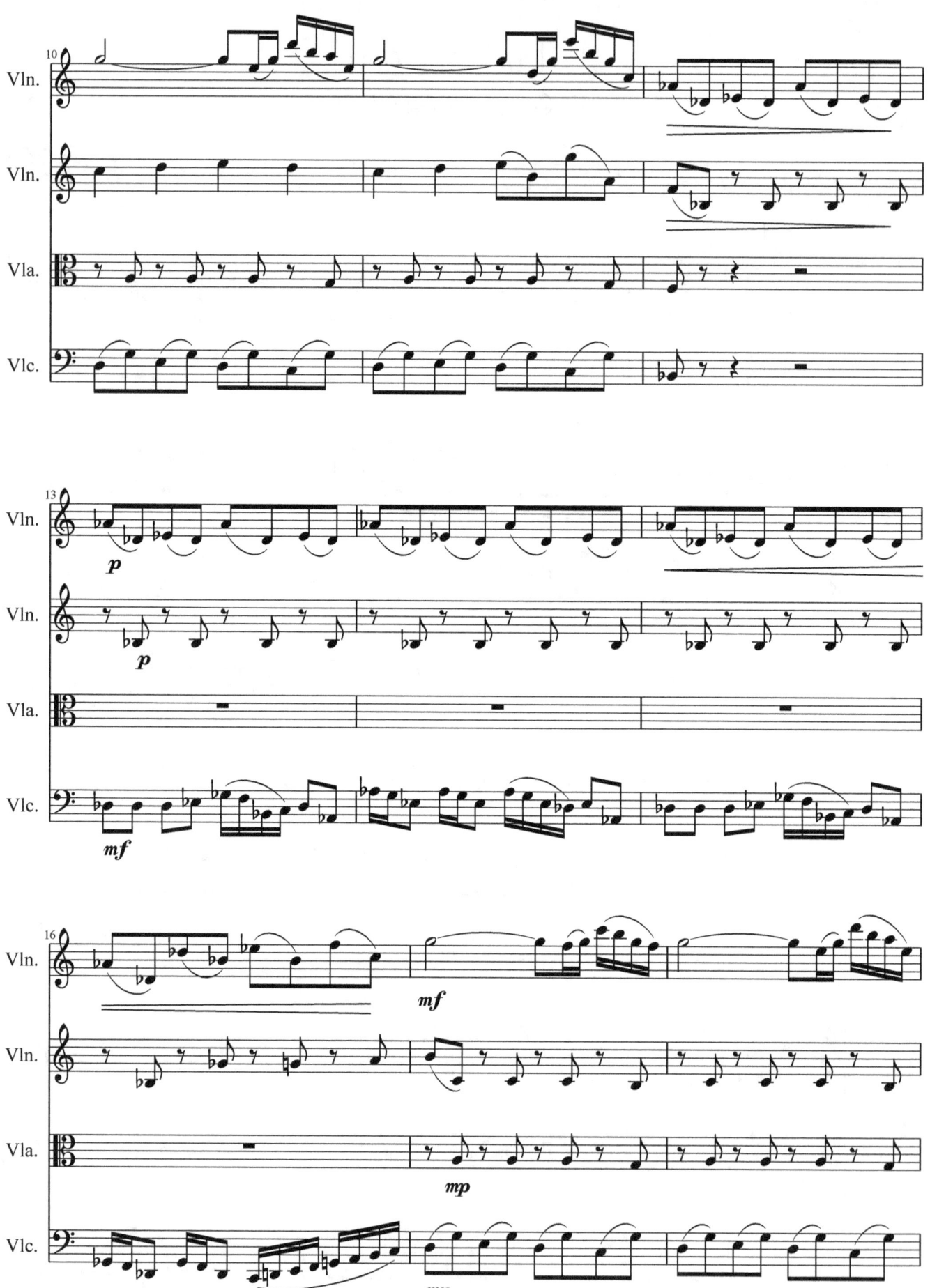

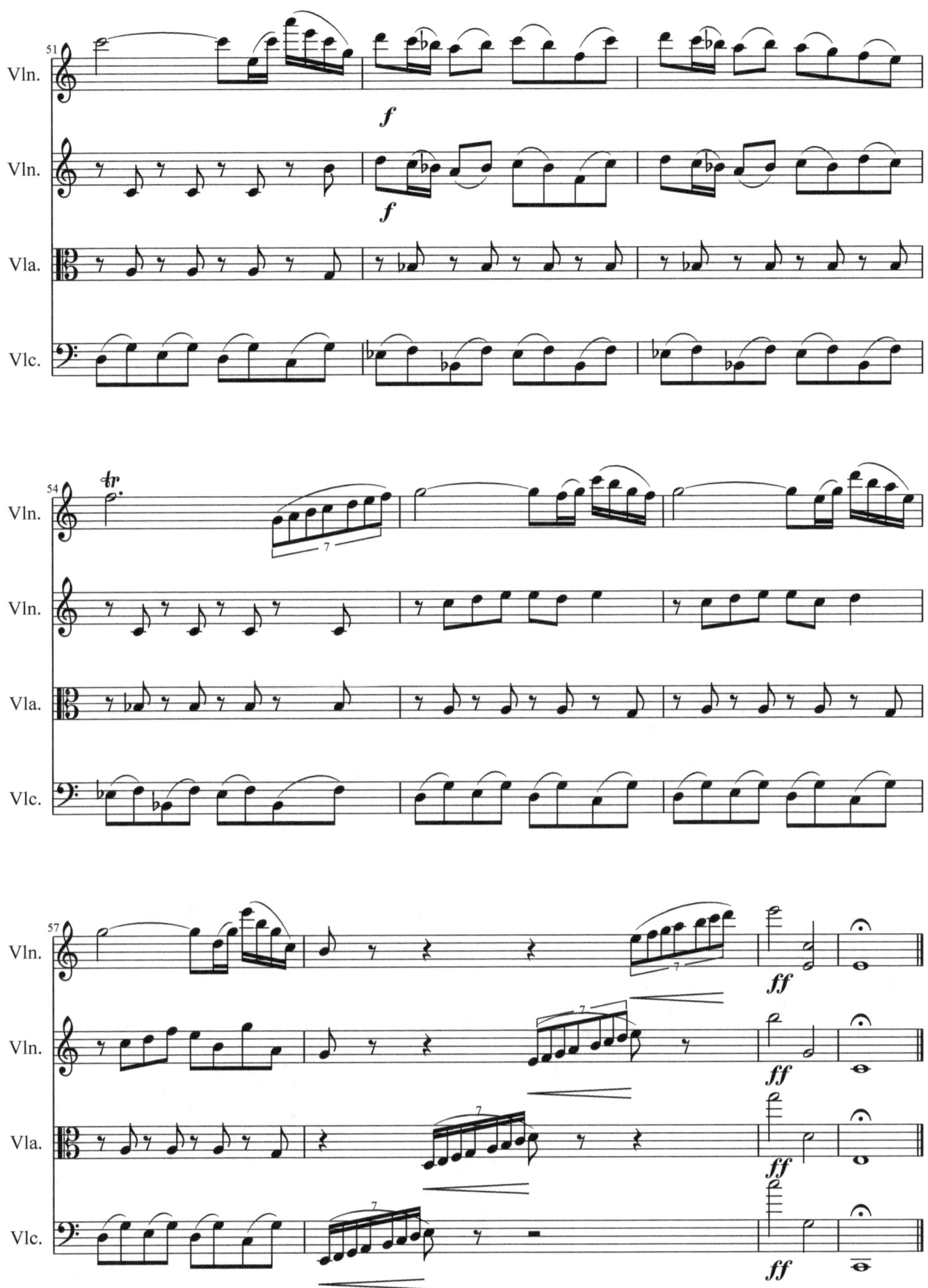

When Frost To Dance
A Sonatina commissioned by Malone

Ken Langer

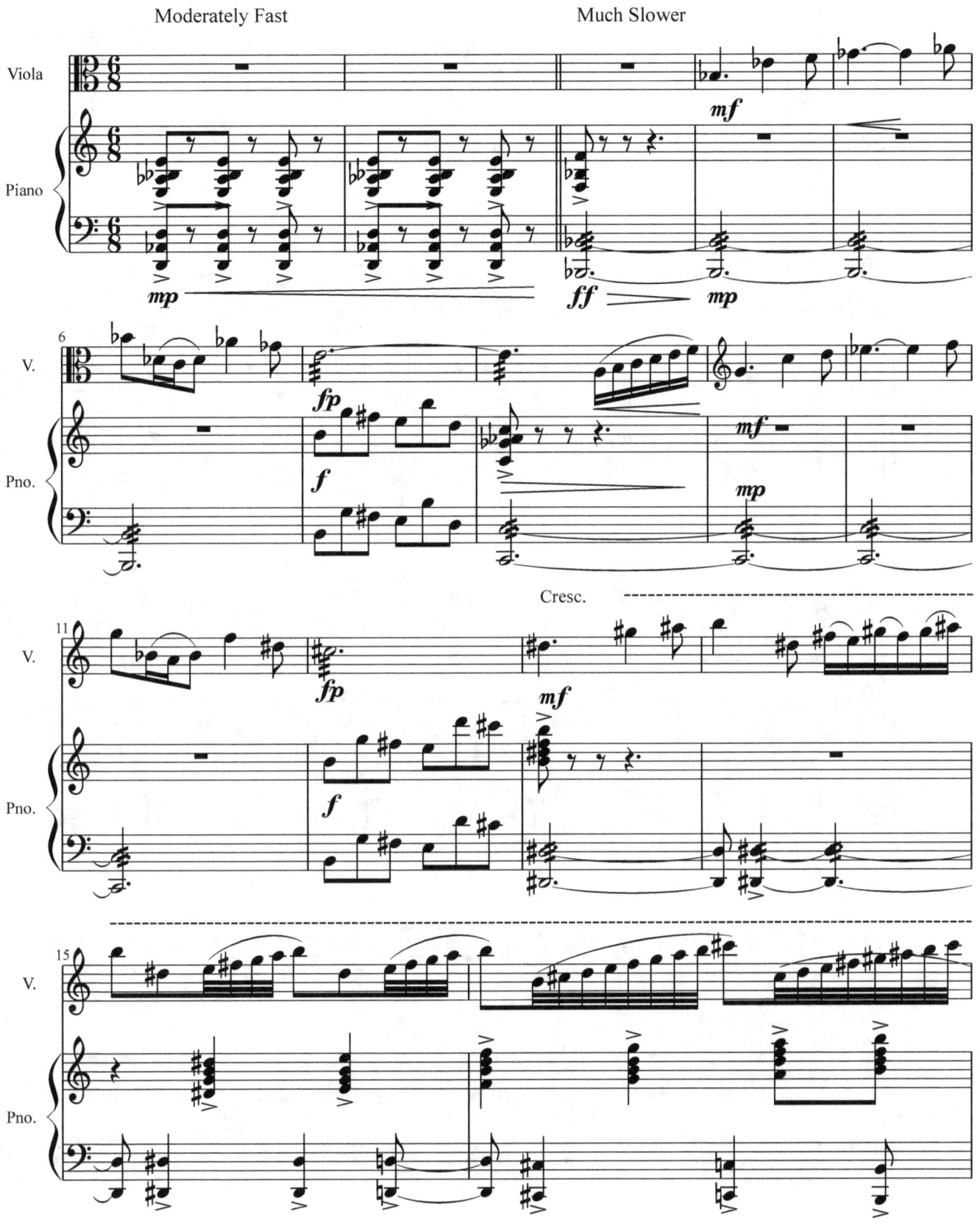

117

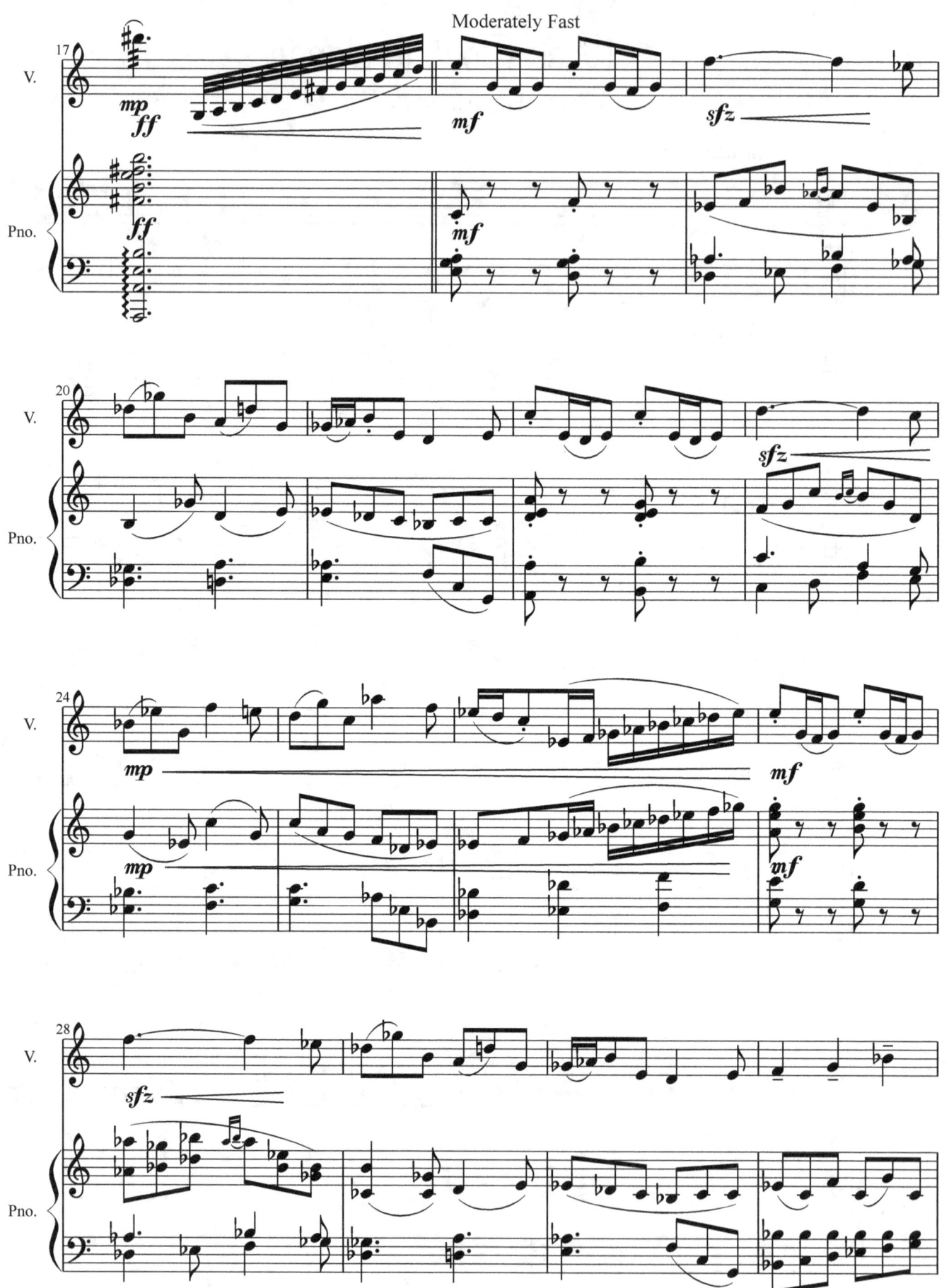

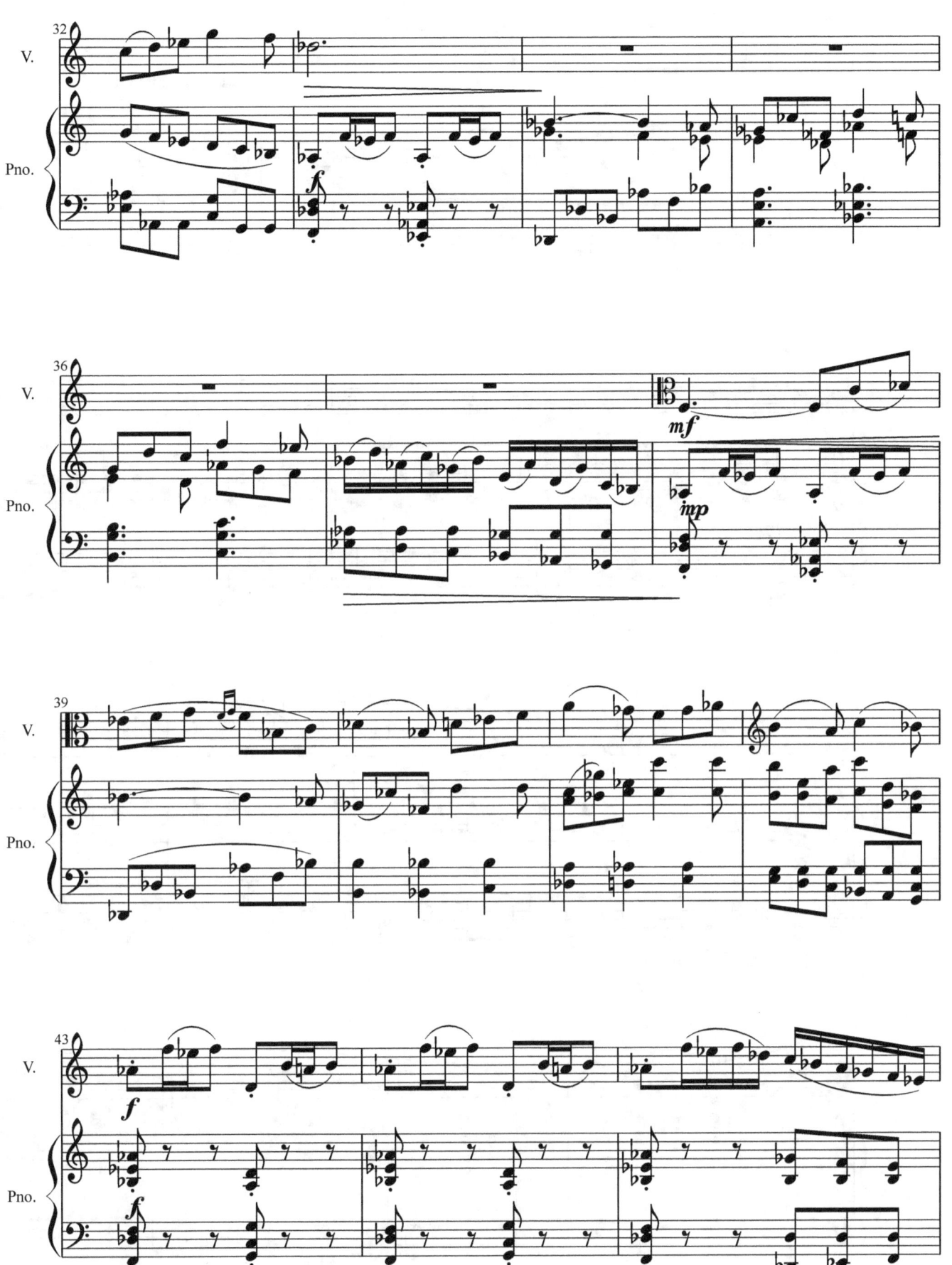

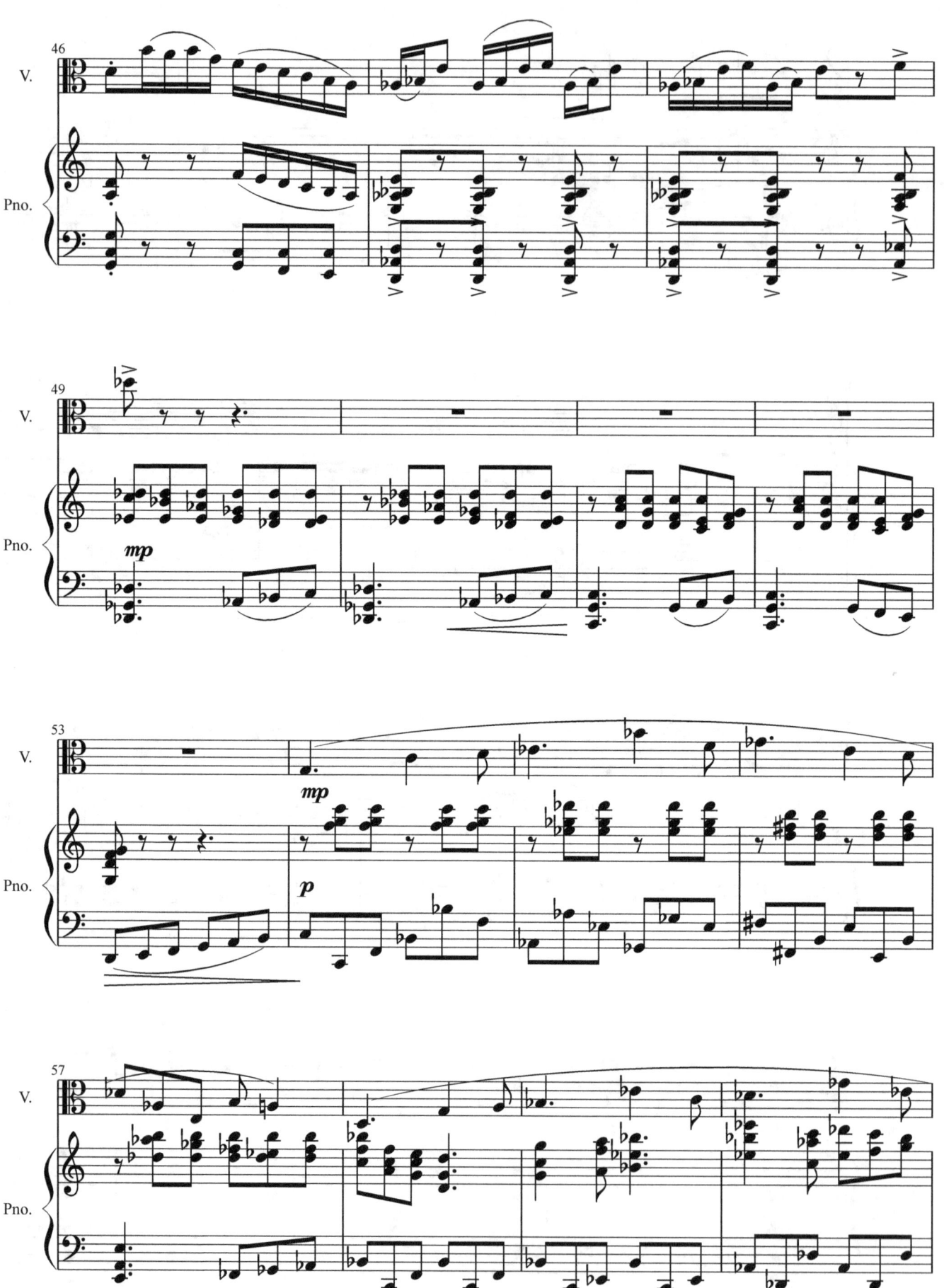

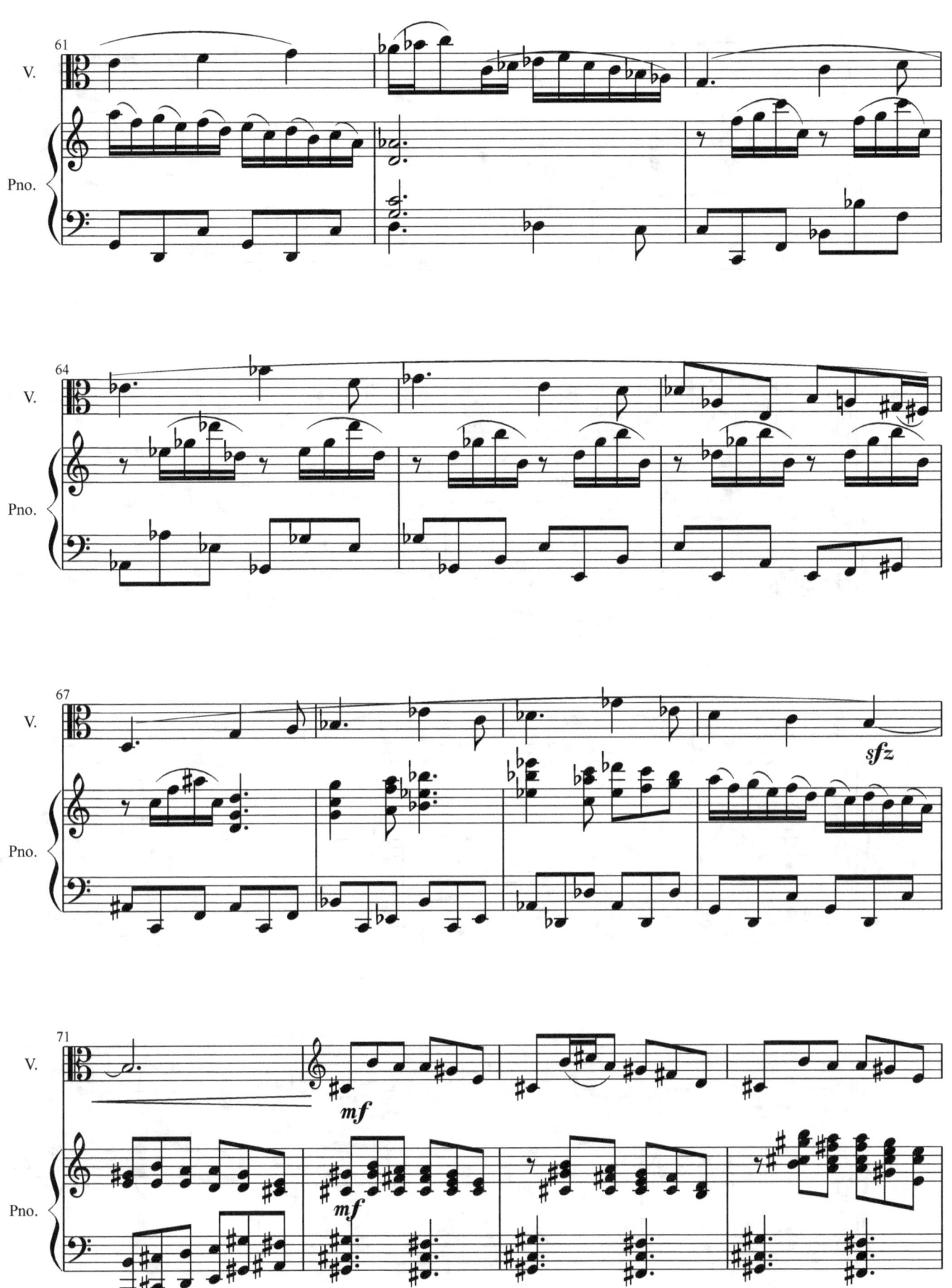

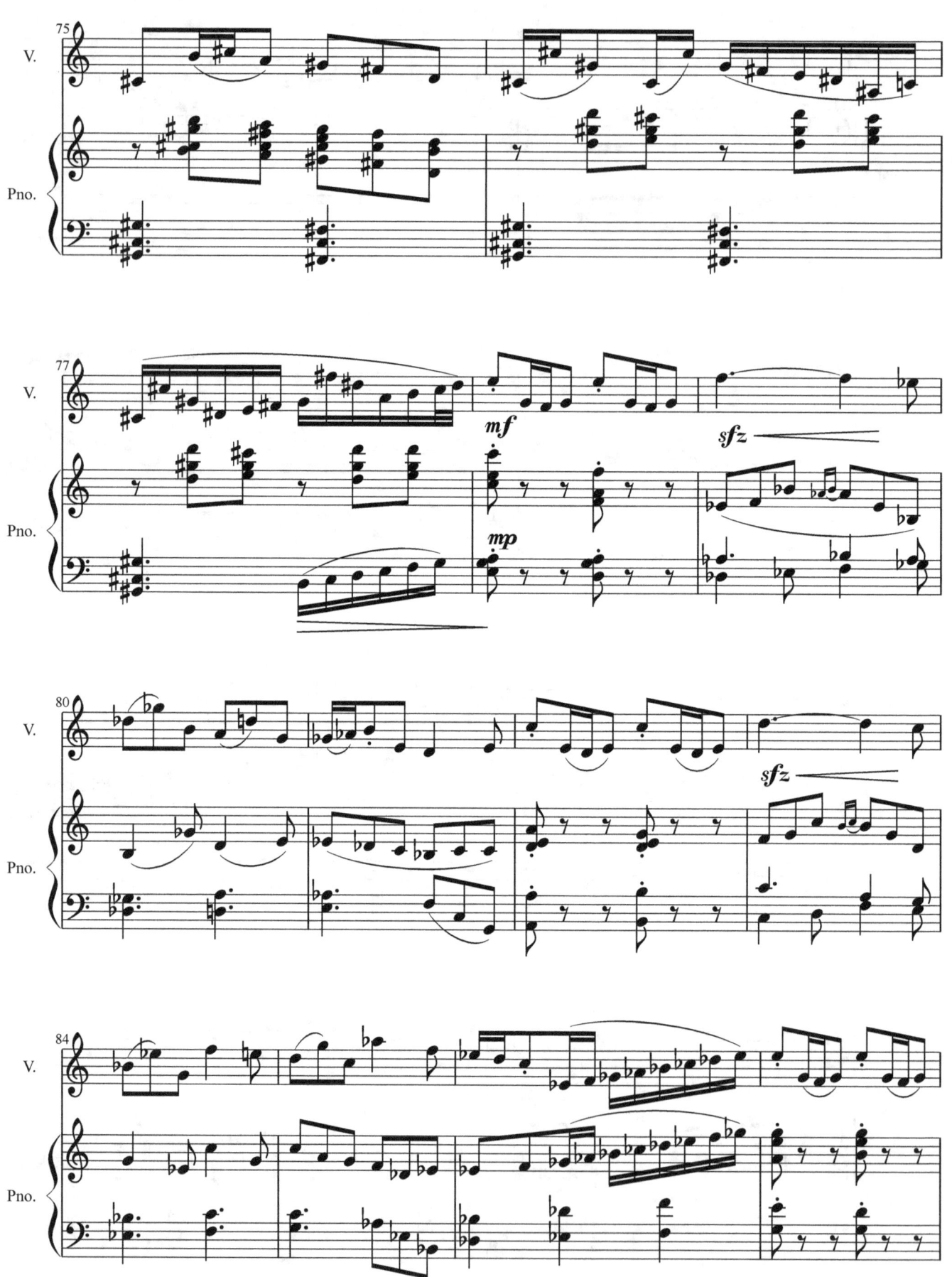

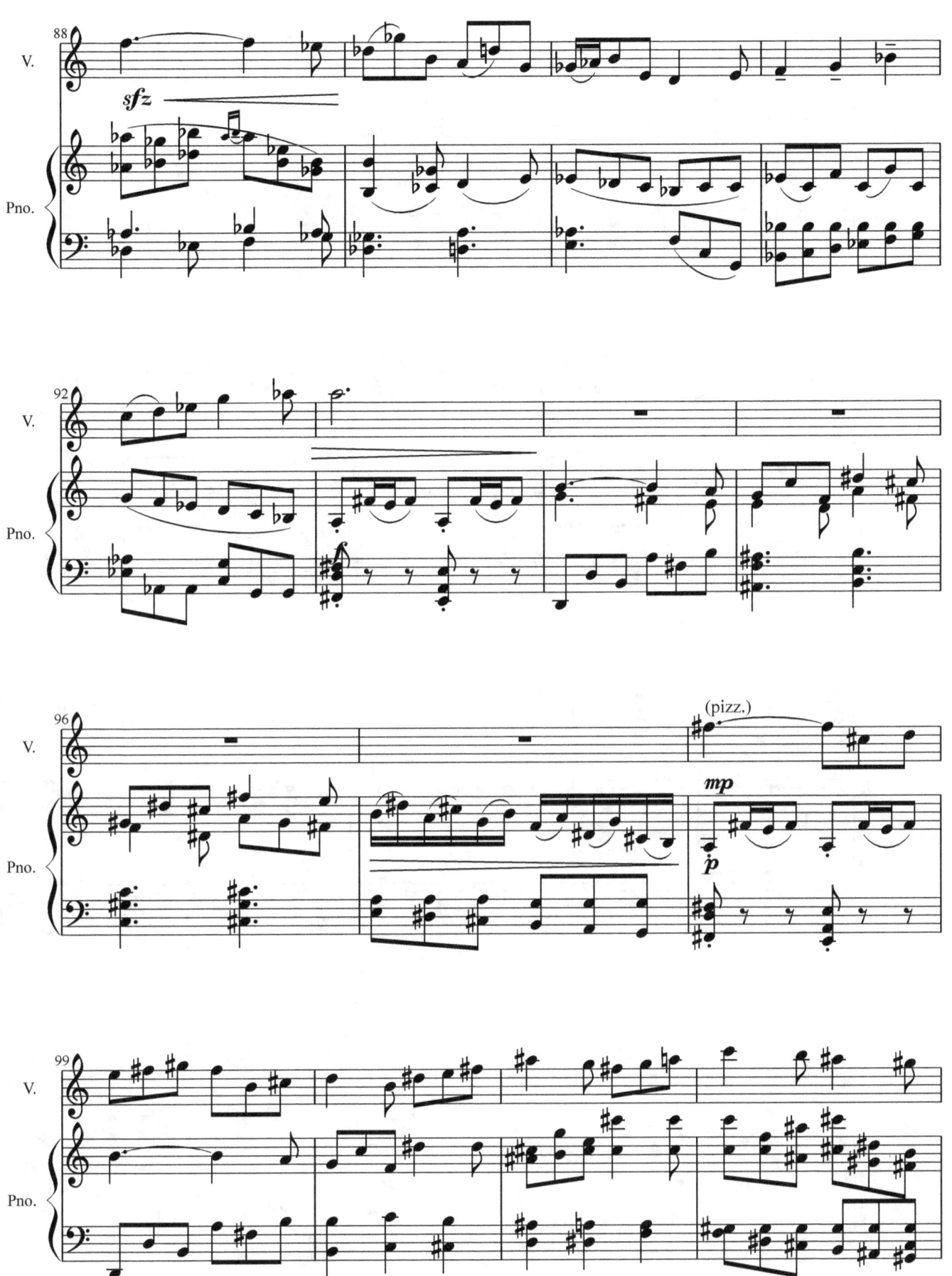

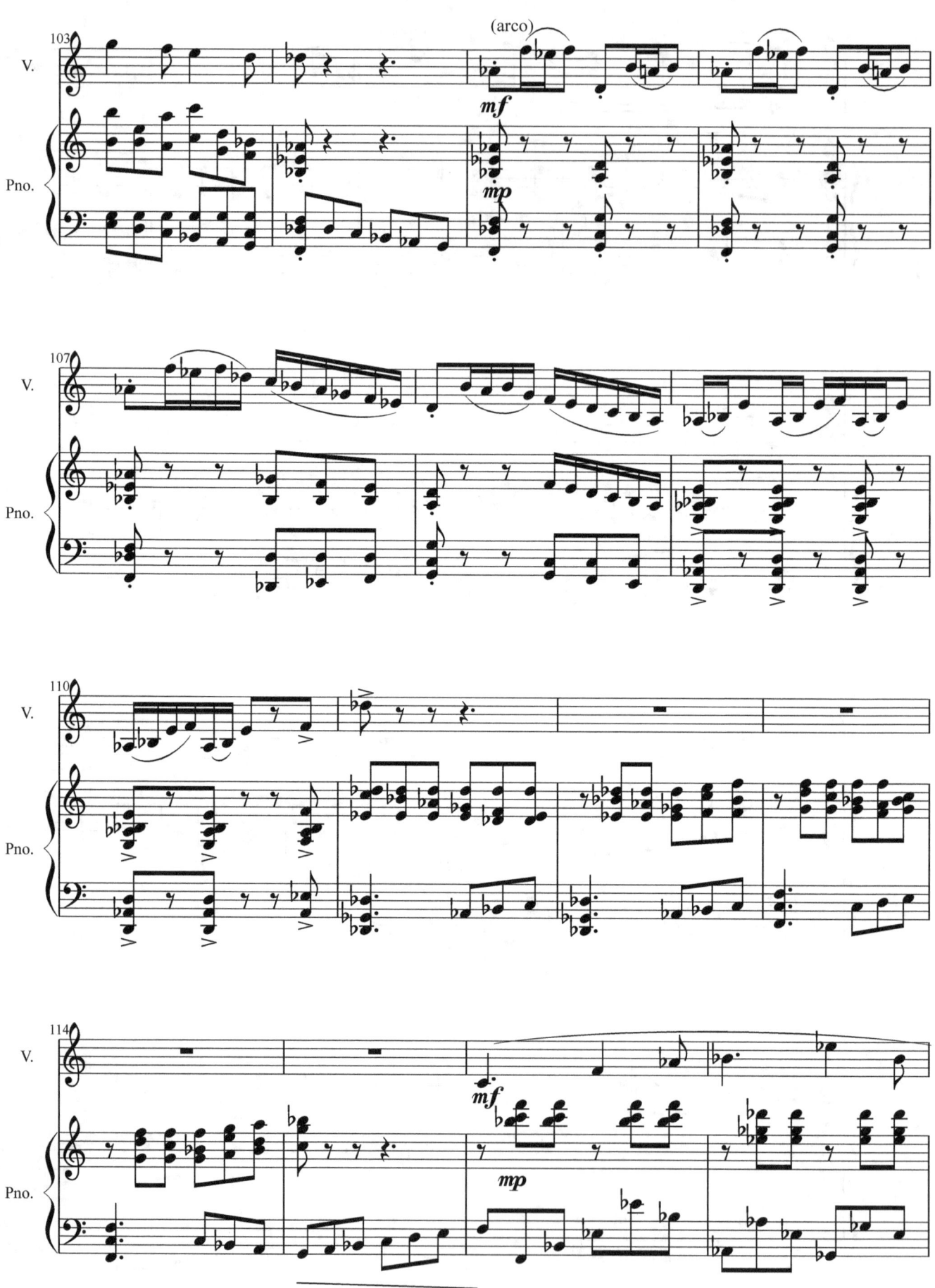

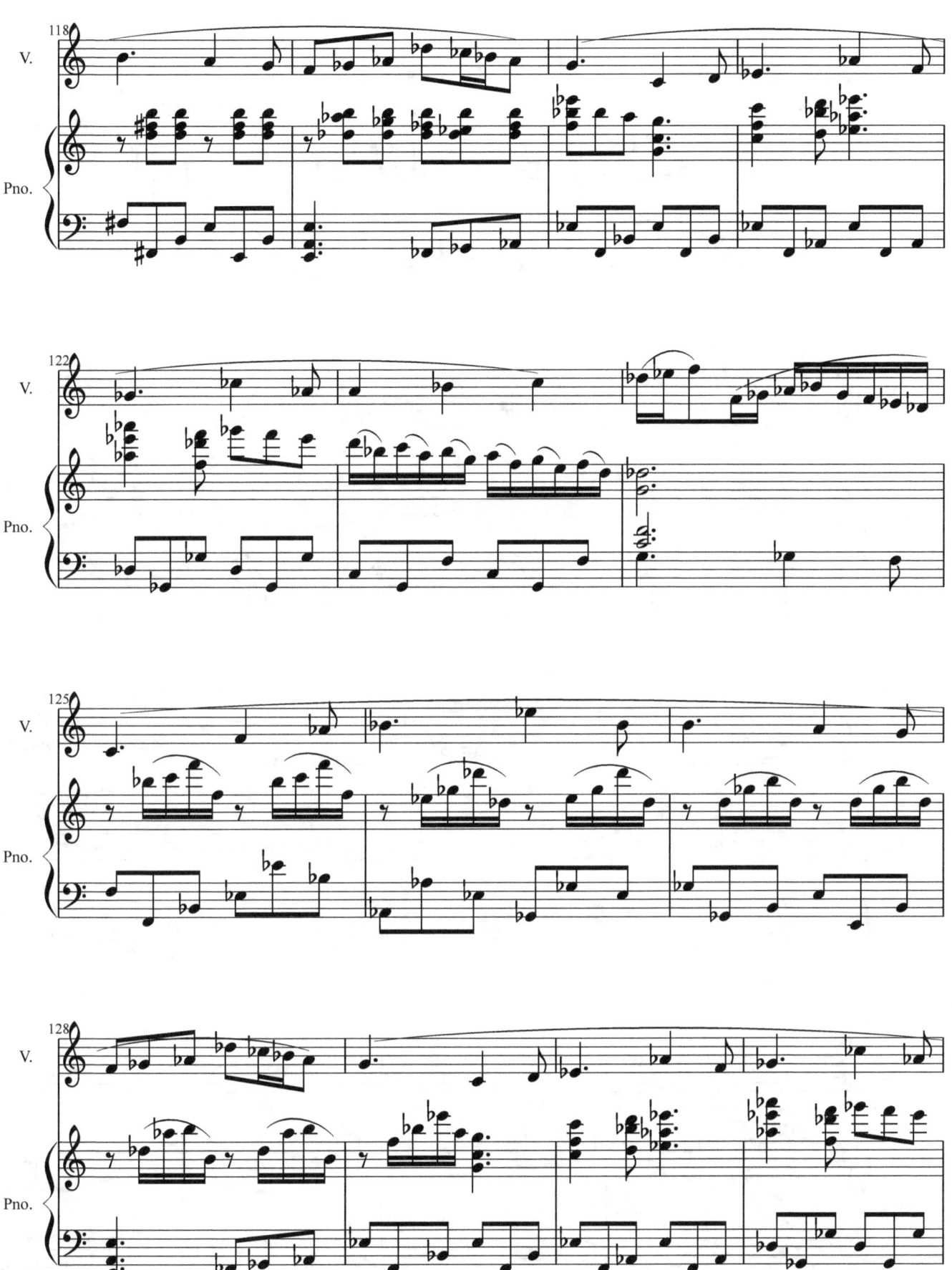

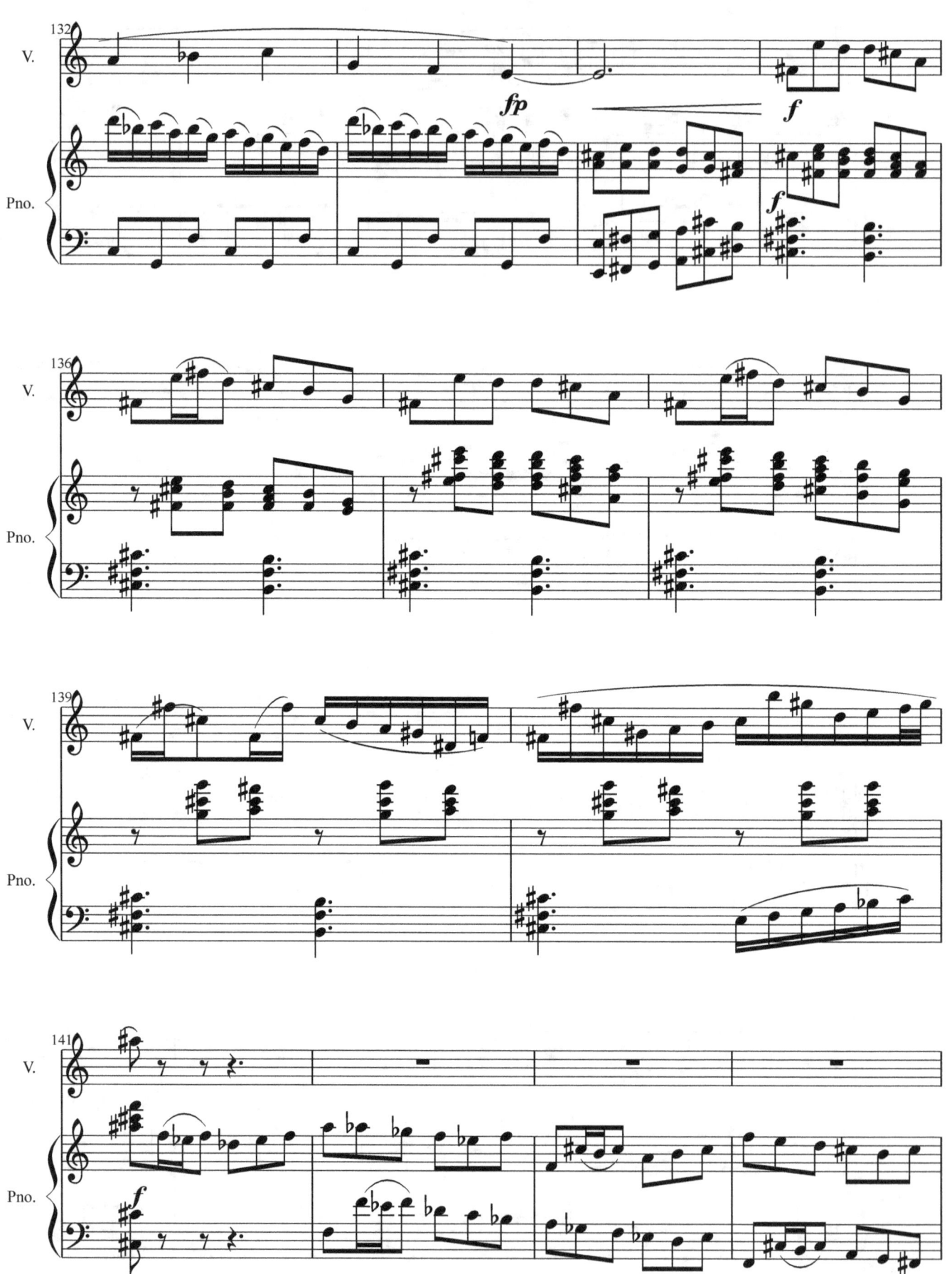

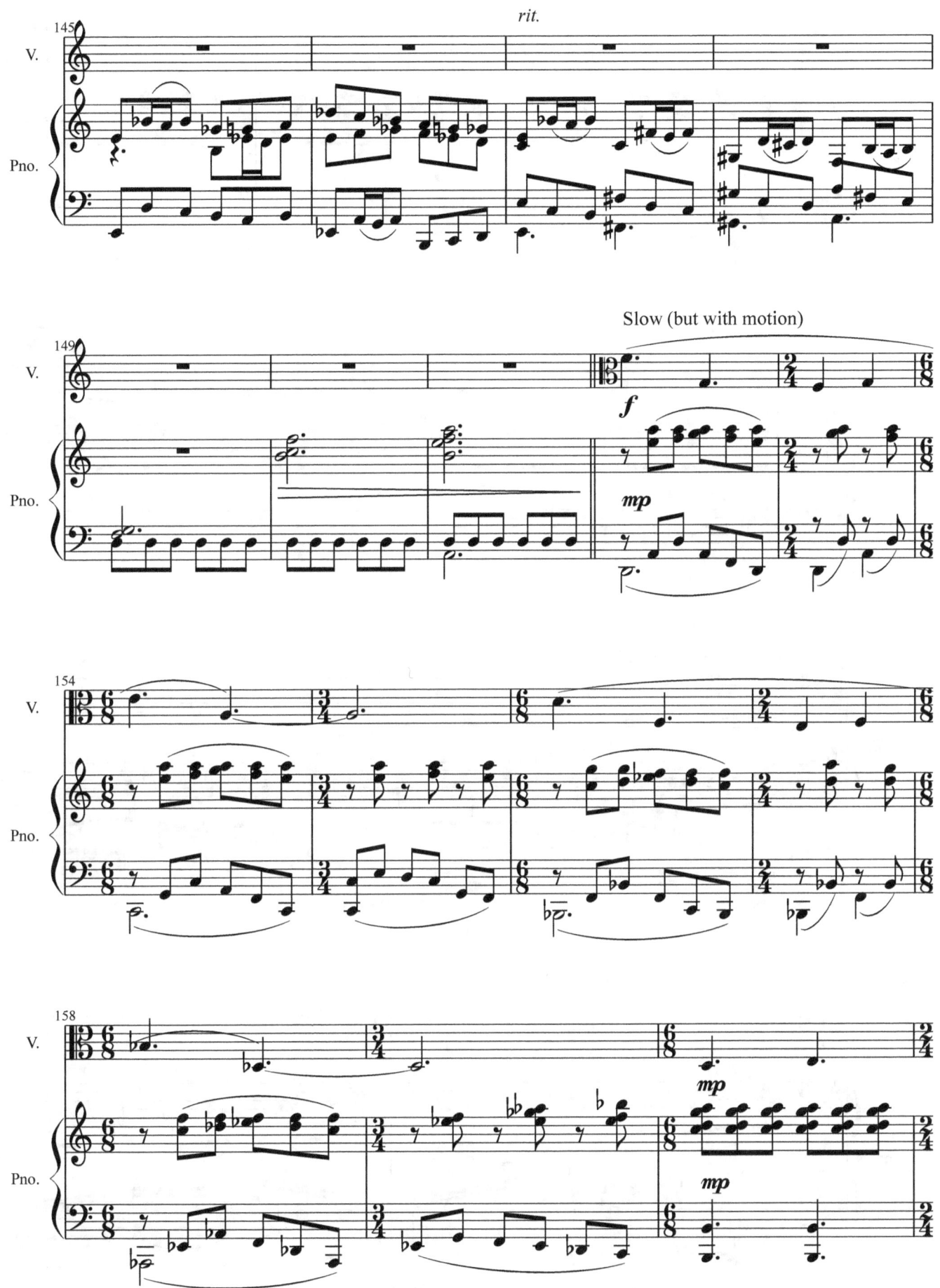

127

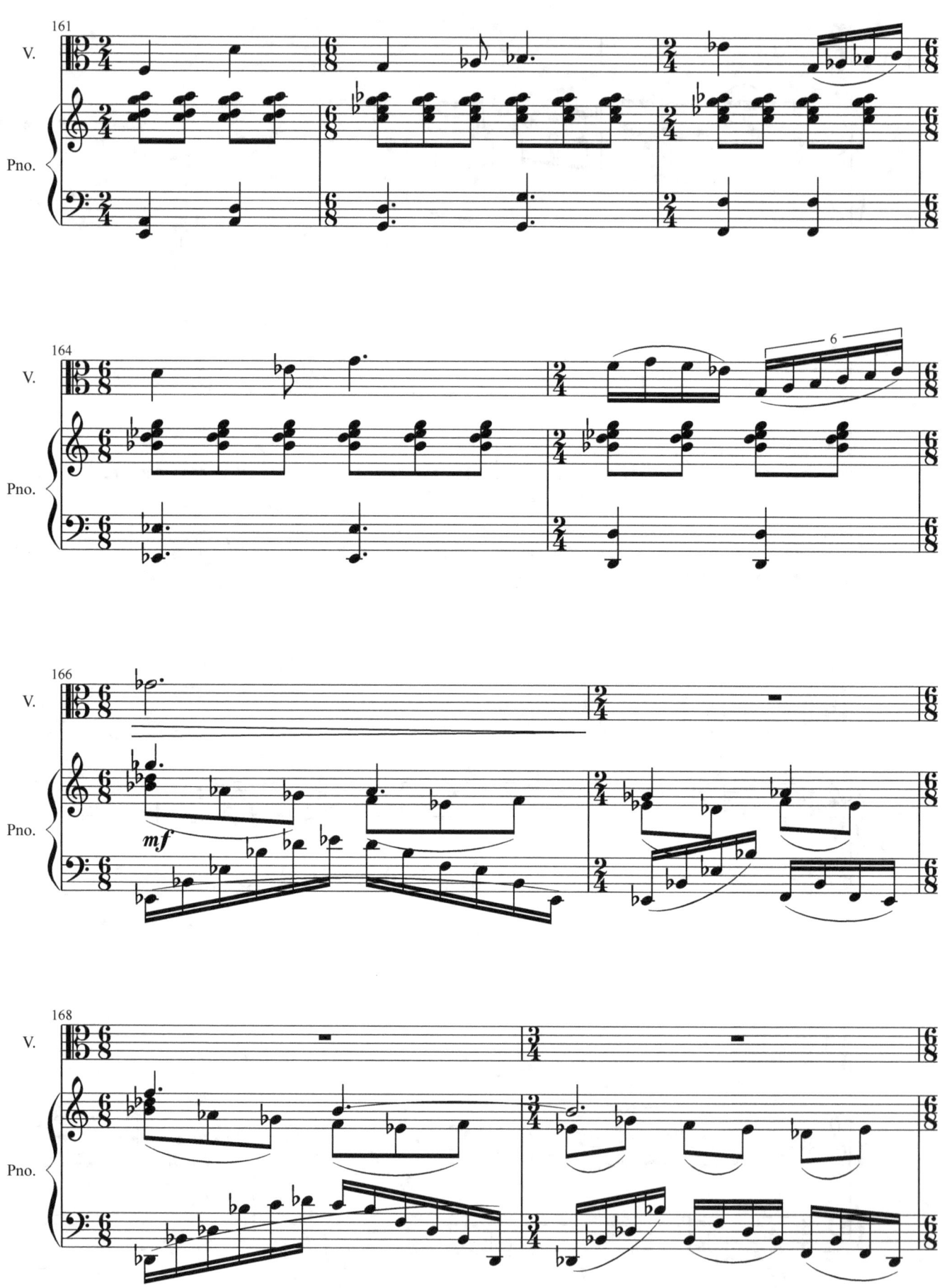

128

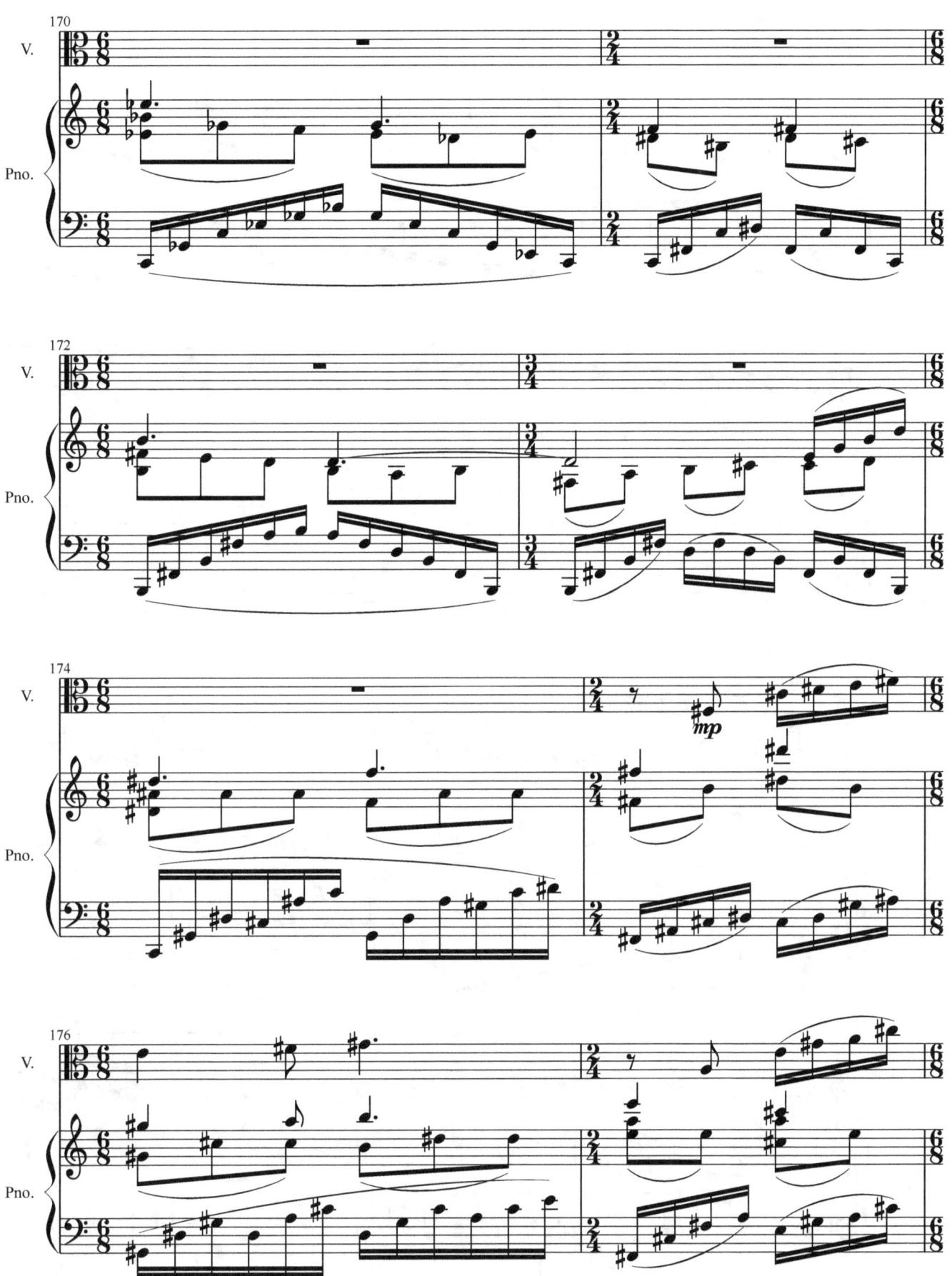

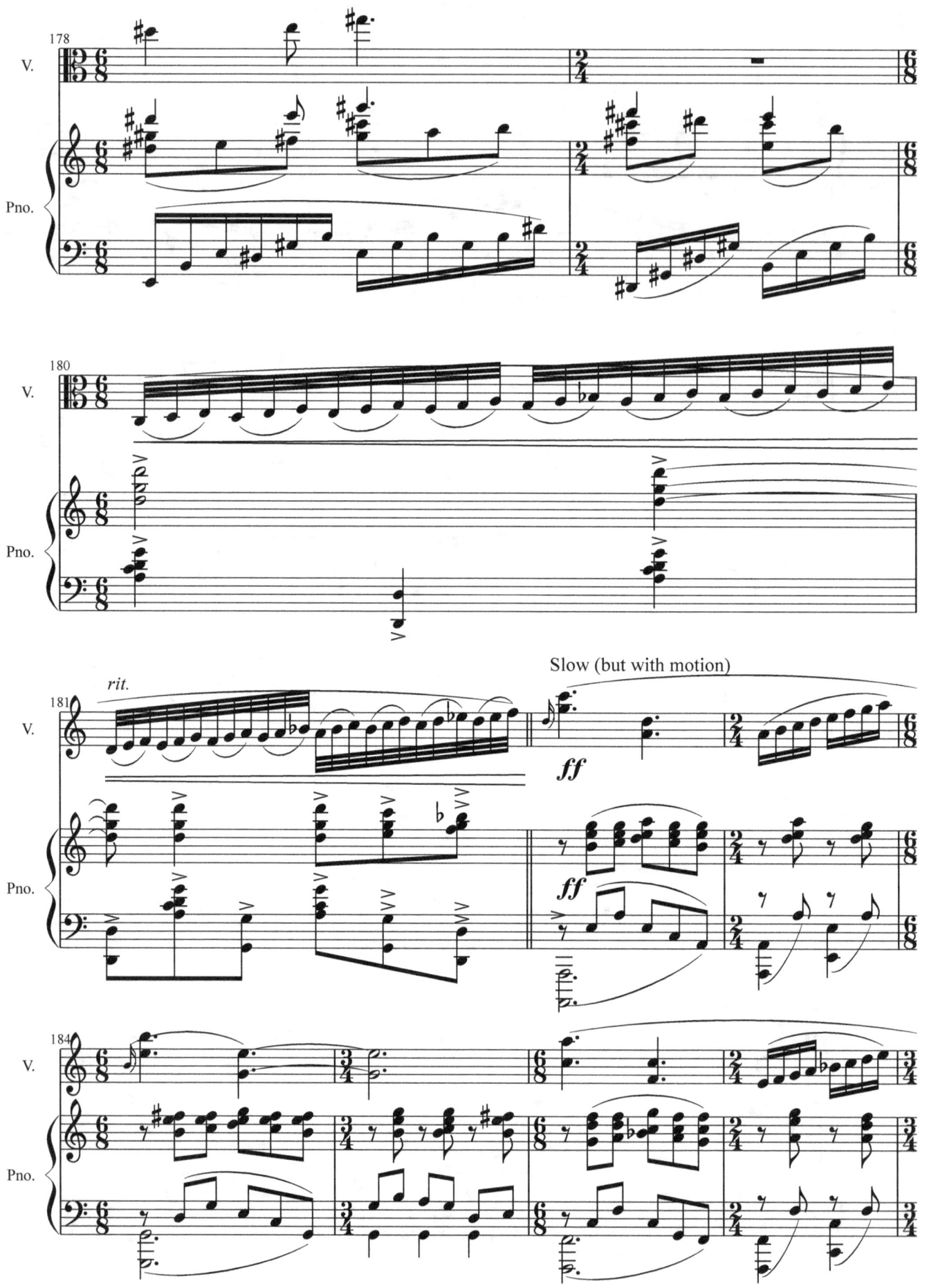

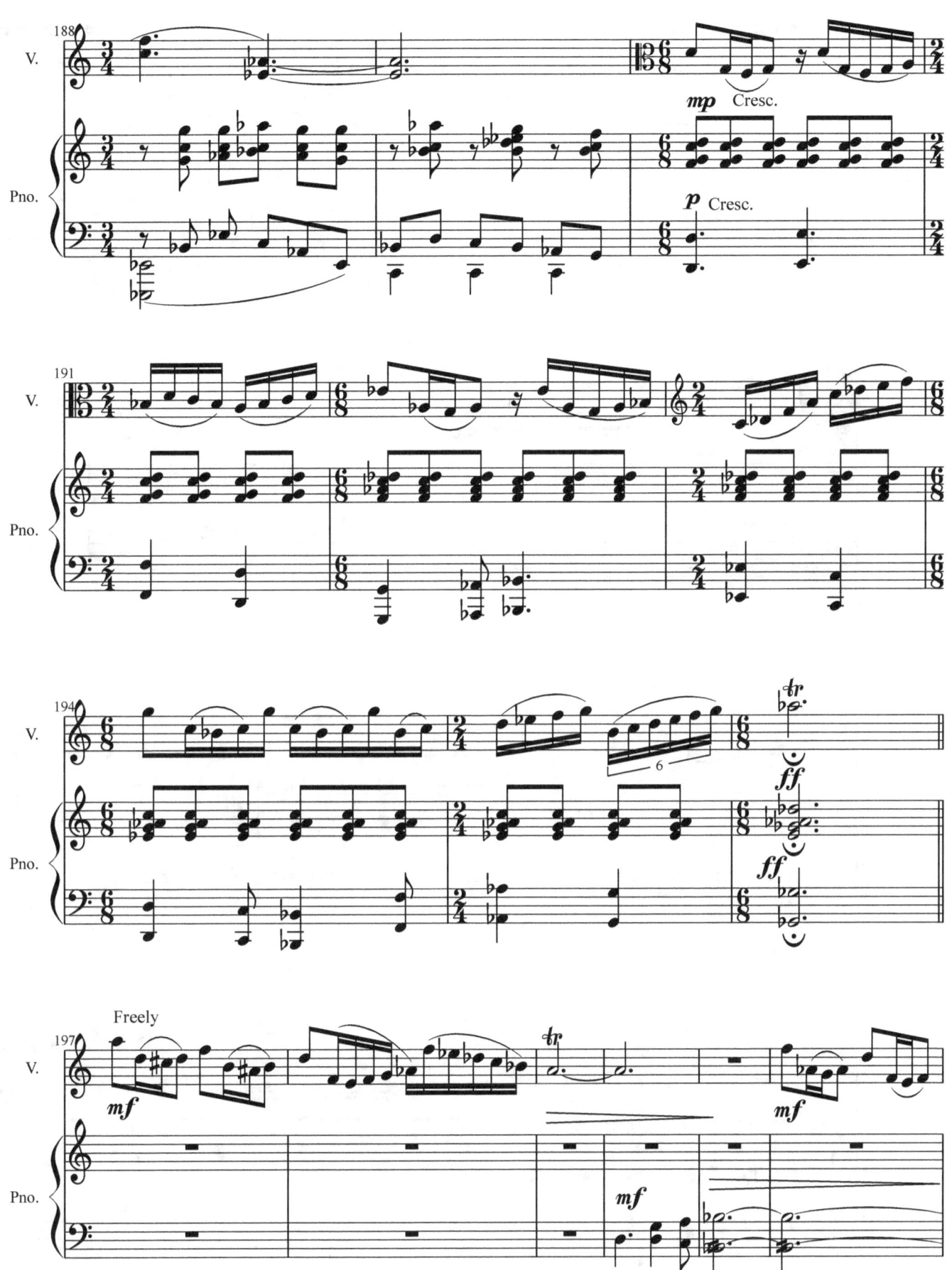

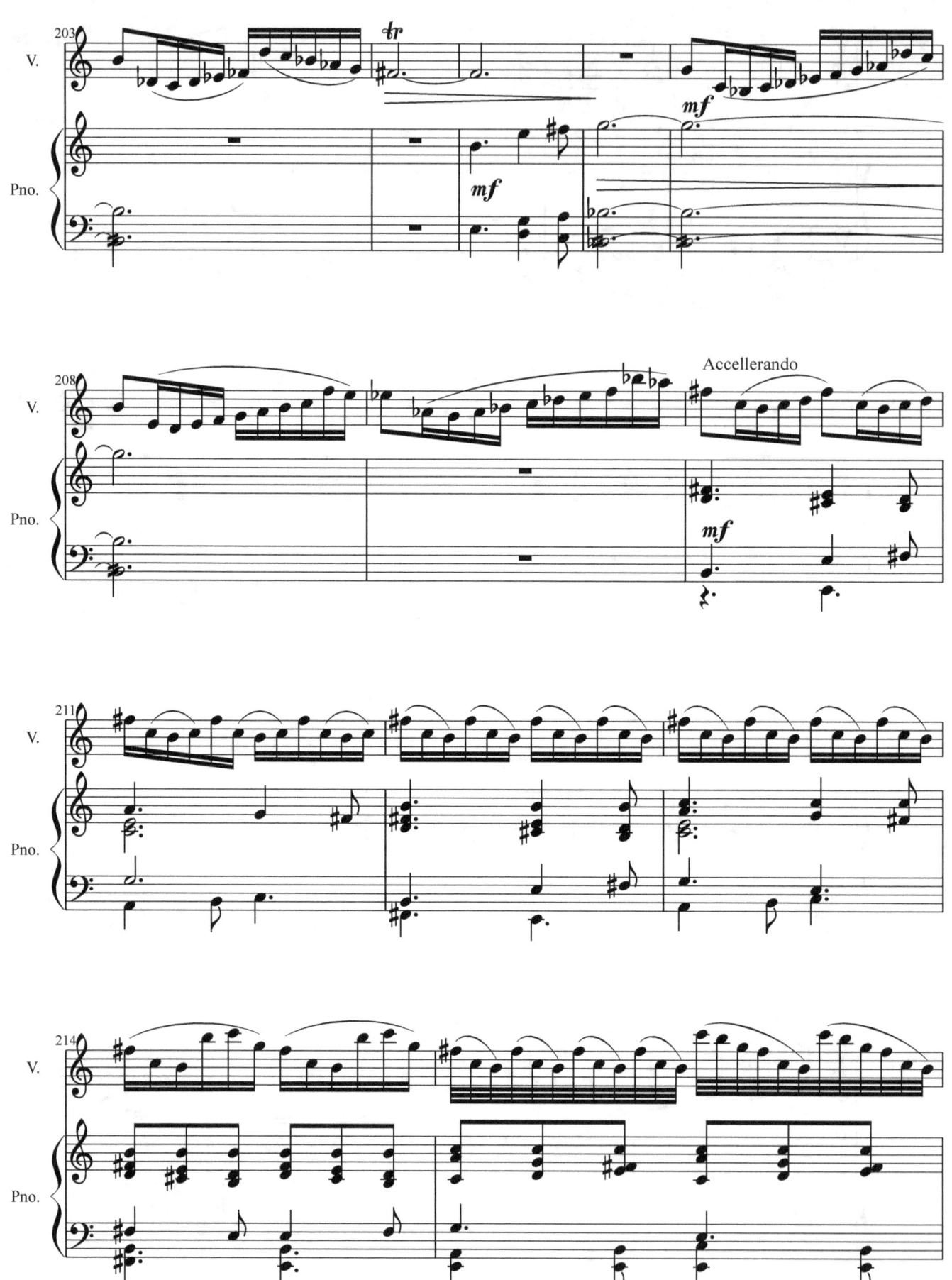

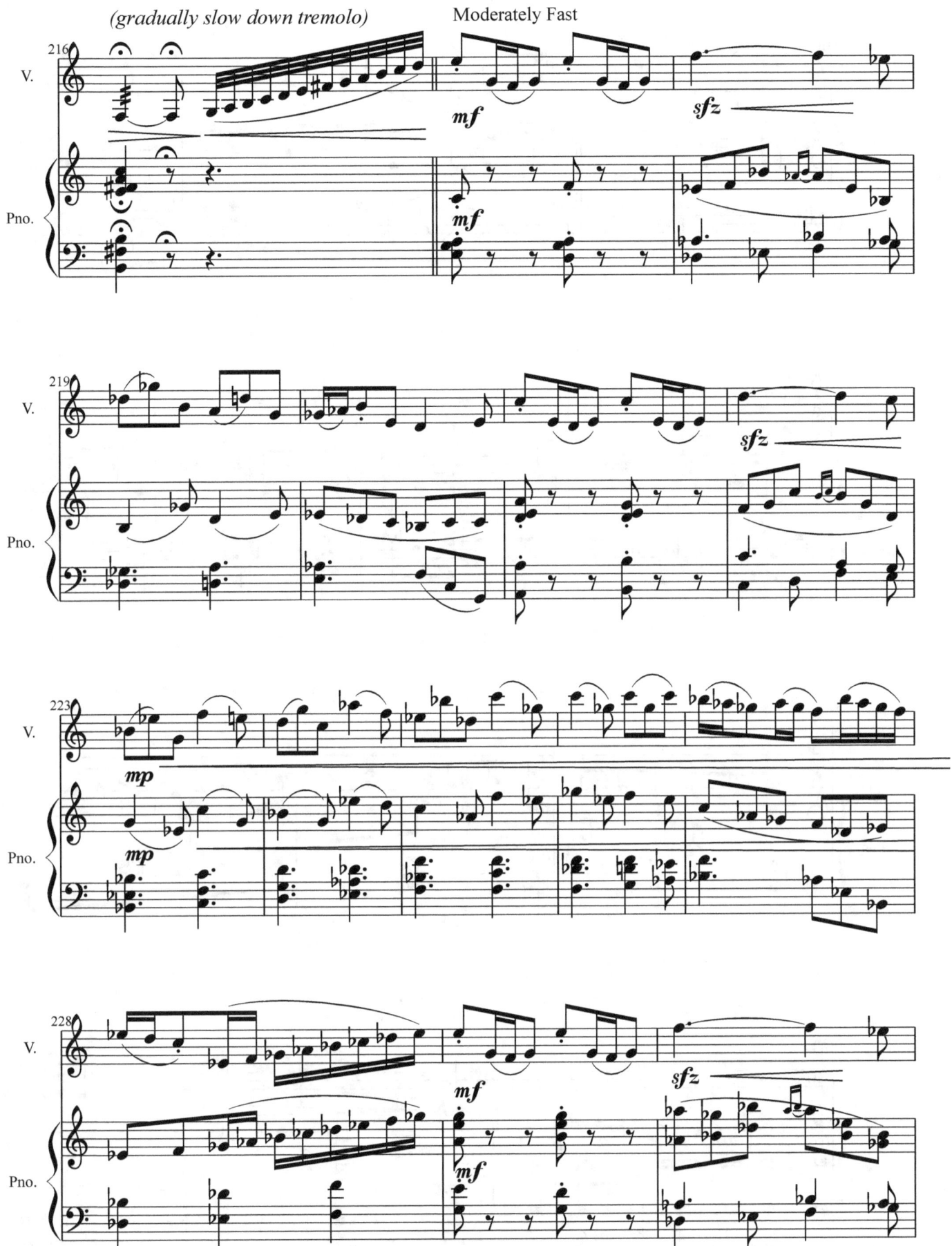

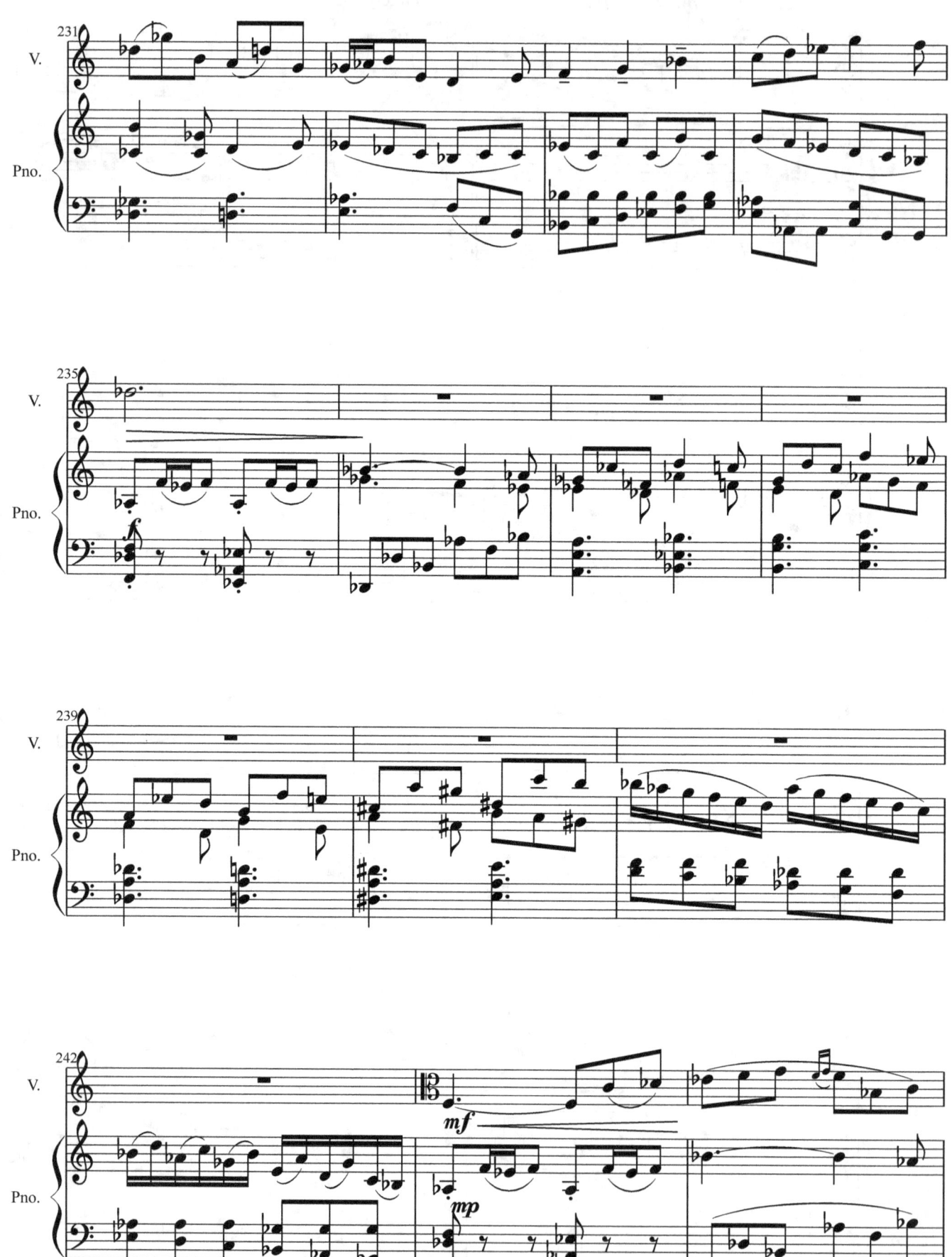

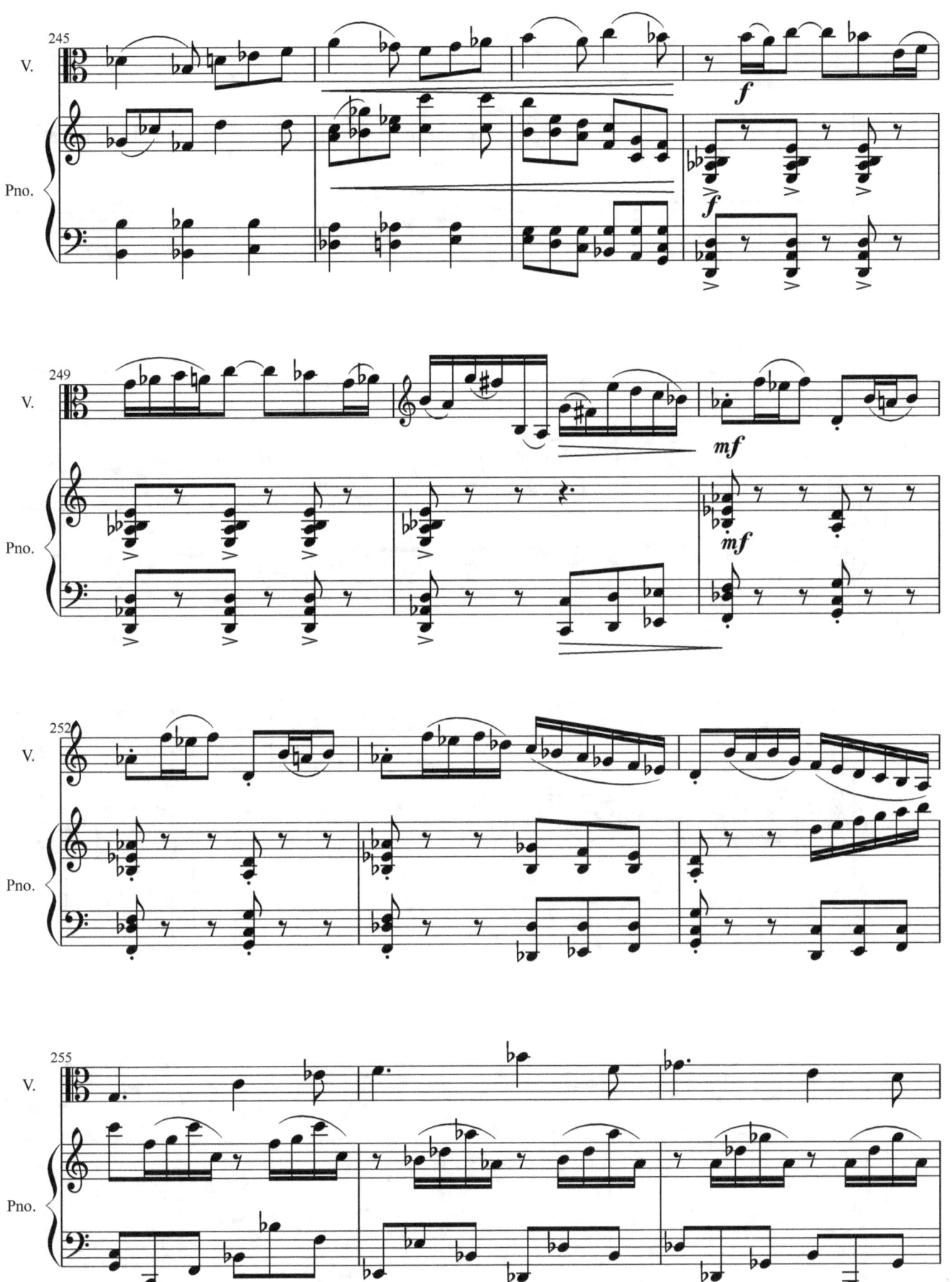

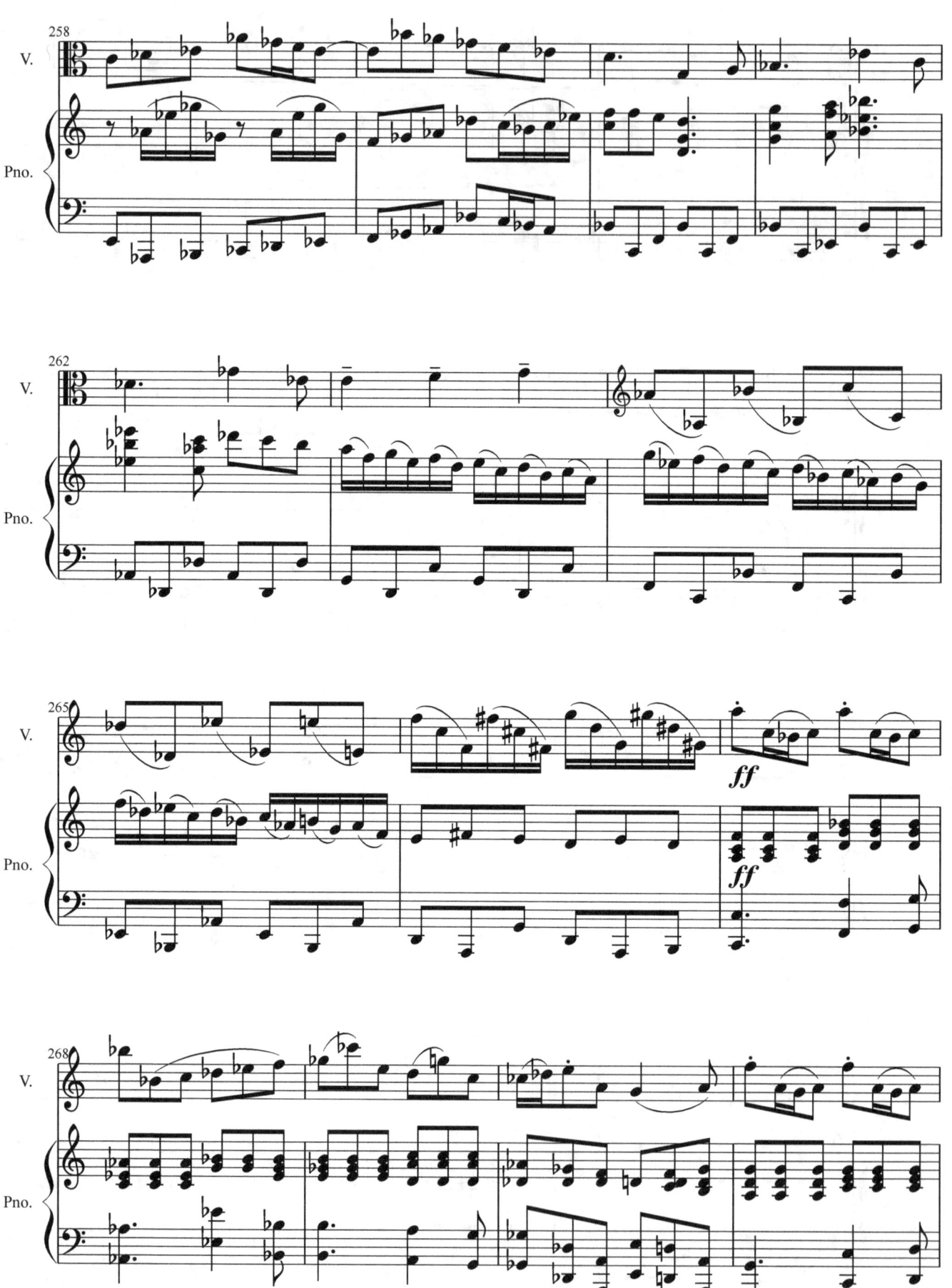

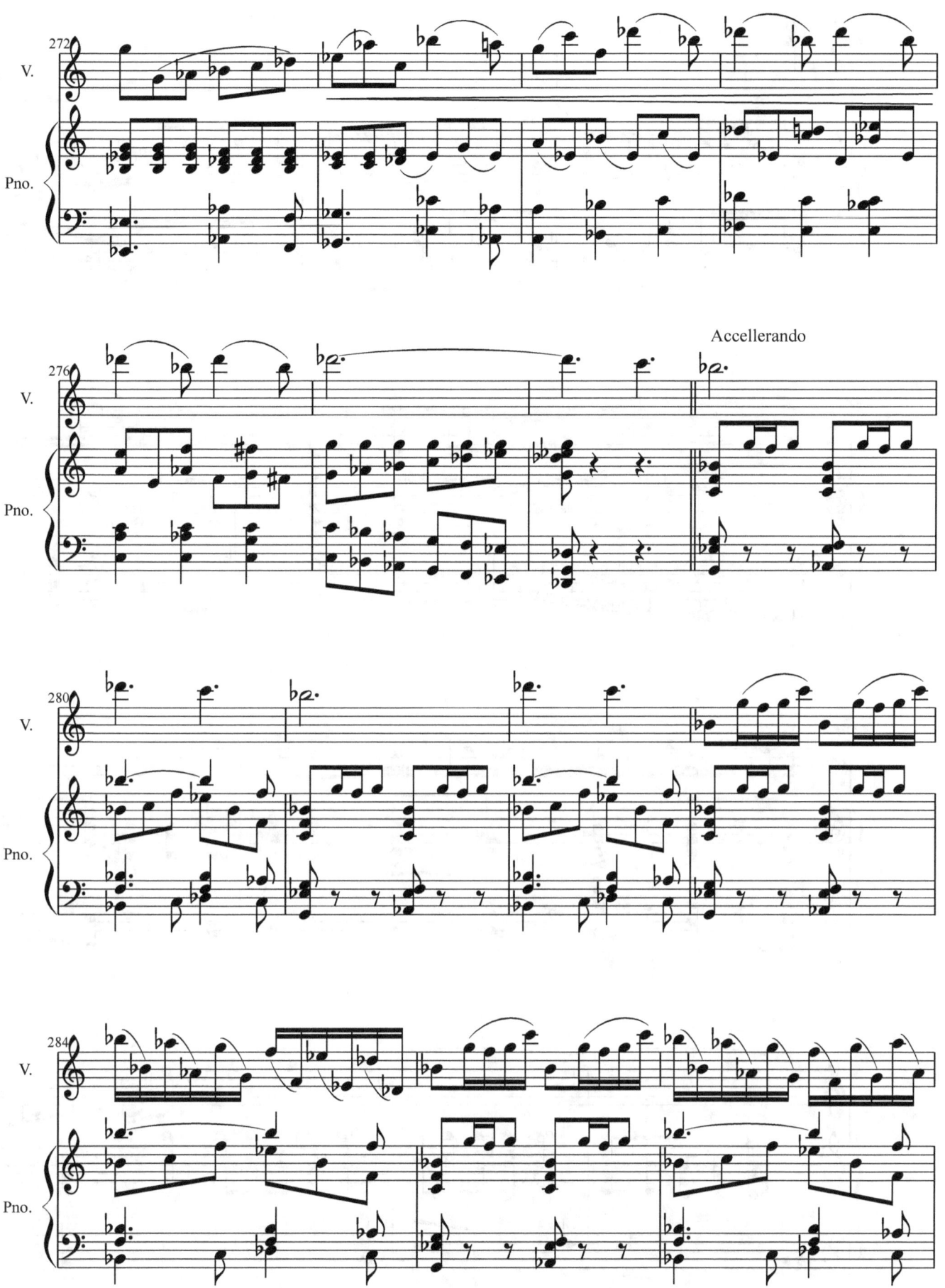

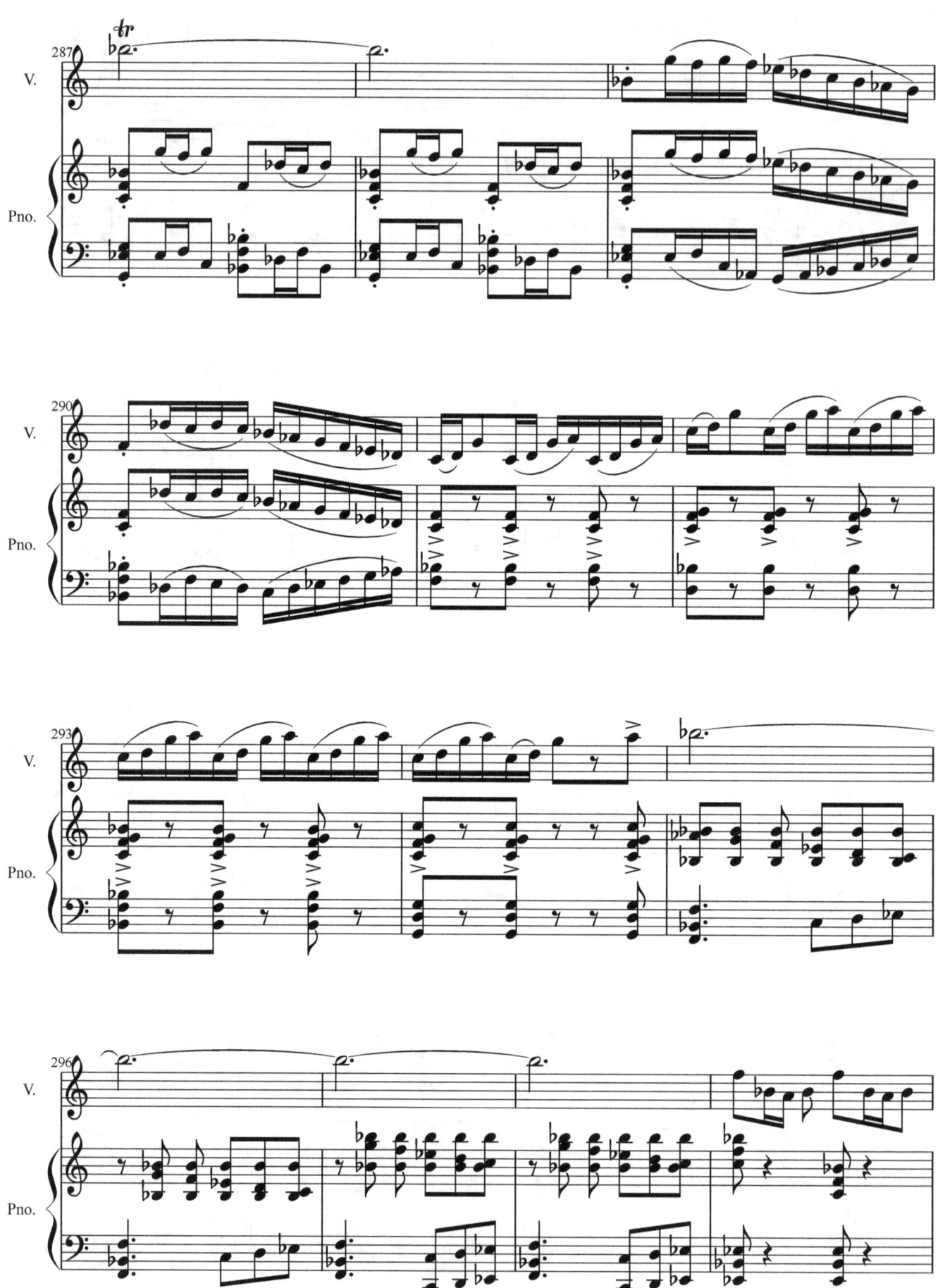

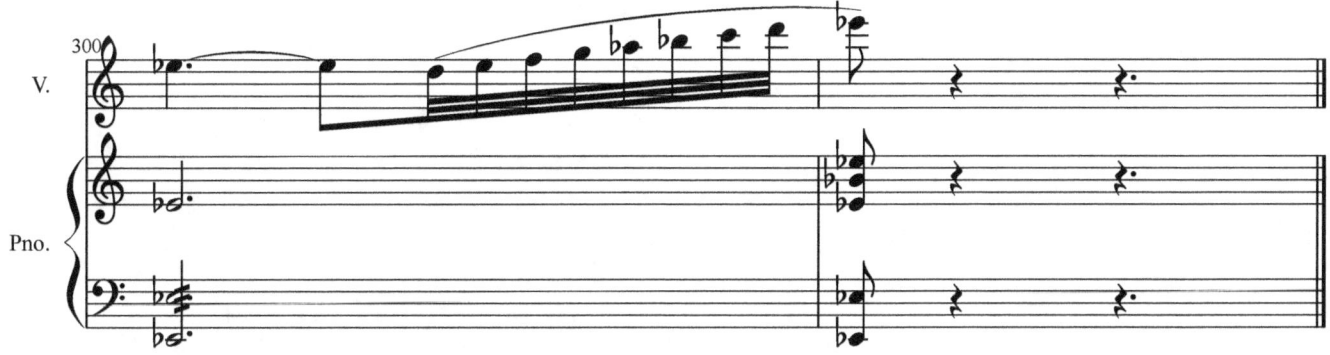

About The Composer

Dr. Kenneth Langer was born in the Pittsburgh area in 1959. He began playing trumpet in the 5th grade and decided in high school to make music his career.

Dr. Langer earned a Bachelor's Degree in Music Education at James Madison University in Harrisonburg, Virginia; a Master's of Music Degree at Radford University in Radford, Virginia; and a Ph.D. In Music Theory and Composition at Kent State University in Kent, Ohio. Since that time, he has taught music at several small colleges.

He has also been the full-time Director of Music and Arts at the Eno River Unitarian-Universalist Fellowship in Durham, North Carolina and the Assistant Conductor and Resident Composer at the Montpelier Unitarian-Universalist Church in Montpelier, Vermont.

During his twenty years of writing over 150 original works of music for various genres including brass, chorus, strings, orchestra, wind ensemble, and woodwinds; he has received numerous awards for his compositions including being named Vermont's Composer of the Year in the year 2000 and winning placement in several international composition contests. He has commercially published well over 30 compositions.

Dr. Langer currently lives in the Boston area with his family where he works as the Head of the Music Program at Northern Essex Community College in Haverhill, Massachusetts.

Publishers

Music For Brass

Nichols Music Company (Ensemble Publications)
P.O. Box 32 Ithaca, NY 14851-0032
www.enspub.com

Solid Brass Music
P.O. Box 2277 Rome GA, 30164
www.solidbrassmusic.com

Cimarron Music Press
15 Corrina Lane Salem CT 06420s
www.cimarronmusic.com

Wehr's Music House
www.wehrs-music-house.com

Music For Chorus

Yelton Rhodes Music
1236 N. Sweetzer Avenue #5 West Hollywood CA 90069
www.yrmusic.com